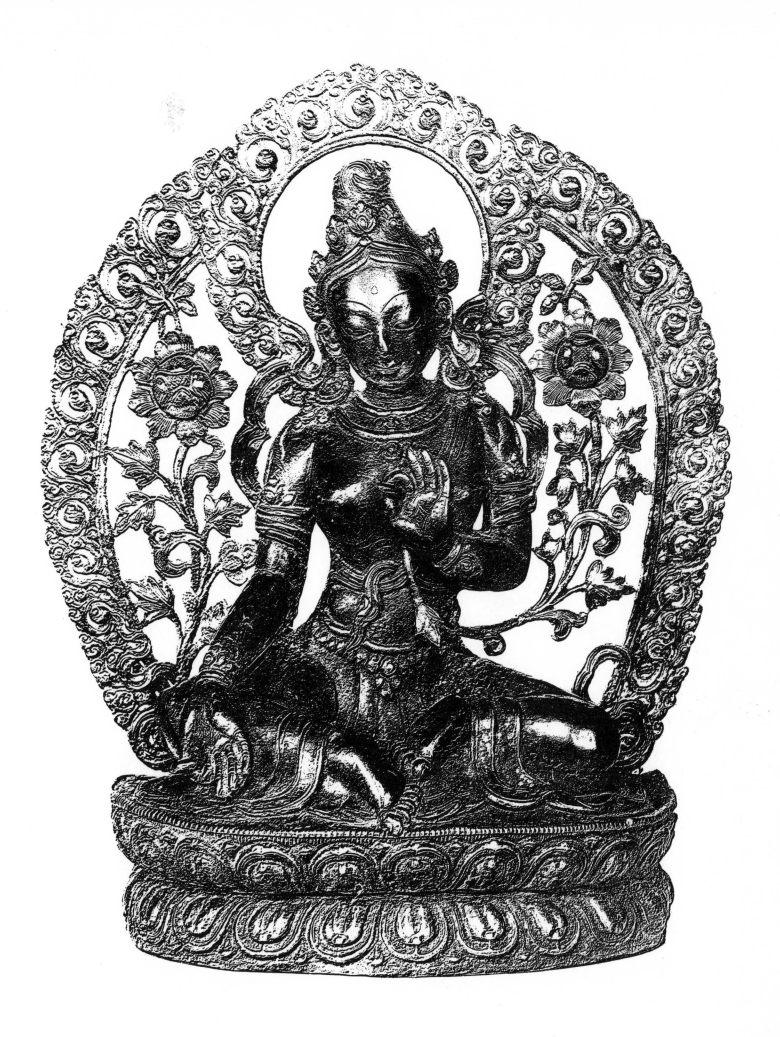

TIBETAN SACRED ART

THE HERITAGE OF TANTRA

BY

DETLEF INGO LAUF

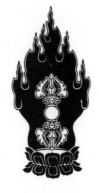

SHAMBHALA

BERKELEY & LONDON

1976

SHAMBHALA PUBLICATIONS, INC.
2045 Francisco Street
Berkeley, California 94709

Originally published in German © 1972 Kümmerly & Frey,
Geographischer Verlag, Berne, Switzerland in cooperation
with the Swiss Tibetan Aid Committee

Translated into English by Ewald Osers
Preface by Michael A.F. Malcolm
© 1976 Shambhala Publications Inc. All rights reserved.
ISBN 87773-089-X LCC 76-14204
Distributed in the United States by Random House and
in Canada by Random House of Canada Ltd.
Distributed in the Commonwealth by Routledge & Kegan Paul Ltd.,
London and Henley-on-Thames.

Printed in Switzerland

Contents

Foreword

When, over ten years ago, the Dalai Lama and (symbolically with him) free Tibet were forced into exile by the pressure of Chinese troops, a profound change began to take place in the country which until then had been known as an ancient seat of civilization, the land of yogis, lamas and saints, a land of a thousand Buddhas. Some ten thousand Tibetans then escaped from their country, but what little they were able to take with them was no longer the old Tibet.

Confronted with a new era in their adopted Indian homeland, Buddhist religion and culture and Tibetan national character must inevitably undergo gradual changes; once this has happened the old Tibet will have finally become a country of the past. The young generation of Tibetans in India are the heirs to a cultural heritage of many different layers, a cultural heritage which has shaped and guided their nation for more than a thousand years, and they will attempt to pass it on. Fortunately for the Tibetans and for Tibetan Buddhism this assimilation to the modern age is taking place against a still living background. There remain extensive and often scarcely accessible areas in Ladakh, Nepal, Sikkim and far beyond the frontiers of Bhutan, where Lamaism continues to enjoy that unbroken tradition and viability it once possessed in Tibet. It is in these countries, along the frontiers of ancient Tibet, in a similarly remote setting of snow-capped Himalayan peaks, that a good portion of the Tibetan heritage survives, a heritage which these regions received a great many centuries ago from the lamas of the Land of Snows. In view of this situation one is justified in saying that Lamaism, although engaged in a sharp confrontation with the modern age still draws on the ancient forces of the Tibetan tradition.

For more than a thousand years Tibet preserved the tradition of Mahâyâna Buddhism long after it had come to an end in India where it had originated. It was in the Tibetan highlands that Buddhism reached its intensive flowering and its typical form known as Lamaism. There was scarcely an area of Tibetan culture, literature or art which had not been profoundly transformed and internalized by the Buddhist teaching. What we see today, at a certain remove, as a particularly typical feature at the end of this long development is the splendour of an art totally permeated and inspired by Tibetan religion.

Some of this forms the subject of this book, which hopes to achieve the double aim of illustrating the nature of Tibetan Buddhism and, with this knowledge, enabling the reader to acquire a deeper understanding of Lamaist art.

The "typical feature" of the Tibetan scene was the universal presence of religious art which left its imprint even in remote and secluded regions. This art is the subject of the present book. In its presentation it proved indispensable to relate it, time and again, to the teachings of the Tibetan Buddhist religion which totally pervade and determine the art of Tibet.

The text of this book is designed to touch systematically on all areas of Lamaism and is therefore arranged progressively, beginning with its general foundations and taking the reader right up to the more

difficult levels of arcane Tibetan knowledge which would normally come within the sphere of Buddhist initiation. An attempt has been made to organize the pictorial material in a similar strictly systematical way and to keep it closely in line with the text. In view of the infinite wealth of knowledge and art passed down to us from Tibet, this book cannot, of course, hope to be more than a modest attempt at opening a few doors to the understanding of its spiritual traditions. The captions to the pictures are therefore fairly extensive in order to reveal the wealth of themes and the profound knowledge concealed in Tibet's religious art. In choosing the works of art reproduced an attempt was made to follow the subject matter of the separate chapters as closely as possible, and to supply at least one example of each artistic category and the most important stylistic trends and artistic techniques.

Although the author was not fortunate enough to see the ancient Tibet as a free country, he has been able to spend long periods of time in all Lamaist countries from western Ladakh through Nepal and Sikkim to eastern Bhutan and to receive, at least, a faithful reflection of Tibet now locked beyond the frontiers of these countries. For that reason also I owe the knowledge compiled in this book chiefly to Tibetan scholars from those regions, who invariably instructed me in the most courteous manner and, above all, supplied me with indispensable source material on Tibet. The present small selection from the Tibetan heritage is gratefully dedicated to them.

Detlef Ingo Lauf

Introduction

Throughout the ages, art has performed a vital function in the life of a people. It is the visible expression of their ideas and aspirations, their needs and hopes, and in this way indicates and reveals the deep relationship that exists between man and his world. Tibetan art is no exception.

Tibetan art, now a unique art form clearly discernible from that of neighbouring countries, did not develop in a vacuum or cut off from outside influences. On the contrary, throughout its history many divergent creative impulses reached the country from all sides. This is evident already at the time of the "Religious Kings" in Tibet, i.e. between 600–850 A D, when datable Tibetan history begins. At that time, Tibet was surrounded by countries having a high level of civilization. In the north the oasis states, Kucha and Khotan, had come under the influence of Buddhism. Kucha, farther north and farther away from Tibet proper, followed the Hinayana tradition, while Khotan, the closest neighbour, had adopted Mahayana Buddhism and had become a centre of the Avatamsaka School of thought which strongly influenced the development of Buddhism in China and Japan. Traces of it are also clearly discernible in the "Old Tradition" (rNying-ma) of Tibet.

To the west of Tibet was Ta-zig, probably Iran; still farther to the west was Byzantium, often called Krom/Phrom in Tibetan sources. Iranian influence is apparent in Tibetan art in a certain way of carving beams and the frequent use of lion figures in the portico of a temple.

Other important areas to the west were Gilgit ('Bru-sha), where the classical Midas theme was used in a temple; and Kashmir, the area to which Rinchen bzangpo went in order to study. On his return to Tibet he founded a number of important temples in Tibet, e.g. Guge and Tholing. Hellenistic trends in Tibetan art came from the ancient land of Gandhara.

South of Tibet, Nepal at that time was developing a civilization of its own, different from that of India. It had considerable influence on the early development of art in Tibet. In India herself, the kingdom of Kanauj under King Harṣa, and Bengal, where tantric Buddhist ideas were developed, were two important centres with which the Tibetans had contact.

China, at that time under the T'ang dynasty (618–908), had less influence on the early development of art in Tibet.

All these various influences are hinted at in early Tibetan sources. It is, for instance, mentioned that the bSam-yas temple was built in the Tibetan manner, whatever this may have meant, but had a Chinese roof in the middle and an Indian roof on top of it; a castle near bSam-yas is said to have combined Khotanese, Chinese and Indian structures.

Contacts with art centres in India, China, Nepal, Kashmir and Khotan continued under King Khri-gtsug lde'u-btsan (805–838), who invited skilled craftsmen from all these countries. Khotanese art, in particular, exerted a deep influence in Tibet that lasted well into the fifteenth century.

9 In reaction to and interrelation with the trends in the surrounding countries, Tibet gradually began to

develop different art schools of her own, which often started from a predominant influence of one of these countries but then developed their own individuality. The earliest such school of artistic trends in painting and sculpture flourished in West Tibet under the kings of Guge. Developed from the style prevailing in Kashmir, it retained its individuality up to the sixteenth/seventeenth centuries in the temples in Spiti, Guge and Purang.

Gyantse in South Tibet developed the Beri or Nepalese style, the most significant style of Tibetan painting up to the fifteenth century.

In Derge, the most important art centre in East Tibet, the line of development was less uniform. There in the fifteenth century the Menri School was founded, which incorporated Chinese and Mongol elements in elegant embroideries and tapestries. In the following century the Khyenri School was founded by 'Jams-dbyangs mKhyen-brtse'i dbang-phyug. In this case, too, the Chinese influence was evident in the treatment of the background and in the close attention to details. The Khyenri School, favoured in the Sa-skya monasteries, declined in the seventeenth century, and the "New Menri" School, blending elements of Khyenri, Gadri and late Indian styles, prevailed in Lhasa and Central Tibet up to the twentieth century. The Gadri or Karma Gadri School, which shows the greatest Chinese influence in the use of colours and shading, retained its individuality for a long time.

Today Tibetan art is no more. The wanton destruction of the seats of learning and centres of art in Tibet, and the imposition of an ideology whose sole content is hatred of everything that is not its own utopia, highlight the forced impoverishment of humanity. D.I. Lauf's book is a testimony to a rich tradition that will be cherished by those who still have a sense of human values and respect for human cultural achievements.

<div align="right">Herbert V. Guenther</div>

Publisher's Preface

The plastic arts have served sacred purposes from the earliest times. In shaping religious symbols, as well as in creating visual metaphors of spiritual encounters, the art of the sacred plays a key role. The many functions of this art—ranging from the role of perpetuating tradition to the inspiration of spiritual ecstasies—are perhaps nowhere more consciously exploited and realized than in the rich and profound traditions of Tibet. From simple portraits of saints and lamas to psycho-cosmic images that are intended as vehicles for spiritual practices, the dynamics of Tibetan sacred art are exceptional.

The recent proliferation of "tantric" imagery, especially that of the Tibetan form of Buddhism called *Vajrayâna,* testifies to the fascination that Tibetan art holds for alien eyes. As the viewer seeks to discover the meaning of the image that attracts his attention, a complex and provocative world view begins to unfold, challenging us to re-view existence as we conceive it. Just as the Buddha challenged his contemporaries, confronting preconceived notions and the paradoxes of existence in a singularly unflinching manner, Tibetan artists, continuing this spiritual tradition, have created compelling and arresting images. To the extent that the viewer is struck by these images, a door to new understanding is opened; the artist's aesthetic abilities thus become extentions of the spiritual teachings—a subtle equation that characterizes the core of the whole Buddhist enterprise.

Among the factors that add to the efficacy and define the particularity of Tibetan art are the completeness of its overall conception, the intensity of its grotesque imagery and concomitant serenity of its quiescent modes, and the combination of seemingly divergent emotive forms within the same composition. In these aspects art reflects religion to such an extent that it might well be said that Tibetan art itself is the most direct and eloquent form of expression that tantric Buddhism has developed.

Iconographically and, by definition, visionary, the art of Tibet is also characterized by a peculiar intensity suggestive of psychic depths. This quality typically reflects the impulse of art, but in the Tibetan context it also refers to one of its most direct aims: the creation of models for visualization meditation. Those who have tried it know that visualization is not easy. Thus, a beautiful, grotesque or moving image may help the meditator to recall the details of a particular form. Therefore, the artist is doubly inspired to create an image that satisfies his own aesthetic requirements and also one that expands the significance of iconographically prescribed forms of the divinities. The inspirational aspect of art then becomes central to the aesthetic endeavor; for it is a religious motive that inspires the art of Tibet and a religious goal of transformation that it seeks to achieve.

Since the introduction of Tibetan culture to the West, various attempts have been made to present the art of Tibet. The unique quality of the present volume is that it presents Tibetan art as it was understood by the artists who created it, the monks and laymen who commissioned it, and the practitioners who used it for spiritual development—that is, as an expression of the Buddhist doctrine and an aid

to meditation.

1 The monastery complex of Khyichu (Tib.: sKyer-chu lha-khang) contains one of the oldest Lamaist temples in Bhutan. Typical of all important places of pilgrimage such as this are the galleries with prayer-wheels (Tib.: Ma-ni-'khor) running around the entire complex. Lamaist temples in Bhutan have a typical broad band of red paint running round the walls at window height.

2 Interior of a Lamaist temple (Tib.: Lha-khang) with wall frescoes and rich ornamental painting. The broad capitals carry the doubly projecting friezes. The beams and the faces of the cross-bearers are painted with cloud and flower ornaments as well as Lantsha inscriptions. In the background is a cycle of frescoes with scenes from the life of the "Precious Guru Pad-masambhava" in his eight mystic manifestations (Tib.: Gu-ru mtshan-brgyad). Padmasambhava was the great tantric master from Uḍḍiyâna with whom the first spread of Buddhism in Tibet (in the eighth century) reached its peak.

3 Even simple wooden columns and their capitals in remote Tibetan mountain monasteries were artistically adorned with attractive flower and leaf ornaments (western Himalayas).

4 Here the capital consists of the head of the water dragon or Makara monster (Tib.: Chu-srin) appearing from the clouds. The dragon guards the vessel of the water of life (Tib.: Tshe-bum) in which the shaft of the column terminates. The

Makara monster is a beast from ancient Indian mythology and was regarded as the giver of the life-energy contained in the element water. The column is in a palace in eastern Lahul (western Himalayas).

5 About five miles west of Lhasa is the monastery of Drepung (Tib.: 'Bras-spungs), founded in 1416 by 'Jam-dbyangs chos-rje, one of the great disciples of the reformer Tsong-kha-pa. This rare painting shows the monastery of Drepung in a some-what stylized view. Monasteries of this magnitude are better described as monastic towns: There were some 7,000 to 8,000 monks living at Drepung. The painting shows the temple struc-tures, assembly halls, instructional and residential buildings. The inscriptions state the monastery's full name: Chos-sde chen-po dpal-ldan 'bras-spungs. At the centre of the monastery we can make out two golden roofs; they belong to the great assembly hall of the monks (Tib.: Dus-khang chen-mo). Above is the School of Tantras (Tib.: sNgags-pa grva-tshang) and below the School of Buddhist Logic (Tib.: bLo-gsal-gling). In front of the monastic town monks are seen crossing the plain in the direction of the gNas-chung monas-tery, where the famous oracular lama of gNas-chung lived. Above Drepung, scattered over the mountain side, are the hermitages (Tib.: Ri-khrod) for those monks who devoted themselves to solitary meditation. On the left of the picture is the reformer Tsong-kha-pa (1357–1419) with his two prin-cipal disciples rGyal-tshab and mKhas-grub.

12

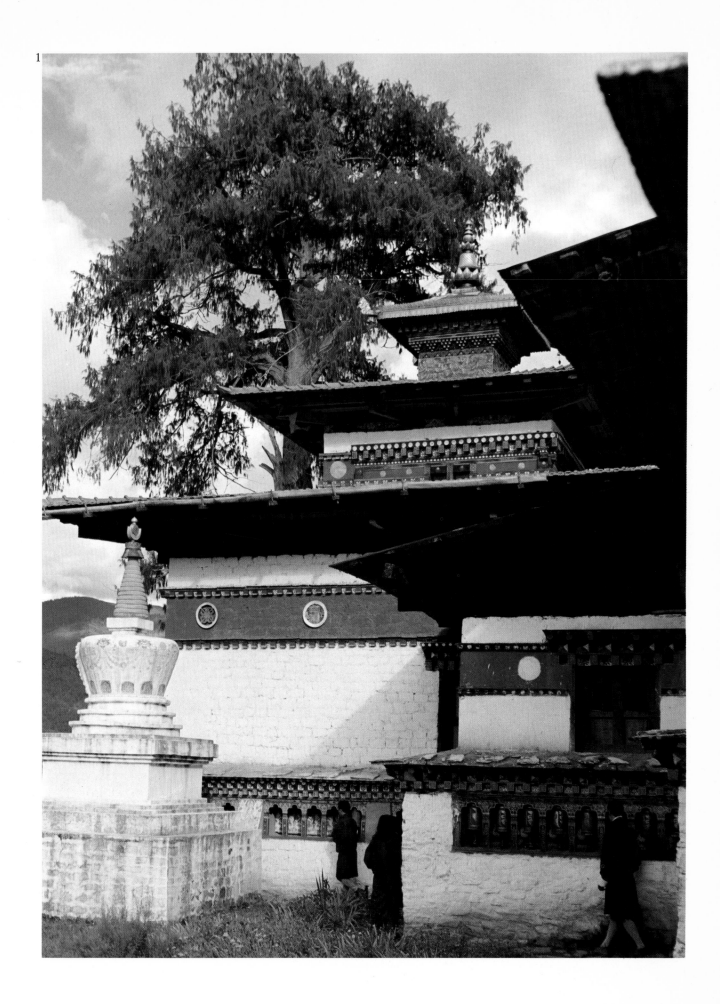

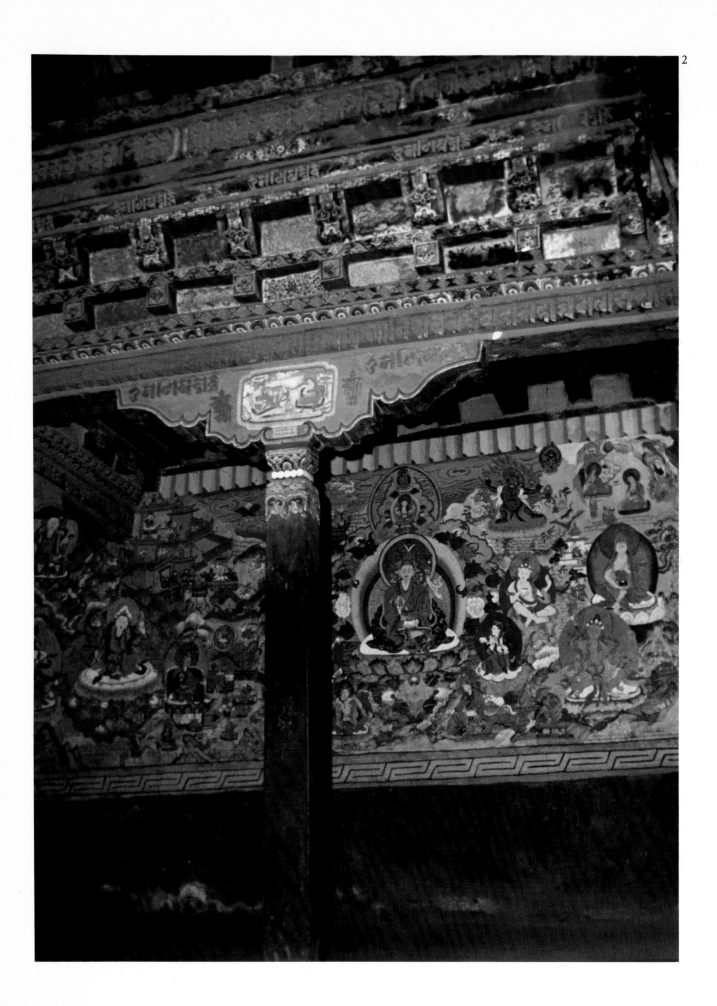

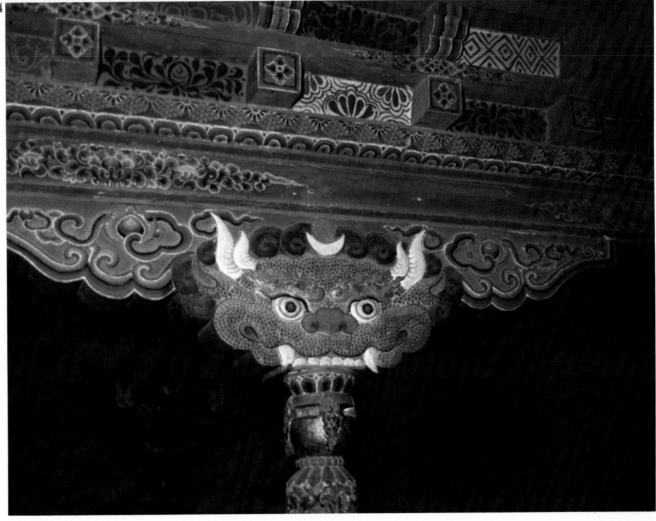

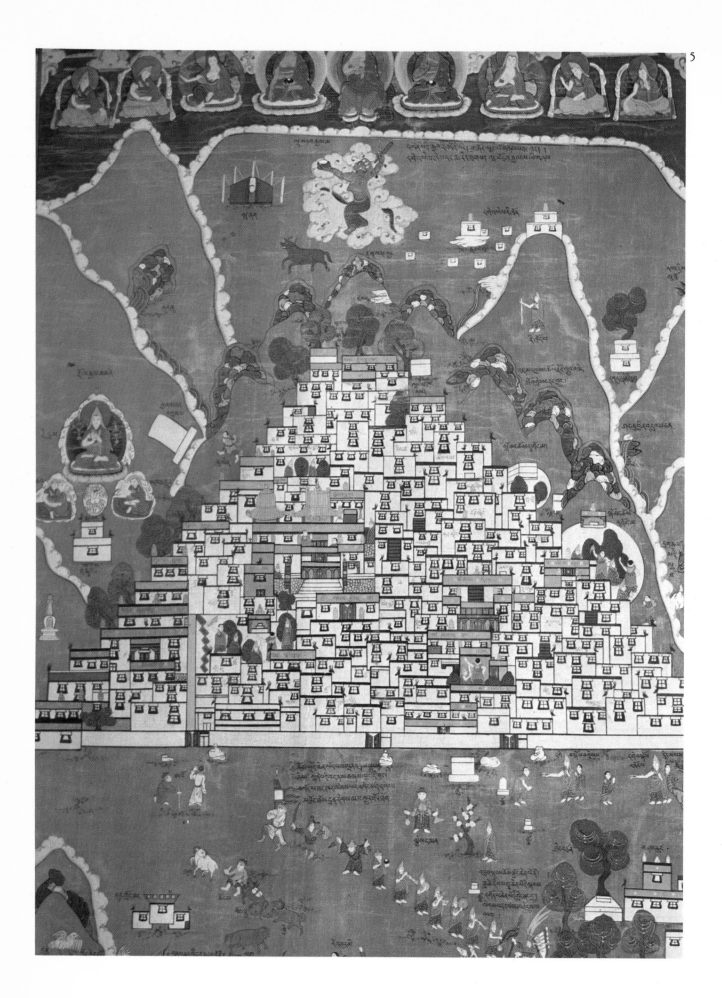

Nature and Origins of Lamaism

For a real understanding of Tibetan art, as presented by the plates in this book, it is indispensable by way of an introduction to outline the fundamental ideas of Buddhism. The Tibetan version of Buddhism, which is generally known as Lamaism, is a complex form of Buddhism developed from several currents of religious doctrine and can only be assessed according to its own laws. On no account must the concept of Lamaism be understood in a derogatory way; it merely stands for that form of Mahâyâna Buddhism which received its peculiar imprint in Tibet through its lamas and its hierarchies. Its teaching, its markedly esoteric forms and ritualistic foundations lent Tibetan Buddhism, at a very early stage, the form we now call Lamaism. We shall later discuss this point in greater detail. Where appropriate, text passages and quotation from Lamaist teachings will be included to enable the reader to understand and interpret Tibetan art and culture from its own sources. The works of religious art, based as they are on the seemingly obscure foundations of Tibetan mysticism, have frequently given rise to wrong conclusions and ideas which fail to do justice to what is known of Lamaist doctrine.

The doctrine created by Buddha has been undergoing a continuous transformation for more than two thousand years through extension, reinterpretation and repeated adaptation to topical currents of thought. The Buddha recognized the inescapable law of cause and effect, the circumstance that everything is born and dies in one long chain of causal connections. "No matter whether perfect beings arise or not", the Buddha said, "it remains a fact and hard necessity of existence that all creation is transitory." All life consists of continually transformed energy, born to life in one form and dying again in order to re-appear in a different form, in another body or sphere of existence. This current of energy consists of karmic forces produced by the individual himself. They are the results of one's present and past thoughts, words and deeds, and also of one's earlier existences which continue to remain active. Thus, according to the Buddha, man creates his own karma through his thirst (Pâli: Tanhâ) or craving for sensual pleasure, for growth and for destruction. Buddha's teaching of detachment was developed to offer deliverance from this sorrow-producing road. The Buddha warns against the three basic human evils which create bad karma and are the cause of even more suffering and countless rebirths: "Desire, hatred and ignorance are the three conditions from which actions spring." In a famous Sûtra (didactic text) the Buddha compares these three basic evils with a fire which consumes man and keeps him permanently burning: "It burns through the fire of desire, through the fire of hatred, through the fire of ignorance; it burns through birth, old age and death, through grief, lamentation, pain, sorrow and despair."

Buddhism claims to show a way out by its teaching of Nirvâna—the complete liberation from the fetters of desire. However, man's attitude to the problem of existence depends on himself. A correct mental attitude reveals that the centre of

17

the world and hence all potentialities lie enclosed within man himself. As the Buddha observed, "the existence of the world, immeasurable and massive though it be, depends on a single thin thread, and this thin thread is each living creature's consciousness in which the world is comprised; the universe is in consciousness."

Nirvâna, the ultimate liberation in all currents of Buddhism, is difficult to explain because of its absoluteness. After complete overcoming of suffering, after complete detachment from the ties of the empirical world, a wise monk may perhaps begin to understand the Buddha's exalted words about Nirvâna: "There is, o monks, something unborn, ungrown, uncreated, unformed. If this unborn, ungrown, uncreated, unformed something did not exist it would not be possible to discover a way out from it."

For a number of centuries early Buddhism preached the ideal of the sage who was known as the Arhat, a monk who had overcome the world and who, in tranquil retirement, had achieved his salvation in meditation, without concern for happenings in the world. Soon however, in the first century B.C., the old school Buddhism, the "small vehicle" (Hînayâna) developed further. In the first century A.D. the great Buddhist philosopher Nâgârjuna appeared on the scene, and with him the old teaching was transformed into the "great vehicle" (Mahâyâna), the religious form which spread throughout nearly all Asian countries and left an enduring mark on Tibet.

Mahâyâna Buddhism offered greater opportunities for the mass of followers, and in particular indicated paths by which the laity also could advance towards enlightenment, paths previously reserved for the monastic class. Mahâyâna developed the essential idea of universal compassion for all living creatures. It called upon all people to seek true Buddhahood within themselves. The two pillars of Mahâyâna were the doctrine of the infinite void (Skr.: Śunyatâ) as the foundation of the entire created world and the pursuit of all-embracing compassion (Skr.: Mahâ-karûnâ) for all beings. Whereas in the past only a few Buddhas had been known (in particular the precursors of Śâkyamuni, the historical Buddha) the Mahâyâna systems henceforth acknowledged a great number, indeed an infinite number, of Buddhas who would appear at all times and in all world systems in order to proclaim the doctrine.

The most important change, however, was the emergence of the Bodhisattva ideal which far transcended the characteristics and value of the Arhat. A Bodhisattva was an active person who carried the teaching of benevolence and compassion out into the world and as a "potential Buddha" placed all his own merit and activity at the disposal of other creatures, in order to show them the path to liberation. The Bodhisattva thus became an active ideal of Mahâyâna Buddhism and the model of universal compassion. A necessary passive element within one's own consciousness was the great void of all phenomena. Ever since the days of Nâgârjuna the concept of Nirvâna thus became identical with that of the great voidness.

18

The Mahâyâna reached its literary peak in the numerous writings about the "perfection of wisdom" which, under the name of Prajñâpâramitâ literature, became the foundation of all subsequent development of Buddhist philosophy. The numerous and extensive texts of this kind all contain Buddhas and Bodhisattvas as mediators of that understanding, of that all-pervading void which underlies all transitory phenomena and is identical to the true nature of reality. The most important Bodhisattvas are Avalokiteśvara and Mañjuśrî; the former personifies great compassion (Skr.: Mahâkaruṇâ), while the latter was venerated as the mediator and revealer of supreme wisdom.

Whereas originally there was but one Buddha (the Buddha Śâkyamuni) as the proclaimer of the doctrine, there were now a multitude of Buddhas. In particular there arose the Mahâyâna ideal of the Buddha, the "Buddha in himself", the Tathâgata, the Buddha "who has thus come and thus gone". In the Mahâyâna Sûtras he teaches that the void is identical with pure perefect wisdom. He finally teaches that all things are "Suchness", that they have their own real nature, and that this original "Suchness" is to be equated with the nature of the void. The true nature of this Tathâgata, i.e. his pure Buddha nature, can be experienced by everyone in himself; anyone can realize within himself the character of "Suchness", the spontaneous knowledge of the Tathâgata.

In the doctrinal systems of Mahâyâna all concepts were thus enhanced, relativized, and even called in question, in order thus to keep them free from all doctrinal ties. Those doctrines which became the central theme of the Prajñâpâramitâ scriptures, such as the relativity of all concepts and phenomena against the infinite background of the great void, led to profound philosophies and bodies of teaching which became known as the Mâdhyamika doctrine, the Vijñânavâda and the Yogâcârâ. This most essential transformation of Buddhist thought into dynamic consciousness was proclaimed by the Tathâgata as follows: "There is no formulation of truth called 'perfection of incomparable enlightenment' because matters taught by the Tathâgata are in their essential nature incomprehensible and inexplicable; they neither exist nor do not exist. This means that Buddhas and Bodhisattvas are enlightened not by rigid doctrines but by an intuitive process which is spontaneous and natural. This unspoken principle is the reason for the different systems of the sages."

The most essential characteristics of Mahâyâna therefore are the multiplicity of Buddhas, the universal ideal of the Buddha figure in the manifestation of the Tathâgata and the idea of enlightenment as personified in the Bodhisattvas who greatly transcended the ancient Arhat ideal of the Buddhist sage.

Finally there also emerged the doctrine of the original Buddha, the Âdibuddha, who was venerated as the mysterious revealer of all doctrines proclaimed by the Buddhas. The Âdibuddha became the highest being of esoteric Buddhism. We shall have occasion to return to all these

fundamental ideas in greater detail in the following chapters.

The Âdibuddha leads us into the realm of the third form of Indian Buddhism, the doctrine of Vajrayâna. Vajrayâna, or "diamond vehicle" was the last development on Indian soil, leading to a purely esoteric Buddhism which subsequently became the basis of Tibetan Buddhism. Vajrayâna produced a certain category of texts which are known as Tantras (Tib.: rGyud). These texts proceed in essence from the spiritual foundations already contained in the Mahâyâna Sûtras. But in contrast to them, the Tantras represent secret writings, in that their teachings are enhanced by magical and mystic contents and above all by an extensive esoteric ritual. Vajrayâna may also be called tantrism because of its predominantly tantric writings. It used secret doctrines, rites and symbols to develop a path of gnostic knowledge which opened up new possibilities of spiritual experience and of practising the Buddhist teachings. Important elements were included also from the ancient Indian tradition of yoga, the main contribution being the doctrines of the Mahâsiddhas, the famous Buddhist "Eighty-four Great Magicians" of the eighth to eleventh centuries.

In brief outline, the Tantras teach a dynamic spiritual system characterized by a mixed application of mystical formulas (the Mantras), their magical-symbolical projections in the form of diagrams (Yantras), secret meditation circles (the Maṇḍalas), and a series of psycho-physical concentrations and yoga exercises. As a conse-quence of this symbolism, a steadily increasing number of "deities" of peaceful or terrifying aspect were developed, each with their specific rituals. The most important characteristic of these gnostic teachings of tantrism is a marked polarization of two opposing forces: the confrontation and dominant unitary principle of male-female polarity. The harmony of male-female polarity to be achieved by way of tantrism was represented by esoteric symbols and a "secret language" (Skr.: Sandhâbâṣâ) in order to protect Tantras against abuse by the uninitiated. Tantrism, therefore, is a secret doctrine which was transmitted by initiations from teacher to disciple. The "Supreme Bliss" (Skr.: Mahâsu-kha) striven for in the Tantras, the mystical union of the polarities, is represented in the writings and in pictorial art by the union of Buddha and Prajñâ (his female equivalent) as a divine pair in embrace (Tib.: Yab-yum).

Needless to say, instruction in the esoteric teachings of the Tantras with their secret symbols and rites requires a spiritual teacher and leader who must himself have mastered the Tantras and the doctrine contained in them. This spiritual teach-er is the guru (Tib.: bla-ma). A guru is indispensable and without him an insight into the Tantras is not only impossible but even the attempt may lead to harm. In the Indian Vajrayâna Buddhism, and later also in Lamaism, the guru became the disciple's supreme teacher, acknowledged as the carrier of all esoteric knowledge and the secret paths of enlightenment. Not infrequently, therefore, the guru as the repository of

20

Fig. 1. Illustration from the Vaidûrya dkar-po: the scholar dPal-mgon 'phrin-las.

the secret Buddhist mysteries and as the keeper of an ancient spiritual tradition, has been compared to the Buddha himself. Lamaism to this day regards guidance by a guru as one of the indispensable conditions for the discovery of a spiritual path.

Let us look for a moment at some of the principles of Vajrayâna, which are at the same time identical with the foundations of Tibetan Buddhism. The concept of Vajrayâna refers to Vajra, the Indian diamond sceptre. This sceptre, which is diamond-shaped at each end, is a symbolic ritual object which is indispensable in the tantric rites. It is usually made of bronze or silver. The void (Skr.: Śûnyatâ) pervading all worlds is likened to the indestructible and transparent nature of the diamond. The supreme truth, the pure nature of diamond-like clarity (see Vajrasattva) is the hoped-for goal of the Tantras. The visible world of phenomena is the realm of sorrowful rebirths of creatures and is known as Saṃsâra; complete deliverance from this world is called Nirvâṇa or freedom from sorrow. According to the teachings of Vajrayâna, however, the two are not of a different character but are one and the same. Both concepts are merely different aspects or manifestations before the background of all-embracing voidness. The sorrow-causing course of the worlds (Saṃsâra) is the state of a mind still held by the three fetters of craving, hatred and delusion. By exercises in the tantric methods of knowledge the disciple experiences the state of Nirvâṇa as the other side of this world. And if he can then realize within himself the Buddha nature of the Tathâgata, the three planes of body, speech and mind are purified of all obscuring obstacles and the path towards the experience of Nirvâṇa is smoothed. The realization and total acceptance of the knowledge of the void vis-à-vis all wordly phenomena is then described as the supreme knowledge or wisdom (Skr.: Prajñâ).

The supreme wisdom of the Buddhist Tantras includes also the knowledge of the unity of male and female elements (Tib.: Yab-yum). The male pole in this context is the path of the active com-

passion of the Bodhisattva in the world of Saṃsâra (Tib.: Thabs snying-rje chen-po). At the end of this path stands the experience of wisdom (Tib.: Shes-rab), characterized by the female symbol of the Ḍâkinî, or Prajñâ. The method or Path (Skr.: Upâya) on the one hand, wisdom (Skr.: Prajñâ) as the goal to be actualized on the other, and the perfect fusion of these two—these are the foundations of tantric philosophy. That is why the art of tantrism visually represents the two polarities in their mystical union, since this inseparable unity is the prerequisite of spiritual enlightenment and liberation. Salvation, therefore, can be found only where the dividing barriers of dualism have been finally overcome. The Buddha or Bodhisattva as the symbol of the tantric path and their female equivalent, the Prajñâ or Ḍâkinî, as the symbol of final wisdom are therefore frequently pictured in the Yab-yum representation of the divine couple.

The sacred formulas of the Mantras are similarly of fundamental importance in tantric esoteric ritual. These Mantras are strings of syllables and incantation formulas addressed to the deities of the Buddhist pantheon. Mantras are found in all texts of the Vajrayâna and the Mahâyâna, in the Dhâraṇîs (magic formulas of single syllables) and in the Sâdhanas, which are short texts for invocation and adoration rituals requesting superior powers (Skr.: Siddhi) from the deities.

Mantras can be very short, consisting of one or more syllables. They are concise elementary verbal symbols during the recitation of which the underlying meanings of deities appear as spiritual images. The Mantras also include the germinal syllables (Skr.: Bîja) which are important in the unfolding of visionary Maṇḍalas. From these syllables derive the various Buddhist symbols, light and rays, from the centre of which the figures of the deities then appear before the eyes of the meditator. These Maṇḍalas are circular diagrams with various geometrical arrangements of the inner courts. In their magical purified circle, the holy dwelling-place of the gods, the beneficial forces and the wisdom of the deities manifest themselves. Such Maṇḍalas are known in a variety of forms, and their symbolic contents are realized by way of meditative contemplation. The Maṇḍalas, moreover, are symbolic representations of the various planes of cosmic happenings, of the elemental forces amidst which the disciple is expected to transport himself during his meditative exercises. Further information about the Maṇḍalas will be given in the chapter entitled "Visonary Unfolding in the Maṇḍala".

The tantric tradition was divided into four categories and, since in the translation from Sanskrit into Tibetan all systems of Vajrayâna and its Tantras were faithfully adopted, it has survived in the same order to the present day:

(1) Kriyâtantra (Tib.: Bya-rgyud)
(2) Caryâtantra (Tib.: sPyod-rgyud)
(3) Yogatantra (Tib.: rNal-'byor-rgyud)
(4) Anuttara (Tib.: bLa-na-med-rgyud)
 Yoga Tantra

The Kriyâtantra is concerned with external exercises such as initiation rites, sacrifices, Mantras and incantations to the deities, and ritual ablutions. In the Caryâtantra the disciple practises his religious exercises. In liturgical devotions and meditations and in the yoga of concentration his internal and external exercises are to be harmonized by meditative techniques as well as by recitation of Mantras and liturgies. Mantras and rituals serve as means on the path to perfection.

The third level, the Yogatantra, represents a higher exercise. Spiritual insight is to be acquired through meditation on the unity of Saṃsâra and Nirvâṇa, on the void and the great bliss, as the disciple, through his yoga, harmonizes the method (Skr.: Upâya) and the hoped-for goal of wisdom (Skr.: Prajñâ). At this stage the Mantras are recited in their most effective way, i.e. silently, as the yogi now experiences the inner vibrations and their visionary creative forces which are to lead to the great synthesis in the experience of light and voidness.

The highest stage, the Anuttara Yoga Tantra, demands of the disciple a constant focusing of his consciousness on a continuous working of the clear pure spirit, which is to have lasting effect on the three planes of body, speech and mind. Here the absolute non-duality is achieved since path and goal are combined in a permanent dynamic integration.

These, then, in very rough outline, were the spiritual transformations of Buddhism whose entire spiritual content was transferred into Tibet starting from the seventh century. The literary tradition comprises not only the Mahâyâna Sûtras and the multitude of Tantras of various Indian schools, but also works in other fields of knowledge received from India, such as the art of magical healing, medicine, astrology, magic, poetry, etc. The entire tradition was subsequently summed up in the collection of writings known as the bKa'-'gyur and the bsTan-'gyur.

However, Tibetan Buddhism, or Lamaism, is not merely a faithful copy of the Indian Mahâyâna and Vajrayâna, but has developed its own characteristic form in Tibet itself. One factor in this change was its confrontation with the ancient Tibetan Bon religion and the widespread and varied popular beliefs of the Tibetans, while another was the further development of Tibetan Buddhism along its own paths since the decline of Buddhism in India.

The Bon religion was the original ancient religion of Tibet. It was of Shamanist character and had a vast pantheon of gods, local deities, demons and spirits in confusing multitude and of archaic stamp. Popular belief, varying from one place to another and kept alive in the vast areas of Tibet; tribal traditions and ancestor worship, combined with the religion taught by the Bon priests, with their exorcism of demons and invocation of spirits—all have survived in Tibet alongside Buddhism. These practices and beliefs confronted Buddhism as it increasingly spread, advancing as far as Mongolia. The spread of Buddhist teachings in Tibet, the Land of Snows, especially during the early period from the seventh to the eleventh century, proceeded with

6 *The Tibetan king Srong-btsan sgam-po reigned from 629 to 649. He was the first king and unifier of the Tibetan kingdom who embraced the teachings of Buddhism. It was he who sent the Tibetan scholar Thon-mi Sambhoṭa to India to find a script suitable for Tibet. Srong-btsan sgam-po was regarded as an incarnation of the Buddha Amitâbha. We can make out the small red Buddha head in the typically Tibetan royal hat which is conically shaped. The king's right hand shows the Mudrâ of wish-granting (Skr.: Varadâ) and the left is held in the gesture of argument (Skr.: Vitarka). He is seated on a magnificent throne and is wearing royal garments. Srong-btsan sgam-po is credited with the authorship of the Maṇi bka'-'bum writings. This Thang-ka in the south Tibetan style is from the early eighteenth century school of bKra-shis lhun-po.*

7, 8 *Prior to the arrival of Buddhism, Bon was the native religion of Tibet. This religion, which varied a good deal from province to province, was a mixture of Shamanist teachings and ancient Tibetan popular beliefs. With the coming of Buddhism, it tried to deepen its own teachings by absorbing Buddhist ideas. The Bon religion probably originated in the highlands of western Tibet, in Zhang-zhung province. A number of Bon demons were magically defeated by Padmasambhava, enlisted as guardian deities and accepted into the Lamaist pantheon. Plate 7 shows a demonic magician accompanied by two monkeys. In Plate 8 we see some of the demons which were feared as denizens of the earth, rocks, mountains and trees. They were deities of disaster, such as the many-eyed scorpion spirit which poisoned small children, or the snake spirits living in damp places. The most important of these spirits were the kLu, the Srin-po, the dMu, the gNyan and the Sa-bdag. Typical of the Bon religion are also the dogs which accompany the earth deities and run ahead of them, as here in front of the mounted demon bTsan.*

9 *Old frescoes from a monastery of the bKa'-brgyud-pa sect. The painting shows the typical representation of the spiritual succession and hierarchy. At the centre is the Âdibuddha Vajradhara, in blue; on either side are the Indian masters Tilopa and Nâropa; and above (from left to right) are Mar-pa, Vajrasattva, Vajrayoginî, Mi-la ras-pa and Ras-chung-pa.*

10 *A large cycle of sixteenth century fresco paintings is found in the ancient inner courtyard of the gTam-shing monastery in the Bumthang province of Bhutan. This is the main residence (Tib.: gDan-sa) of the great "treasure-finder" Padma gling-pa who has left us important scriptures of the gTer-ma tradition. This painting reveals even more clearly the essential features of hierachic representation. At the centre, seated upon a lotus throne, is an important lama with red cap; his hands are held in the Dharmacakramudrâ. The vertical columns on both sides show lamas and disciples of his doctrinal tradition.*

11 *Gilded bronze of the tantric master Abhayâkaragupta, one of the most important Indian scholars (about 1084–1130). Âcârya Abhayâkaragupta came from Odivisa in southern India. He first studied in Bengal, then became abbot at Bodhgayâ and later at the famous universities of Nâlandâ and Vikramaśîla in Bihar. "This great Âcârya Abhayâkara", Târanâtha wrote, "who was a perfect Iśvara of knowledge, mercy and magic power, was the last of the famous great Âcâryas who embraced the perfect doctrine..." The scholar was an important author and translator into Tibetan. Of the eighteen works he translated, the most important for our knowledge of Buddhist iconography are the Vajravalînâmaṇḍala and Niṣpannayogâvalî. This beautiful eighteenth century bronze shows the skilful use of the technique of partial gilding, which spared the body, leaving it in the dark basic colour of bronze in contrast to the brilliant garments. The delicate ornaments of garment and throne cushion were applied with a graving punch after the casting of the bronze.*

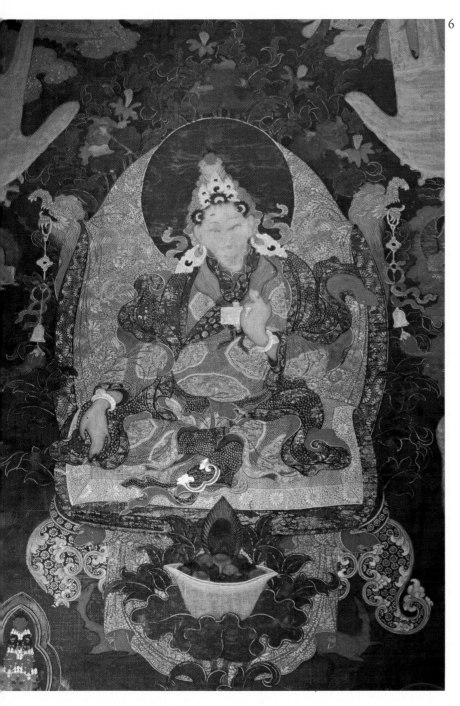

6 7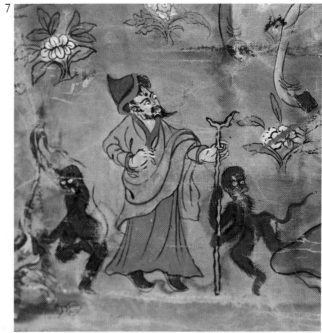

8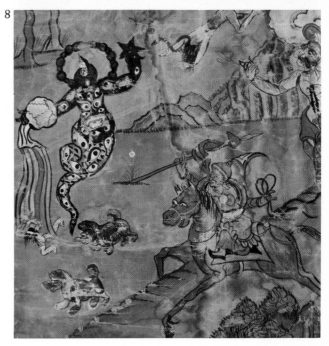

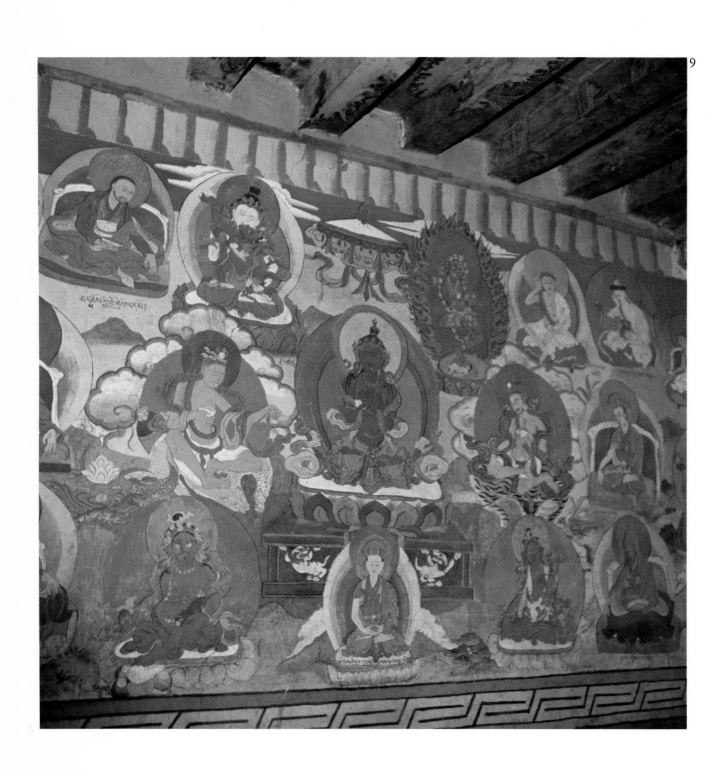

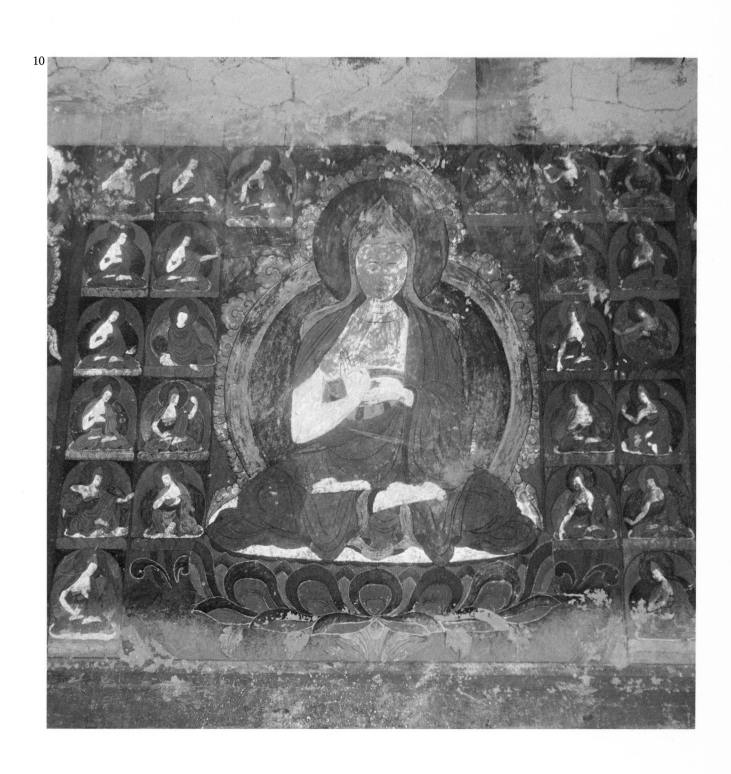

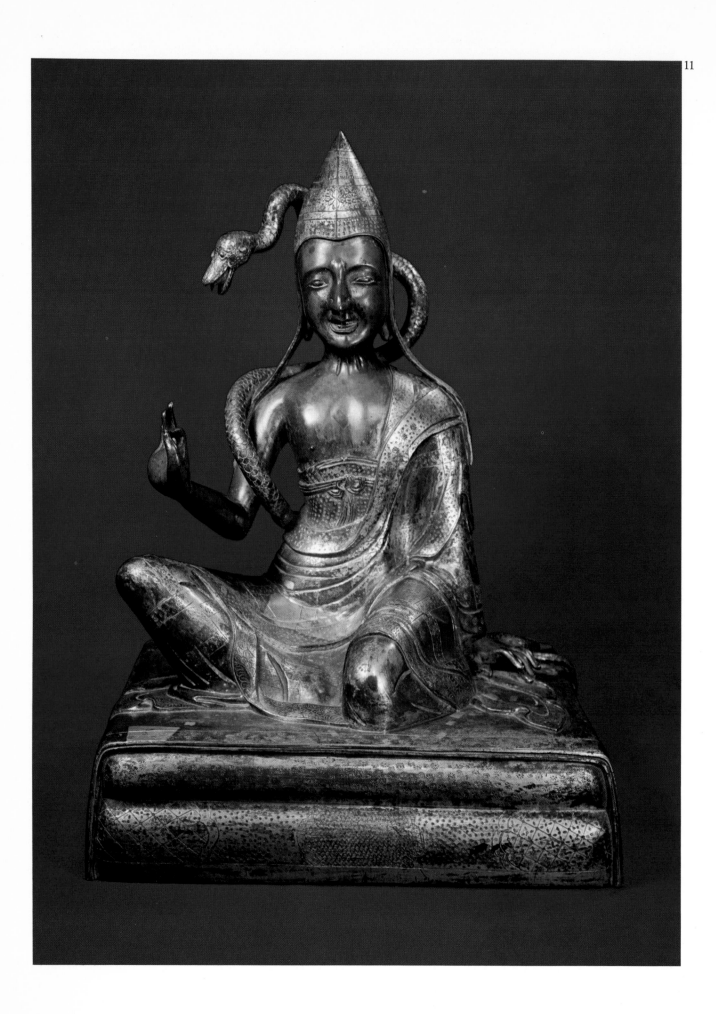

great intensity only because the religious teachers, especially of the older sects, skilfully absorbed numerous elements of the Bon religion, re-interpreting and re-valuing them whenever defeat of the ancient traditions proved impossible. Thus in many spheres of cult practices, ritual and sacrifice symbolism, as well as in the rituals associated with the dead, elements of the Bon religion or of local Tibetan popular belief were taken over and integrated after a most extensive re-valuation. In Tibet, more than anywhere else, Buddhism proved its great capacity for adaptation and assimilation. Typical of this process is the large number of purely Tibetan deities accepted as guardian deities into the Lamaist pantheon by tantric teachers after these deities had been subjugated by magical exorcism to the "services of Buddhist teaching". These indigenous deities were formerly powers of disaster, but they now continued their existence as powerful guardian deities of the Tibetan religion, and ruled over the hosts of evil forces.

In this way the transformation of Buddhist teaching imported from India gradually proceeded, and what emerged was the changed form of Tibetan Lamaism. With central Tibet as a starting point, the great monasteries were founded until, over the centuries, some thousand monasteries and hermitages sprang up even far beyond the frontiers of the Roof of Asia. There the monks and yogis continued India's ancient religious legacy, practising the teaching and writing commentaries on the scriptures. Through an extensive literature Tibetan teachers enlarged the traditional body of Buddhist thought which in India was by then in a state of decline.

The Indian patterns of Buddhist succession were preserved in Tibet. In addition to the lay followers there were ordained monks (Tib.: dGe-slong) and Siddhas (Tib.: Grub-thob), those yogis who were initiated into certain tantric doctrines. The monks lived in monasteries in accordance with the strict rules of Vinaya, while the Siddhas, as tantric yogis following different rules, preferred to live in hermitages, lonely spots or mountain caves in order to realize their spiritual aims in extreme solitude.

The foundations of Lamaism were laid during the period from the seventh to the twelfth century. At first the new religion aroused only limited interest in Tibet when it confronted the native Bon religion as an alien doctrine. Gradually, however, especially with the support of the Tibetan kings, some of whom were interested in the new teaching, Buddhism gained ground. King Srong-btsan sgam-po (629–649) was the first ruler to come into contact with Buddhism in a major way. He married two wives, Bhrikutî from Nepal and Kong-jo from China. Both women came from countries where Buddhism was widespread. These two queens founded the oldest temples in Lhasa, the Ra-mo-che and the 'Phrul-snang, and it was there that the first images of Buddha were set up in Tibet. The most important measure taken by Srong-btsan sgam-po for Tibet and the success of Buddhism was commanding his scholar Thon-mi Sambhota to find a script in India which could serve as a

Fig. 2. Illustration from the Vaidûrya dkar-po: the Lama Śrîbhadrabodhi.

model for a Tibetan script. Only thus was it possible for the Buddhist teachings to be translated from Sanskrit into the Tibetan language, and subsequently to spread throughout the country.

These relatively small beginnings were followed, about a hundred years later, by stronger support on the part of king Khri-srong-lde'u-btsan (756–797) who showed great interest in the new religion. This king had the scholar Śântarakṣita brought from India and subsequently, on his advice, Padmasambhava also came to Tibet. Both men were famous Indian teachers and began the systematic introduction of Buddhism into Tibet by translating canonical writings and founding the first monastery (ca. 775), called bSam-yas. The square layout of the monastery within a circle surrounding the main temple reflects the idea of the cosmic world structure, represented here in the form of a Maṇḍala. The bSam-yas monastery is believed to have been built on the model of the Indian monastery of Odantapurî in Bihar.

Padmasambhava was a tantric teacher of the Indian Siddha Schools, whose magical-mystic skills and powerful personality had a lasting effect on Lamaism. Śântarakṣita, on the other hand, was the type of scholarly monk whose strength was in the field of monastic discipline and scholarship. Thus Śântarakṣita concerned himself principally with monastic instruction and transmission of knowledge while Padmasambhava devoted himself to magic practices, exorcising the hostile powers which were threatening the new centres dedicated to Buddhism. On his journeys in Tibet Padmasambhava was accompanied by his two disciples and wives, Mandârava and Ye-shes mtsho-rgyal. Tradition relates that during that period he subjected and banished many demons which threatened the land of Tibet. With the support of the Tibetan kings, bSam-yas became the first centre of Buddhist translating and teaching activity; among those working there were the famous tantric teachers Vairocana, Vimalamitra, Jinamitra, Śântigarbha and Dânaśîla.

The followers of the Buddhist doctrines of this first period in Tibet later called themselves the rNying-ma-pa sect. Much of the progress made by Tibetan Buddhism during this period was shortly afterwards destroyed through the persecution under King gLang-dar-ma (836–842), a staunch supporter of the old Bon religion. Monasteries were expropriated and the monks fled to neighbouring countries or far into eastern Tibet. That was the end of the first period of the spread of the doctrine (Tib.: sNga-dar) in Tibet.

About a generation later Buddhism slowly began to revive in a newly organized second spread of the doctrine (Tib.: Phyi-dar), which in the tenth century received the support of the kings of western Tibet and in the eleventh led to the final victory of Buddhism over the still prevalent Bon religion.

The second spread of Buddhism proceeded under the patronage of the western Tibetan kings from their main residence of Gu-ge. From this important cultural centre several Buddhist kings in the tenth and eleventh centuries supported the scholars who had come from India and Kashmir. This renewal of the faith is associated with the names of two outstanding teachers: Atîsa (958–1054) from India and Rin-chen bzang-po (958–1055) from western Tibet.

After prolonged periods of study in the countries of southern Asia, Atîsa came to Tibet in 1042 and stayed there for the rest of his life. With great energy he thoroughly revised the surviving and partly degenerated doctrines of the first period and started the translation of Indian texts. Well over a hundred writings were produced in Tibetan translation under his guidance or with his participation. One highly important doctrine introduced into Tibet by Atîsa was the tradition of Kâlacakra (The Wheel of Ages). This late tantric work contains mystic teachings on cosmology and astrology. Atîsa also brought to Tibet the doctrine of the Âdibuddha, the revealer of all secret knowledge.

Rin-chen bzang-po, together with sixteen chosen disciples, was sent to Kashmir by the west Tibetan king Ye-shes-'od to study Buddhist doctrine. Rich in new knowledge and experiences and laden with numerous sacred scriptures he later returned to Tibet. There he developed an indefatigable translating activity and was responsible for the foundation of numerous temples and monasteries. In co-operation with Kashmiri artists, Rin-chen bzang-po had temples built and decorated with wall-paintings according to his own designs. It is very largely due to the tireless energy of Atîsa and Rin-chen bzang-po that Buddhism was widely restored in Tibet. The most important centre of spiritual work in this classical period of the Buddhist Renaissance was the monastery and Golden Temple of Toling (Tib.: sTod-gling-gser-khang).

Atîsa's work was continued by outstanding disciples, the most important of whom were 'Brom-ston (1005–1064), Legs-pa'i shes-rab (d. 1073) and Po-to-ba (1031–1105). In 1056 'Brom-ston founded the Rva-sgreng monastery which became the parent monastery of a highly respect-

ed sect. Its reputation was based on strict rules and spiritual discipline, and came to be known as bKa'-gdams-pa. The Abbot bLo-gros grags-pa (1106–1166), a disciple of Po-to-ba, became the founder of sNar-thang monastery in 1153; this monastery subsequently became one of the most important printing centres for Buddhist canonical writing.

The eleventh century saw the foundation of various Buddhist sects and their monasteries; it was then that the principal sects and traditions emerged and that great teachers laid the foundations of the future development of Lamaism. The bKa'-gdams-pa sect only survived until the fifteenth century, when it underwent reformation under Tsong-kha-pa and was absorbed in the newly organized and reformed dGe-lugs-pa sect.

The first parent monasteries of the different sects each produced different doctrinal currents; branch monasteries were founded and further sub-sects emerged. On this broad basis of various doctrinal interpretations and different doctrinal traditions arose the hierarchies of abbots and grand lamas who acquired not only spiritual but also considerable temporal power. A number of sects were founded on the basis of certain differences in doctrinal tradition and of varying emphases on certain features of Buddhist teaching. These features are generally grouped into five main trends:

(1) bKa'-brgyud-pa
(2) Sa-skya-pa
(3) rNying-ma-pa
(4) Zhi-byed-pa
(5) dGe-lugs-pa (with bKa'-gdams-pa)

We shall deal first with the two large sects which developed, alongside the bKa'-gdams-pa sect, at the time of the Buddhist Renaissance.

The bKa'-brgyud-pa Sects

Just as the beginnings of Tibetan Buddhism were imported from India and formed the early school of the followers of Padmasambhava, so subsequent sects, which emerged at the time of the Renaissance of Lamaism, similarly derived their spiritual descent from Indian masters. The bKa'-brgyud-pa was established by Mar-pa from Lho-brag in southern Tibet. Mar-pa (1012–1097) himself made several journeys to India in order to be instructed in the teachings of tantrism by his guru Nâropa (ca. 1016–1100), the highly revered abbot of the famous Nâlandâ monastery. On these journeys Mar-pa brought Buddhist books back to Tibet which he later translated. Mar-pa also spent some time as a disciple of the scholar 'Brog-mi at his monastery Myu-gu-lung, and became one of Tibet's most important translators. As he was invariably surrounded by a great number of disciples, the teachings were transmitted by him to various principal disciples who then carried on his spiritual heritage along different lines.

His most important disciple, who had to submit to prolonged trials before being admitted to the esoteric doctrines, was Mi-la ras-pa (1040–1123). 32

Only after severe and protracted trials and various privations was Mi-la ras-pa initiated by his master Mar-pa into all the secret teachings which had been acquired in India.

He later became Tibet's most famous and most popular poet-ascetic and yogi who, in the traditional manner, passed on his knowledge to a large group of listeners and followers in the form of meditative cantos. Mi-la ras-pa, the yogi and mystic who practised contemplation in remote rocky caves and among snow-capped mountains, and his gifted successor sGam-po-pa, decisively moulded the character of the bKa'-brgyud-pa sects. Mention must also be made of Mi-la's favourite disciple, Ras-chung-pa (1083–1161), to whom are traditionally attributed the biographies and works of his master which are among the finest spiritual treasures of Tibetan Lamaism. The spiritual succession established by Ras-chung-pa is known as "the line of oral instructions of Ras-chung-pa" (Tib.: Ras-chung snyan-brgyud); these instructions have come down to us in a collection of writings called the Ras-chung bka'-'bum.

The proper successor of Mi-la ras-pa was a physician from Dvags-po, later known as sGam-po-pa (1079–1153). He accumulated a large body of knowledge and left his successors a substantial collection of writings. From his large number of disciples several sub-sects soon developed and are sometimes known by the collective name of Dvags-po bka'-brgyud-pa. Among his more important pupils was Dus-gsum mkhyen-pa (1110–1193), who later founded the largest branch of the bKa'-brgyud-pa sects, the Karma bKa'-brgyud-pa. The line of Karma-pa lamas consists of a single unbroken succession of reincarnations down to the present day. Apart from this major branch, the principal bKa'-brgyud-pa schools were the 'Bri-khung-pa, the 'Brug-pa and the sTag-lung-pa. The twelfth century, that period of prolific growth of Lamaism, saw the foundation of most of the parent monasteries of the bKa'-brgyud-pa tradition:

(1)	Karma-gdan-sa	1147
(2)	Lha-lung	1154
(3)	gDan-sa-mthil	1158
(4)	'Bri-khung	1167
(5)	mTshal-gung-thang	1175
(6)	Rva-lung	1180
(7)	sTag-lung	1180
(8)	mTshur-phu	1185

The doctrinal tradition of these sects is regarded as the secret revelation of the Âdibuddha Vajradhara, and the teachings of the yoga and the Tantras of that movement were always handed down in particular secrecy. Their emphasis is on the practice of the doctrine of the "great seal" or Mahâmudrâ (Tib.: Phyag-rgya chen-po), introduced from India by Mar-pa. The Mahâmudrâ was taught by Nâropa, an important Indian master who has also handed down to us the six teachings of Nâro (Tib.: Nâ-ro'i chos-drug). They represent a concentrated legacy of esoteric knowledge about the Buddhist yoga of the ancient Indian Siddha School. These precious teachings are known by the following names:

33

(1) Mystic Warmth	(Tib.: gTum-mo)
(2) Mahâmâya (illusory body)	(Tib.: sGyu-lus)
(3) Dream State	(Tib.: rMi-lam)
(4) Clear Light	(Tib.: 'Od-gsal)
(5) Transference of Consciousness	(Tib.: 'Pho-ba)
(6) State after Death	(Tib.: Bar-do)

Simultaneously with the transmission of these, the Yoginî Ni-gu-ma (the sister disciple of Nâropa) transmitted the six doctrines in a special form (Tib.: Ni-gu chos-drug or Su-kha chos-drug) which formed the centre of study especially in the Shangs-pa bka'-brgyud-pa. Of great importance in the bKa'-brgyud-pa sect are the doctrinal systems concerning the initiation deities Hevajra, Cakrasaṃvara and the Ḍâkinî Vajra-vârâhî. Among Tibetan works the best known is the biography of Mi-la ras-pa (Tib.: Mi-la rnam-thar), his "Hundred Thousand Cantos" (Tib.: Mi-la mgur-'bum) and the comprehensive literary work of sGam-po-pa. They were followed by the outstanding collected works of the great scholar and historian Padma dkar-po (1527–1592). His works, in twelve volumes, are a collection and commentary on a large part of the total knowledge of the bKa'-brgyud-pa and in particular the teachings of the Indian masters Tilopa and Nâropa.

The Sa-skya-pa Sects

The Sa-skya-pa sect, which emerged from the school of the translator 'Brog-mi, temporarily gained an almost exclusive predominance in Tibet and for nearly a hundred years it became an exceedingly powerful political and spiritual force. From the twelfth to the end of the thirteenth century this sect exerted a strong influence in Tibet, Mongolia and even at the Chinese Court.

The teachings transmitted by 'Brog-mi (992–1072) were the starting point of the religious doctrine of the Sa-skya-pa order. 'Brog-mi had been a disciple of the Buddhist Abbot Śân-tibhadra in India. From there he brought to Tibet the teaching of Siddha Virûpa and invited Gayadhara, the disciple of Virûpa, to the Myu-gu-lung monastery, which he founded in 1043. Next, dKon-mchog rgyal-po of the 'Khon family joined 'Brog-mi as a disciple and subsequently founded the "Grey Earth" (Tib.: Sa-skya) monastery in 1073. This foundation soon developed into the famous parent monastery of the Grand Lamas of Sa-skya, famed far and wide as a centre of Buddhist scholarship, poetry and art. But it was only under the next abbot, Sa-chen kun-dga' snying-po (1092–1158), that the Sa-skya-pa sect developed as an independent doctrinal movement. Under the leadership of this learned abbot the spiritual and temporal power of the sect rapidly extended all over Tibet, and even noblemen and sovereigns soon solicited the protection of these Grand Lamas. The first 34

Fig. 3. Title vignette from the Mani bka'-'bum.
King Srong-btsan sgam-po of Tibet with his two wives Khri-btsun from Nepal (left) and Kong-jo from China (right).

Fig. 4. Title vignette from the Mani bka'-'bum.
The Guru Padmasambhava with his two women disciples Mandârava (left) and Ye-shes mtsho-rgyal (right).

Grand Abbot was succeeded by four others of outstanding importance: bSod-nams rtse-mo (1142–1182), Grags-pa rgyal-mtshan (1147 to 1216), Sa-skya Paṇḍita (1182–1251) and 'Phags-pa (1235–1280).

The fourth Grand Lama, Sa-skya Paṇḍita, raised the sect to the peak of power and reputation through his scholarship, tolerance and far-reaching influence. In short, these Grand Lamas of Sa-skya were most erudite figures who had made names for themselves through their extensive religious, dogmatic, tantric and ethical writings.

35 The abbots were regarded as incarnations of the Bodhisattva of wisdom, Mañjuśrî. Sa-skya Paṇḍita also developed political contacts with the rulers of the Mongolian Empire. He, and even more so his successor 'Phags-pa, maintained relations with the powerful descendants of Genghis Khan. A large number of Mongolians were converted to Buddhism in that early period, and 'Phags-pa Lama drafted a first version of the Mongolian script (the so-called 'Phags-pa square script) designed to be used for the translation of the Buddhist scriptures. However, this Imperial Script introduced and decreed by Kublai Khan in 1294 does not seem to have proved successful, and after a few more

models a form of writing taken over from the Uigurs was later adopted for Mongolia.

The external importance of the Sa-skya-pa sect began to decline again in the thirteenth century. The fourteenth and fifteenth centuries then witnessed the emergence of several sub-sects, among which mention should be made of the Tshar-pa sect inspired by the Lama Yar-klungs sen-ge rgyal-mtshan, with its parent monastery of bSam-gtan-gling, as well as of the Ngor-pa sect. The latter, under its first abbot, Ngor-chen kun-dga' bzang-po (1382–1444), established the great parent monastery of Ngor Evam chos-ldan (1429) which soon acquired considerable importance in Tibet's cultural history.

Typical of the teachings of the Sa-skya-pa sect are the version of the Hevajra Tantras transmitted by 'Brog-mi according to the Indian master Sântibhadra and, above all, the special doctrine of the "Way and the Fruit" (Tib.: Lam-'bras). In addition a great many works and commentaries on philosophy, the Tantras, rhetoric, logic, dogma, history and grammar were written. The Sa-skya sects also promoted the arts in a major way by commissioning Tibetan and Nepalese artists to decorate monasteries, and even invited groups of Nepalese artists to work in Tibet. The southerly position of the monasteries and their close links with Buddhist Nepal resulted in Nepalese and Indian stylistic influences reaching Tibet. The artistic activity of the Sa-skya sects and their connection with Nepal has thus exerted a marked influence on the development and stylistic enrichment of all subsequent Tibetan art.

The rNying-ma-pa Sect

The history of the rNying-ma-pa sect, in spite of its long existence, is not as clearly defined in hard dates and lines of hierarchical succession as is the case with other Tibetan Buddhist sects which enjoyed more favourable conditions. One of the reasons was that the followers of the earliest currents of Lamaism, established by Padmasambhava in the eighth century, lived at first mainly as tantric yogis in small monastic communities (with the exception of bSam-yas) and in caves for meditation. This meant that initially there was no succession of great abbots in a leading central monastery which would have been authoritative for the whole of the rNying-ma-pa sect. Moreover, the uninterrupted chain of transmission from guru to disciple, which is so essential in Buddhism, suffered a vital break, and indeed a prolonged interruption, during the persecution of Buddhism under King gLang-darma.

While other sects were able to re-orient themselves in the Indian tradition, the followers of the Old Line appear to have encountered far more trouble in recovering their ancient tradition and adding to it new doctrines. Most importantly, many writings of the early days of the first spread of Buddhism, writings recognized by the rNying-ma-pa sect, do not form part of the official canon of Tibetan Buddhism, which acknowledged only the works dating back to the second spread of the doctrine. Therefore, since part of these old doctrines were rejected by the

other sects, the rNying-ma-pa sect has followed its own ways since the eleventh century.

The most peculiar and interesting phenomenon in the spiritual life of the old sect is the literary category of "treasures" (Tib.: gTer-ma); these are typical of the unobtrusive work of the rNying-ma-pa which consisted in the transmission of highly secret doctrines differing in many respects from the doctrinal systems of other sects. These gTer-ma manuscripts are Lamaist writings of deep religious and mystic content, said to have been hidden in secret places by Padmasambhava and his successors, in order that they might be "discovered" by posterity at a later, more favourable, period. The "discoverers" of these writings are known as "treasure-finders" (Tib.: gTer-ston). They gained respect and veneration among their followers for giving a new impulse to the rNying-ma-pa sect as the re-discoverers of the ancient teachings. The earliest "discoverers" of such sacred scriptures lived in the eleventh and twelfth centuries. They were the monk Grva-pa mngon-shes (1012–1090) who "discovered" mainly Tibetan medical writings, and the Lama Zhang-ston bkra-shis rdo-rje (1087–1167) from Yar-'brog who is credited with the re-discovery of the fundamental writings of the sNying-thig. He "discovered" the ancient Vimalamitra manuscript at mChims-phu (near bSam-yas) in 1037.

The names of more than fifty such "treasure-finders" have been handed down to us. One of the most important among them is O-rgyan gling-pa (b. 1323) from gYo-ru gra-nang, who "discovered" the biographical writings which play an important role in the teachings of Padmasambhava. From 1346 onwards, first under the Red Stûpa of bSam-yas and later at other sacred localities, O-rgyan gling-pa "found" important gTer-ma. The biographies of Padmasambhava (Tib.: Padma-bka'i thang-yig and Padma rnam-thar chung-ba) and the bKa'-thang sde-lnga found at bSam-yas are his most important contributions.

In the fourteenth century there lived another gTer-ston lama, Karma gling-pa, who "found" the famous manuscripts of the Tibetan Book of the Dead at sGam-po-gdar. The fourteenth century produced several important "treasure-finders", such as Sangs-rgyas gling-pa (1340–1396), rDo-rje gling-pa (1346–1406) and Rin-chen gling-pa (1403–1479); together with those named above they marked the golden age of the rNying-ma-pa sect, when the writings of the entire movement were gathered, assembled, and printed in voluminous collections. One such collection is that of the ancient Tantras (Tib.: rNying-ma'i rgyud-'bum) and the other collection is the "Great Precious Treasure of the gTer-ma" (Tib.: Rin-chen gter-mdzod).

As a rule the monasteries of the rNying-ma-pa were smaller than those of the other sects. They were situated in remote parts of the country frequently at great distances from one another. In the seventeenth century these old establishments were extended and enlarged under the guidance of outstanding abbots. Among these Rig-'dzin gter-bdag gling-pa (1646–1714) was a leading

figure. The great monasteries of the rNying-ma-pa sect are listed below, together with their dates of foundation:

(1)	bSam-yas	775
(2)	Ka-thog rdo-rje-gdan	1159
(3)	dPal-yul	1653
(4)	rDo-rje-brag	¡1668
(5)	sMin-grol-gling	1676
(6)	rDzogs-chen	1685
(7)	Zhe-chen dar-rgyas-gling	1734

The rNying-ma-pa tradition differs on some important points from that of later schools. The Buddhist doctrines are sub-divided here into nine sections or "vehicles" (Tib.: Theg-pa-dgu) which can be summed up in three groups of three:

Lower Stage	Middle Stage	Highest Stage
Śrâvakayâna	Kriyâtantra	Mahâyogatantra
Pratyekabuddhayâna	Upayogatantra	Anuyogatantra
Bodhisattvayâna	Yogatantra	Atiyogatantra

This pattern-of-nine classification of Buddhist teaching is something unusual and possibly reflects the influence of Bon religious doctrine. One should bear in mind that early Lamaism was only able to prevail in Tibet by assimilating older traditions. The fundamental Guhyagarbha Tantra (Tib.: gSang-ba snying-po'i-rgyud) as well as the above mentioned doctrines of sNying-thig both date back to the early period of the first spread of Buddhism. For the rNying-ma-pa sect they represent the principal foundations of the doctrine of "Great Perfection" (Tib.: rDzogs-chen), which is realized in the supreme yoga, the Atiyoga. The teachings of the Tibetan Book of the Dead, a gTer-ma discovered by Karma gling-pa which describes the paths through the world after death, will be discussed in detail in the chapter on "Visionary Unfolding in the Maṇḍala".

The Zhi-byed-pa Sect

In the twelfth century in southern Tibet there emerged a particular tradition of doctrines developed from the spiritual legacy of the south Indian master Dam-pa sangs-rgyas. This monk belonged to the tantric school of the famous Vik-ramaśîla monastery in southern India. He is believed to have first come to Tibet in 1092 and to have met with the famous Tibetan yogi Mi-la ras-pa. During his stay in Tibet this south Indian master taught two systems which were subsequently adopted by a special sect of yogis. The two paths were the teaching of "Laying Suffering to Rest" (Tib.: Zhi-byed) and the teaching of "Severance" (Tib.: gCod) of all roots of thinking linked to the external world. Links with transitory things, according to the doctrine, result in the experience of the world of suffering. The gCod teachings were of strikingly original character and gave rise to a widely ramified tradition in Tibet.

In 1097 Dam-pa sangs-rgyas founded the Ding-ri glang-'khor monastery which became the cen-

38

tre of his school. His two best known successors were sKyo-ston bsod-nams bla-ma and the Buddhist nun Ma-gcig lab-kyi-sgron-ma (1055–1149). She was an exceedingly active religious teacher who founded a special doctrine of the gCod system which she later transmitted to her two disciples Khu-sgom chos-kyi seng-ge and rGyal-ba don-grub at her religious house of Zangs-ri mkhar-dmar.

The Zhi-byed-pa doctrines, which originated in India from the Prajñâpâramita tradition, were enlarged by Tibetan and partially Shamanist influences of the Bon religion and handed down in two versions as the male line (Tib.: Pho-gcod) and the female line (Tib.: Mo-gcod). The peculiar, psychologically interesting doctrine of mystic self-sacrifice, which demands of the disciple a symbolic sacrifice and dissolution of his body to propitiate the ferocious deities, to be achieved by yoga meditation, was soon practised and largely adopted in modified forms by other sects. It appears therefore that the Zhi-byed-pa sect and its followers have long continued not so much as an independent school but rather in the form of currents within the rNying-ma-pa and the bKa'-brgyud-pa.

The dGe-lugs-pa Sect

The growth of the bKa'-gdams-pa sect was described above in our brief historical outline. With Atîsa as a starting point it continued as a school of strict monastic discipline until the fif-teenth century. The organisation of the bKa'-gdams-pa sect and its monasteries became the foundation of the great Reform of Lamaism undertaken by Tsong-kha-pa (1357–1419). Tsong-kha-pa was born not far from Kumbum in north-eastern Tibet and in his youth he visited several teachers and monasteries. At Sa-skya, sNar-thang, Jo-nang and in Lhasa he acquired a wealth of knowledge. Eventually he settled at the ancient bKa'-gdams-pa monastery of Rva-sgreng to formulate anew the teachings of Buddhism, to bring order into the extensive doctrinal system and to put down in writing his conclusions. His major work of this time was the "Path of Enlightenment" (Tib.: Byang-chub lam-rim), which became the basis of his reformed teachings and of the sect which he founded soon afterwards. Because of the yellow caps which his followers have worn ever since, the dGe-lugs-pa is also known as the Yellow Cap sect. Tsong-kha-pa was a highly gifted writer and scholar, and by the end of his active life his works comprised more than three hundred titles collected in sixteen volumes. The rapidly growing number of his adherents soon led to the foundation of new monasteries which soon were among the greatest institutions in Tibet.

The first to be founded, in 1409, was the dGa'-ldan monastery near Lhasa, where Tsong-kha-pa was installed as the first abbot. Shortly afterwards the other two great monasteries were founded: 'Bras-spungs in 1416 and Se-ra in 1419. These three parent monasteries were described as the pillars of Tibet's Yellow Church; each of

Fig. 5. Illustration from the Vaidûrya dkar-po: the Lama Chos-grags rgya-mtsho (right).

these institutions housed several thousand monks.

After the death of Tsong-kha-pa (1419) his work was continued by the three Lamas rGyal-tshab, mKhas-grub and dGe-'dun-grub. The numbered line of Dalai Lamas—the succession of reincarnated Grand Lamas of the dGe-lugs-pa Order who regard themselves as reincarnations of the Bodhisattva sPyan-ras-gzigs (Avalokiteś-vara)—began with dGe-'dun-grub. The Grand Lamas of the Yellow Cap sect also attained temporal power over Tibet and ruled the country from Lhasa, the city where the fifth Dalai Lama, in the sixteenth century, built the palace of the ecclesiastical rulers called the Potala. While the Dalai Lamas had to concern themselves very largely with temporal and political matters, the Panchen Lamas (as reincarnated lamas who were put in charge of the new bKra-shis lhun-po monastery in the fifteenth century) were able to devote themselves to a greater extent to exclusively religious matters. The famous bKra-shis lhun-po monastery was founded in 1447 and became the largest in Tibet. The Panchen Lamas (Tib.: Pan-chen bLa-ma) were regarded as reincarnations of the Buddha Amitâbha who rules over the Western Paradise (Skr.: Sukhâvatî).

Under the third Dalai Lama, bSod-nams rgya-mtsho, (1543–1588) the final conversion of the Mongols to Buddhism took place and Mongolia became a domain of the dGe-lugs-pa sect. The largest and most famous monastery in Mongolia was Erdeni-Dsu, founded in 1586. The growing influence of the Yellow Cap Lamas in all parts of Tibet and their vigorous political activity resulted in the Reformed Church becoming Tibet's official church.

Among the Grand Lamas of the Yellow Caps the most important figure was the fifth Dalai Lama, Ngag-dbang blo-bzang rgya-mtsho (1607–1682), who was not only a great scholar but also a strong and wise political leader of his country. He was, moreover, the author of important writings, having studied the assembled knowledge of the ancient Tibetan Buddhist sects. He also enlarged the Potala to serve as the cen-

tral residence of the Tibetan government. It was he who became appointed by the Emperor of Mongolia to be the spiritual and temporal ruler of Tibet.

The doctrinal system of the Yellow Church was defined by Tsong-kha-pa as emphasising the "Middle Path" (Skr.: Mâdhyamika) of the Indian philosopher Nâgârjuna, the doctrines of the perfection of knowledge (Skr.: Prajñâpâramitâ) and increasing attention to monastic discipline. Logic and philosophy were included in the monastic curriculum to a greater extent and the ancient Tantras were revised. The most important Tantras, the Guhyasamâja and Kâlacakra, became the subjects of extensive studies and commentaries. The God of Death, Yamântaka (Tib.: gShin-rje gshed), is revered as the powerful guardian deity of this reformed set.

Under the hierarchy of the Dalai Lamas Tibet once more attained the brilliance and greatness of a theocratic state commanding respect from all its neighbours. The monastic system and the relationships within the Reformed Church were organized in strict detail, and embassies of the Tibetan ecclesiastical power were set up in neighbouring countries. The holiest place for the followers of the teachings of Tsong-kha-pa was at his birthplace in Kumbum. Here the monastery of Kumbum (Tib.: sKu-'bum) was founded in 1578. Its magnificent temples were annually visited by thousands of pilgrims who came to pay homage to their founder.

Form and Secret Revelation in Tibetan Art

A deeper understanding of Tibetan art can only be achieved by a thorough acquaintance with the basic ideas of Buddhist thought. We shall therefore examine the relations between Buddhist doctrines and the objectives of art, since in Tibet, as in many civilizations, religion forms the background of all artistic expression. Tibet's cultural history shows beyond any doubt that it was the refinement of Tibetan and central Asian culture, which emerged with Buddhism, that triggered such a wide range of artistic creativity in all fields. However, this impetus initially came not merely from Buddhist doctrine but also from that great influx of artists who brought with them their techniques and stylistic ideas. This impetus is best seen as a powerful cultural influence, associated with Buddhism, that reached Tibet from India. But there were also important stimuli from different artistic traditions originating in central Asia and China. In this chapter we shall concern ourselves chiefly with the examination and interpretation of the spiritual foundations. Stylistic and art-historical observations will be confined, as far as possible, to the captions of the pictures. Reference should therefore be made to the sources listed in the appended bibliography for a study of the history of Tibetan art.

Mahâyâna Buddhism and, subsequently, the teachings of Vajrayâna with their grandly conceived Sûtras—those long didactic texts whose content points towards transcendental spheres—represent a unique background for the evolution of such a richly stratified art as that of Tibet. Tibetan artistic work in all its aspects, but particularly in painting, was determined by and orientated towards religion. Apart from purely historical representations, Tibetan artists found all their other themes in the infinitely rich world of Buddhist ideas, its hagiology, its didactic texts, the symbols, meditations and visions outlined in them, and the superior worlds described in them, their heavenly spheres and their world-renouncing states. The Mahâyâna—with its doctrine of Bodhisattvas descending from spheres of purity; with its revelation of an infinite number of Buddhas and Bodhisattvas active in countless countries of the ten regions of the world, illuminating them with the light of knowledge; with the teaching of the transformation of Bodhisattvas through numerous forms and worlds of reincarnation, where, in all good and bad forms of existence, they work for the enlightenment of all beings—only such an all-embracing religion could provide an inexhaustible source of artistic inspiration and produce a wealth of artistic work in India and later also in Tibet. In Tibetan painting, then, we find a great variety of colours, and a free and seemingly unrestricted use of different colours for one and the same motif. We encounter landscapes and clouds in "possible" but also, from a naturalistic point of view, "impossible" colour compositions, in colours feasible perhaps only in a dream or in a vision, so that we are induced to seek the cause which gave rise to an art of this kind. This cause is to be found in the forms of Mahâyâna and Vajrayâna as briefly outlined in the opening chapter.

Important perspectives which influenced the creation of art were: the fundamental realization of the transience of the external world, the relativity of all values (so impressively revealed in tantrism), and the transparency of all visible and created manifestations against the invisible but translucent background of the universal void. The world is seen as a manifestation of forms composed of separate transitory elements, forms which are themselves transient and hence illusory. All phenomena are only states of momentary existence in a stream of continuous arising and decay. The world that appears to our eyes can be seen with the inner eye of clairvoyancy in all its causal relationships; it can be surveyed by the inner eye in its past, present and future stages. The identity of the void and the manifest, repeatedly emphasized in the extensive literature of "Perfect Wisdom which has Attained the Other Shore" (Skr.: Prajñâpâramitâ), enables the artist to see the world of phenomena as a vision, as a state yet to be realized, in which form and colour are changed at will in accordance with the intensity of contemplation. The value of the colours is relative and adjusts itself to the aspect of the moment and not to external reality. Similarly, meditations on remote lands of the Buddhas and the celestial realms of the Bodhisattvas open up to the artist a visionary world of divine spheres to be experienced in a super-sensual way, spheres which he then tries to depict in transparent colours.

The Mahâyâna doctrine of the three bodies (Skr.: Trikâya) opens up to him further realms for pictorial art. The artist therefore tries his hand at representing the bodies of the heavenly enjoyment of supreme happiness (Skr.: Sambhogakâya) in which the Bodhisattvas reside; he creates the ideal picture of the Buddha in the pure body of his earthly incarnation (Skr.: Nirmânakâya), or else he tries to represent the highest form of the Buddha as the body of the universal law (Skr.: Dharmakâya), the nature of the Buddha hood. All these worlds and their illusory forms or the reflections of light-filled forms of higher realizations can be penetrated by the artist with the rays of knowledge as is recommended in the meditation for monks and lay followers. This light-filled character, this dissolution or transparent penetration of material with the rays of enlightenment, makes things appear in the visionary reflection of the five-coloured rays which, in Vajrayâna mysticism, become the foundation of systematic pictorial meditation. Thus the entire material world is composed, in accordance with Buddhist doctrine, of five elements whose subtle material forms manifest themselves to the inner eye as a five-coloured light.

These infinite possibilities open to the artistically creative spirit are constrained however by an ancient traditional Indian iconography which prescribes a strict hierarchical and creatively ordered pattern within which the representations have to be kept. At an early date the large number of Buddhas, Bodhisattvas, deities and saints was fixed in iconographic textbooks. Their appearance was clearly defined in terms of form, 44

dimension and colour, as well as appropriate symbolism. It is thanks to these definitions that we are nowadays able to reliably identify and describe the deities. The number of these pictures with all their variations and special forms runs into thousands. The accepted special symbols of deities (Tib.: Phyag-mtshan), the positions of the hands (Skr.: Mudrâ), the positions of the body (Skr.: Âsana), as well as the colours are the familiar identification marks recognizable by those initiated into the mysteries of Vajrayâna. Only when all these aspects are taken together with their underlying meanings can the entire cognitive content of a picture be understood.

The artist, of course, must also be initiated into this normally arcane knowledge before attempting the difficult representation of such symbolic deities. He creates those Buddhas and Bodhisattvas who—raised to a pure, higher sphere on their lotus flowers—radiate in a thousand works of pictorial art. The lotus, the symbol of creation from the primeval ocean of forms, is the first pure flower not stained with the dust of the sixfold world. It is thus, in Buddhism, the symbol of purity and also of the meditative unfolding of the heart offered up by the yogi as a symbolic throne for the deities. The lotus is the unfolding centre of the heart upon whose petal throne the germinal syllables (Skr.: Bîja) issue forth and radiate multicoloured light so that the deities may arise from this light. It is from the heart-lotus that all images and visions originate which then grow into the magnificent pantheon of the Buddha worlds. These worlds are realized by the mystic in his meditations: he experiences them and actualizes their meaning, eventually "returning" them back into the infinite voidness.

The meanings contained in many Mantras and germinal syllables as crystallization points for the visionary representation of the tantric deities are part of the basic knowledge of the Tibetan artist. He has learned the classical Indian Sâdhanas—those short meditative texts with Mantras (as invocations)—in which the deities were described with all their attributes, Mudrâs and colours for the purpose of pictorial meditation. Meditating on such Sâdhanas himself, the artist, time and again, becomes the creator of these embedded images—images developed out of himself. The Tibetan artist, being initiated into the profound teachings of the themes represented by him, thus creates works which in turn can be, and are designed to be, understood only by the initiated. This is an important factor in the contemplation of Tibetan art, an art frequently so obscurely encoded that access to it often seems barred to a thinking mind.

However, the meditations are not solely determined by an ultimate goal or by different stages of purification and knowledge. It should be remembered that a sculpture, an iconographic painting, a visionary representation (especially in the Maṇḍalas) can represent only one of the different levels of the inner path of knowledge. Such pictures may correspond, for instance, to the stage of the pure spirit, the pure word or the transfigured body. But the pictures may also

refer to the plane of the Buddhas, the esoteric initiation deities, the paradisical worlds of Amitâbha (Skr.: Sukhâvatî) or the Bardo state. All these possibilities must be considered in an examination and interpretation of Tibetan art. They prove that this art often has a profound background of many separate levels, frequently transcending the boundaries of what is representable. Anything beyond those boundaries—the spiritual content, the meditative level, the experiential content and the degree of initiation—is expressed as far as possible by symbols of form, implement and colour. Many pictures simultaneously show several levels of internal transformation or several levels of meditation which only the initiated can realize during contemplation. This religious art therefore aims not at laying claims to perfect aesthetics or creative beauty or appeal of form but, by observing a strictly formalized iconography, aims at making visible religious, meditational, purely spiritual and visionary contents so that the initiated may in turn re-live them. To the initiate, therefore, the work of art is only an external aid for pictorial meditation. The works of art serve spiritual discipline and realization; they are objects for a ritual of invocation and veneration of the deities, and hence fulfil a totally different function from that of decoration or art for art's sake. This is particularly true of the scrolls (Tib.: Thang-ka) which were used in temples and for domestic altars; they functioned as supports for visualization of the deities whose qualities the initiate strives to develop within himself.

All these techniques of visualization or mystic introspection of secret fields of force (lotus centres), of which many variants were taught, are based on the ancient Indian practice of yoga, which has survived in a pure form in Tibetan yogic traditions. Buddhist yoga—which leads to the light of knowledge, the secret teachings of the "Clear Light" (Tib.: 'Od-gsal), the "Dream State" (Tib.: rMi-lam) and of the "Illusory Manifested Body" (Tib.: sGyu-lus)—was developed by the Indian Mahâsiddhas and resulted in a number of possible ecstatic states, with visions which relativize all external laws of image, colour and form. That is why the handling of colour in Tibetan works of art is often preternatural, highly expressive, visionary and fantastic. Landscapes, trees, sky and clouds often correspond more to the inner picture of an all-transforming vision than to an external realistic picture of nature. Time and again clouds may appear at any point in the painting, in colours which appear unreal. The clouds frequently carry the deities as symbolic apparitions. Clouds are the ethereal, heavenly or dream-like sphere from which visions emerge; they can become the bearers of meditative representations and the transparent source of visions. But often the pictorial representations of the customary earthly and the visionary transcendental spheres move freely, without boundaries and seem to merge with one another. In some pictures the heavenly sphere reaches far down into the earthly world, in others the trees and snowy summits reach up into the realm of Buddhas and Ḍâkinîs floating 46

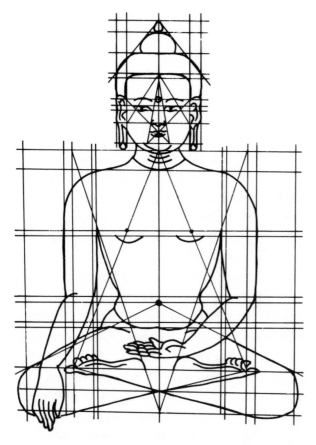

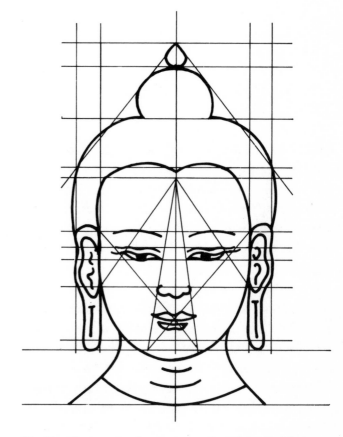

Fig. 6a. Diagram for the representation of the Buddha.　　　*Fig. 6b. Diagram for the representation of the Buddha.*

within the clouds, and on other pictures cosmic creations of the world appear, between heaven and earth—Maṇḍalas or shining realms of Amitâbha's Western Paradise.

There is a lot more to be said about the various themes but we shall have several opportunities to return to them in subsequent chapters.

We should be able now to approach Tibet's great artistic heritage with a deeper understanding. This is not art for art's sake but a serious attempt to represent doctrine, symbolism and the ideal image, worldly and transcendental experience, reality and the visionary content of meditation, the courses of the worlds, enlightenment and salvation, things created and things transparent, and finally the nature of the void itself. Just as objects in the world of phenomena are transient

and void, so the work of art is likewise void in itself, without real and abiding existence. For the Tibetans who used these works for devotional exercises in their monasteries, these representations were pictures of momentary phenomena meant for meditation, to be filled with life through invocation. These representations were not experienced as definite deities or real figures, but as symbols of a spiritual process which could be perfected and realized only in pure introspection.

Let us look now at the pictorial forms and techniques used by the Tibetan artists. As mentioned before, the iconography follows the strict principles of the iconometric books, as shown by Figures 6a and 6b for the representational diagram of the Buddha.

47

Just as in our diagram of the Buddha, there are rigid diagrams for all principal types in Buddhist iconography, and it was in accordance with their unchanging rules that the deities were drawn. This system was developed in India and was brought to Tibet where it was handed down in iconographic textbooks.

The representation proceeds from an assumed central line, known as the Brahmâ line (Tib.: Tshangs-thig). It forms the centre of every figure and follows the organic line of the spine. This line is simultaneously regarded as the centre of the universe, just as man should regard himself as its active centre. From this main central axis degrees of subdivision are drawn in symmetrical harmony as guidelines for the units of measurement which the Tibetans laid down in each case as a definite number of finger-widths. Such diagrams were used as "blueprints" for the manufacture of statues as well as for all paintings. When the painting was on canvas or a fresco the diagram was first faintly outlined on the ground, with the iconographic drawing executed over it. This formalization of diagrams for the images of saints and deities, which were the main subjects of Tibetan art, might easily have led to a rigid standardization. But in spite of these rules there was always sufficient artistic latitude in what freedom there was left for grouping the figures in a meaningful yet lively manner and for creating the non-prescribed backgrounds, landscapes and scenes in appropriate colours. In spite of this limited freedom of artistic creativity we find in Tibetan art a sufficient number of examples of great mastery whose unique quality has no parallel. And as the pictures are intended to reflect meditational experiences and in turn give rise to them, we find even in the portrayal of the greatest movement a controlled mastery of line which never bursts its bounds or loses control of itself. Again and again we admire the flame-ringed deities of visionary paintings whose vigorous movement governs the picture but whose rhythm is clearly defined and strictly ordered. An incredible dynamism often resides in a movement skilfully emphasized by colours, in the vigour of ecstatic visionary states experienced through yoga, lending the pictures an immanent fervour. And this dynamism manifests itself equally in the depicting of exceedingly peaceful and relaxed moods, moods of transcendental effect, in which the element of the void is felt to breathe from the picture.

Lamaist art is found in all spheres—architecture, sculpture and painting. In addition there was a rich popular art, executed with great skill and abounding in highly decorative forms, which succeeded in lending artistic adornment to objects of daily use. The shrines and temples of Tibetan monasteries contained statues of the Buddhas, deities and many saints of Lamaism. They were made of stucco (especially the large-size statues), bronze or wood. Gold, silver, semi-precious stones and bright colours were used for the surface decoration of works of art. Smaller statuettes and especially precious votive images were also made of beaten gold or silver, ivory or semi-precious stones. The small and medium

48

bronzes, which form the majority of the illustrations in this book, were found chiefly on top of the shrines of temples or hermitages, and on the domestic altars of lamas or pious lay followers. Every Tibetan family which could afford to do so used to set up a house altar or made a room available for devotions, where the lamas of nearby monasteries would frequently be invited for private domestic devotions.

The art of casting Buddhist bronzes was originally brought to Tibet from India and Nepal. The techniques employed and the different alloys used were kept a secret by the families or schools of artists which had established themselves in the various provinces of Tibet. One distinguishes very dark, reddish brown, yellow and almost silver-bright bronzes according to the kind of material used. According to stylistic form, we can recognize Kashmiri and west Tibetan types, and types from southern and eastern Tibet. Many of these bronzes were gilded or else painted in various iconographically determined colours. The colouring and the patterns used for the raiments, the type of the folds of the clothes, the Buddhas' crowns and the shape of the lotus petals all provide stylistic pointers as to the origin of a bronze. The classical provinces of bronze casting were Guge in western Tibet, the south Tibetan regions around Gyantse and Lhasa, and the east Tibetan province of Kham with its centre at Derge. Especially valuable are the bronzes with inlaid precious metals such as gold or silver, an ancient technique found at an early date in India and Kashmir and used in order to make bronzes seem more lively. There are also bronzes in which decorative parts were made as inlays of different coloured bronze alloys. The finest bronzes were those cast from a wax model by the "lost wax" technique. Every bronze of this type was a unique work of art since the mould had to be destroyed after setting in order to reveal the bronze casting. The field of painting comprised large-scale room decoration and murals at one end of the scale and relatively small-scale art of painting on canvas in the form of scrolls, the Thang-kas. Within the monasteries, the temples were most lavishly painted. Columns, capitals, friezes and architraves were decorated in colours on a red ground, with sacred symbols, calligraphic lettering, flowers, intertwining leaves and dragon motifs. The art of handwriting and miniature painting was also held in high esteem and will be discussed separately in the chapter on "The Noble Art of Writing".

The contents of entire textbooks, especially the Tantras, were brought to visible life by the artist in the form of frescoes along temple walls. Many monasteries of western and southern Tibet became famous for their magnificent cycles of frescoes in which the whole pantheon of Buddhas, saints, and protective deities was unfolded before the spectator's eye. The most magnificent of this kind were probably those in the Temple of a Hundred Thousand Buddhas (Tib.: sKu-'bum) at Gyantse and the paintings in the ancient and since abandoned temples of Tsaparang in western Tibet.

In the field of painting we must confine ourselves in this book to that genre which is still accessible to us—the scrolls or Thang-kas. These scrolls, framed in brocade or silk, served the monks and yogis as aids to meditation and were hung in the temples or on shrines whenever they were needed for certain rituals; during the rest of the time they could be kept rolled up. These Thang-kas were mostly painted on canvas, less often on silk. According to the various techniques employed they can be classified under four heads:

(1) Thang-kas painted in colour (also from printing blocks);
(2) Gold paintings, either on gold ground or red ground with line-drawing in gold and colouring (Tib.: gSer-thang or gSer-bris);
(3) Painting on black ground, monochrome with white or gold, or polychrome with limited use of iconographic decorative colours;
(4) Pure embroidery or appliqué techniques, sometimes with additional painting.

Thang-kas, a good number of which are reproduced in this book, can also be grouped according to their pictorial content under the following subject headings:

(1) Historical or legendary representations;
(2) Representations of the spiritual succession and hierarchy;
(3) Representations of meditative contents;
(4) Maṇḍalas (concentric Maṇḍalas) and cosmic diagrams;
(5) Visionary representations.

In the first category, for instance, we find the representations from the life of the Buddha, the saints, the Arhats, the yogis and the Siddhas, and legends of saints or stories of Tibetan kings. These include the Gesar epic, a favourite subject in all Tibetan regions.

The second group is frequently found as wall paintings in monasteries, as well as in many Thang-kas. These are the pictures showing the line of gurus, the founders and the Grand Lamas of a sect or doctrinal tradition. They are described, for instance, as the "Golden Rosary of the Gurus of the bKa'-brgyud-pa" or similarly. These paintings—mirrors, as it were, of the spiritual descent or succession—provide instant information to anyone entering the monastery about the sect or doctrinal tradition represented there. This is why these representations of the succession include not only the teachers but also the specific esoteric divinities and guardian deities of a particular school. This group of paintings also includes the popular form of a "Family Tree of Buddhas and Lamas" (Tib.: Tshogs-shing), in which the entire line of masters and disciples as well as all saints and deities are grouped together in the manner of a great family tree.

The third category includes the large number of pictures of meditative content, representing Buddhas, Bodhisattvas, and esoteric deities or Dharmapâlas in various arrangements. The range of subjects is quite extensive. These meditational pictures are aids to contemplation of certain aspects of the esoteric teachings and the 50

attributes of the deities, as well as to meditation on the ideals of Mahâyâna Buddhism generally. Under the fourth group we shall consider only those Maṇḍalas which are represented in a closed (concentric) form. These Maṇḍalas are esoteric meditation diagrams embodying a particular doctrine or some partial aspect of a doctrine. This doctrine is to be understood through progressive pictorial meditation proceeding from the centre of the picture. The Maṇḍalas thus serve the inner process of individuation—spiritual contents to be systematically attained through yoga. These contents are contained in the Maṇḍalas, coded in a wealth of symbolism, and are intended to achieve a step-by-step purification of consciousness through growing awareness of the spiritual values of the secret doctrine.

Finally the fifth group comprises all paintings of visionary type—the various visions of Yidams and guardian deities according to the traditions of leading Indian and Tibetan masters; the visionary pictures, mostly on black ground, from the temples of guardian deities; the so-called projectional representations; and the indirect or open Maṇḍalas, those groups of deities in an open space which produce a complete Maṇḍala if supplemented by the dynamics of prescribed pictorial meditation. This group of works of art, in particular, is of a highly esoteric character and was most strictly guarded in Tibet against the eyes of the uninitiated. The paintings from the temples of the guardian deities are for us, to this day, the ones whose real significance and inner force remain most hidden from us. The sight of these wrathful representations on a black ground engender psychic processes of individuation which demand a thorough preparation and an advanced knowledge of manipulation of the forces and powers of human consciousness.

12 This Thang-ka of the rNying-ma-pa tradition shows the Buddha Śâkyamûni at the centre with the begging bowl (Skr.: Pâtra) in his left hand. At the top, in the centre, is the Âdibuddha Samantabhadra (Tib.: Kun-tu-bzang-po) in union with his white Prajñâ; top left we see the Guru Padmasambhava (Tib.: Padma byung-gnas) and top right the blue Dhyânibuddha Akṣobhya (Tib.: Mi-'khrugs-pa) with the Vajra. At the bottom, in the centre, seated upon a lotus throne, is the white Buddha Vajrasattva (Tib.: rDo-rje sems-dpa') and on the right the green goddess Târâ. Below in the centre, surrounded by a halo of flames, are the guardian deities Vajrapâṇi (Tib.: Phyag-na rdo-rje) and the red Raktayamântaka (Tib.: gShin-rje-gshed dmar-po).

Notes on the Plates 12 and 13

13 Tibetan painting of the rNying-ma-pa sect. It shows the "Precious Guru" Padmasambhava (centre) surrounded by the twenty-five yogis from mChims-phu (Tib.: rJe-dbang nyer-lnga). These yogis of ancient ninth century Tibet were famous for their magic skills acquired through yoga. Thus they were able to move freely through the air, pass through rocks and perform alchemist transmutations of substances. Tibet, eighteenth century.

51

14 This Thang-ka shows the Paradise of Padmasambhava *(Tib.: Zangs-mdog dpal-ri), a favourite theme in the mysticism of the old rNying-ma-pa sects. The sacred copper-coloured mountain rises from the lake, the realm of the Nâga king, and reaches up into the Brâhma world. The great celestial palace of Padmasambhava has four sides with four gates and eight corners and is totally translucent from outside and inside. Enthroned at its centre is the "Precious Guru" Padmasambhava with his two female disciples Mandârava and Ye-shes mtsho-rgyal. They are handing him the tantric Kapâla as an offering. Padmasambhava is surrounded by the assembled eight gurus who are regarded as earlier incarnations of the tantric master from Uḍḍiyâna. They are, reading from left to right, the Gurus mTsho-skyes rdo-rje, Padma rgyal-po, Śâkya seng-ge, Seng-ge sgra-sgrogs, rDo-rje gro-lod, Nyi-ma 'od-zer, bLo-ldan mchog-sred and Padmasambhava. Their colours refer to the order of the eight gurus in the Maṇḍala. Above the head of the "Precious Guru" there appear the four-armed Avalokiteśvara, and above him the Buddha Amitâbha. Padmasambhava is regarded as an incarnation of the Bodhisattva Avalokiteśvara; this is in line with the customary Trikâya representation of Padmasambhava—i.e. in his Dharmakâya form as Amitâbha, in his Sambhogakâya aspect as Avalokiteśvara, and in the earthly Nirmâṇakâya as Padmasambhava. In the wide heavenly spheres above, nymphs (Skr.: Kinnaras) are flying, and emerging from the clouds are the guardian deities Ma-ling nag-po (left) and Pe-har rgyal-po (right), with their companions, as well as the Buddha Sarvavid-Vairocana (Tib.: Kun-rig) at the very top in the centre. Eighteenth century.*

15 After the foundation of the Ngor monastery in southern Tibet (1429) a new spiritual and cultural centre developed there under the guidance of the first "Great Abbot" Ngor-chen kun-dga' bzang-po. Its tradition is typically revealed in this seventeenth century painting. We see an important monk of the Sa-skya-pa line on a richly decorated lotus throne with a delicately worked body and head halo against a red background. Many of the stylistic elements of the magnificent throne, the vases with the water of life on either side of the lama, and the forms of the flame aura suggest the influence of Nepalese art. The lamas of Ngor, more than anyone else, maintained intensive cultural exchanges with Nepal, inviting to Tibet many Nepalese artists who then, jointly with Tibetans, decorated the monasteries. Numerous motifs of Nepalese art found a fertile soil in the southern school of Tibet and became a permanent enriching element of Tibetan art. The top row shows the Âdibuddha and the Indian Siddhas whose doctrines were handed down through the line of the Sa-skya lamas. On the two sides we see the succession of Tibetan gurus while the lower part of the picture contains various forms of Mañjuśrî and Avalokiteśvara. Tibet, sixteenth century.

16 One of the first gurus of the Sa-skya sect was the Indian Mahâsiddha Virûpa (bottom right), from southern India. In his right hand he swings a small Ḍamarŭ, and in his left he holds the tantric Kapâla. Sitting on a footstool facing him, is the Lama gSer-ling-pa with a yellow cap; above them is an aged hermit with white hair. This eighteenth century painting convincingly reveals the strong influence of Chinese art, an influence which has persisted in Tibet ever since. The flowing treatment of the landscape, the diagonal development of the action, the representation of plants, animals and rocks, as well as the translucent colours of Chinese painting technique determine the character of this picture.

17 Section from a painting representing the Buddha Śâkyamuni. Here we have the fully developed artistic representation of the Buddha in Tibetan painting, showing him as the supreme and almost supernatural being. The landscape and its detail recedes far into the background against the radiance of the blue halo. The Buddha's raiment is of fine brocade. The sumptuous, richly decorated lion's throne, and the cloth of distinction covering it with the wheel symbol of the spiritual ruler, are delicately decorated with gold leaf. In addition, a wealth of symbolic offerings have been placed before the throne—pearls, coral, earrings, ivory and conch-shell. South Tibetan painting, about 1700.

12

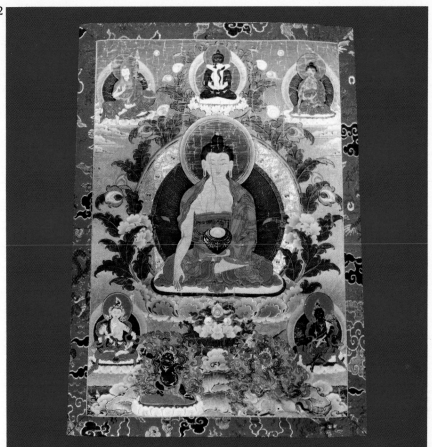

13

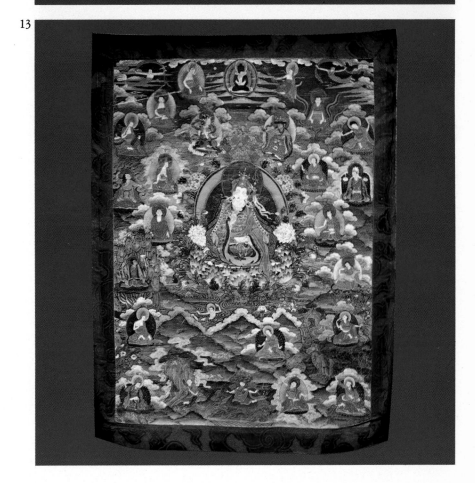

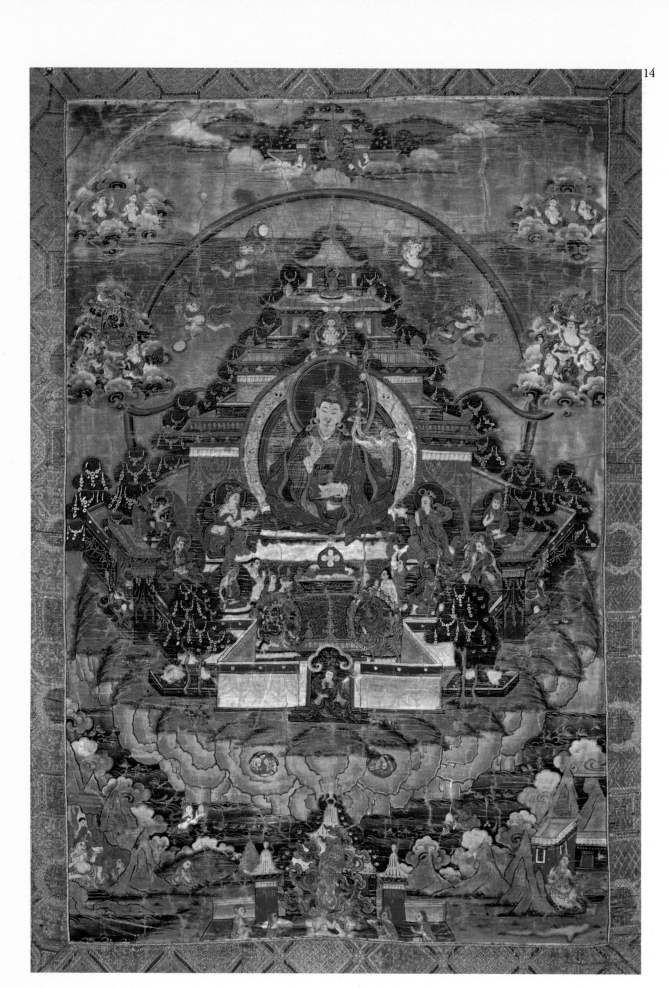

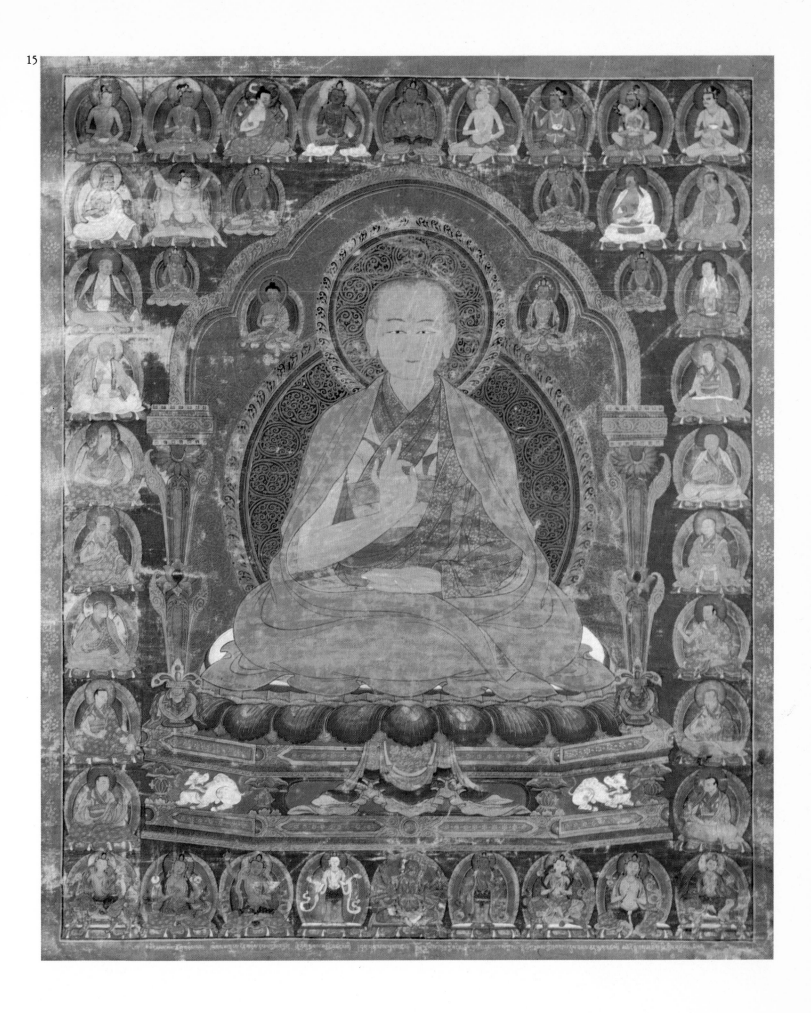

16

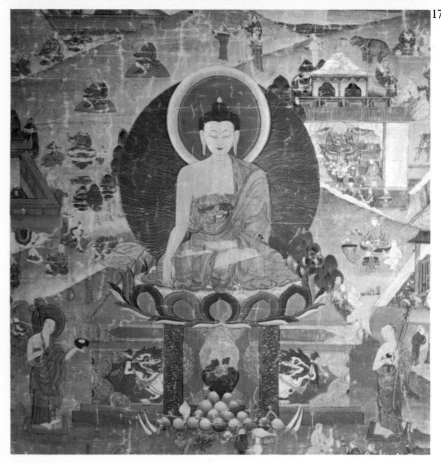

17

The Representation of Buddhas and Bodhisattvas

The Buddha

After these general introductory chapters on the development of Tibetan Buddhism and its art forms we shall now consider the great archetypes represented by bronzes and paintings. Moreover, as many original texts as possible will be quoted from Buddhist writings whenever they are likely to help the reader understand the pictures from within their own spiritual world.

First of all, there are the representations of the Buddha which, as the oldest and most important cult images of Buddhism, were present in every temple and every shrine of its followers. Even though the Buddha, as the founder of a religion, is a figure familiar to virtually everybody, it will pay us to look more closely at his picture. One such bronze statue (Plate 18) shows the Buddha seated upon a double lotus throne. He is wearing a monk's robe which leaves the right shoulder bare while the end of the cloth is draped over his left shoulder. The hands are shown in two different positions (Skr.: Mudrâ). Such Mudrâs invariably had a certain symbolic meaning, either relating to certain events in the saint's life or symbolizing their particular spiritual attributes at various steps towards perfection. For this reason a Buddha figure or a deity may be shown in different Mudrâs. These Mudrâs have remained unchanged since ancient times and each has its clearly defined significance. The Buddha holds his right hand in a typical gesture of touching the earth (Skr.: Bhûmisparśamudrâ) while his left rests on his lap in the gesture of meditation (Skr.: Dhyânamudrâ).

The reason why the Buddha has traditionally been represented with these Mudrâs can be found in a key incident in the spiritual development of his life. In the Lalitavistara-sûtra we find the following account of an event in the life of the Buddha: After the Buddha had attained enlightenment under the Bodhi tree, Mâra, the Evil One, tried to deflect him from his good intentions. However, "the son of the Śâkyas, having realized that all elements are relative and in truth unreal, and being equipped with a spirit (all-pervading and peaceful) like the heavens, was not confused by the manifold skills of Mâra's companions." When the Evil One tried for a last time to contradict the Buddha, claiming that he, the Buddha, had no witness to testify to his enlightenment and the truth of his teachings, the Buddha replied: "This earth is my witness." And touching the earth with his right hand, he said: "This earth is the soil bearing all living creatures, it is equal and it is unbiased with regard to all that moves and does not move. May it make manifest that I am not lying and may it be my witness against you!" And as he uttered these words the earth shook six times and there emerged Sthâvarâ, the Goddess of Earth. Revealing half of her body she folded her hands and said: "O Supreme Being, it is thus."

It is this incident—the Buddha's calling upon the earth in witness of the truth of his enlightenment—that has found its artistic expression as the Mudrâ of touching the earth. Over the centuries the representations of the Buddha became increasingly elaborate, and in particular the

lotus throne became the object of artistic imagination. With the emergence of the Mahâyâna the adoration of the Buddha as an omniscient godlike being commenced. The double lotus throne became a symbol of the world being overcome by the Buddha who, after enlightenment, lived on in a state of supreme exaltation over the illusory world of earthly existence.

"Just as a blue lotus, or red lotus, or white lotus, born in the water and growing in the water, rises above the water and stands there unsullied by the water, so I too, being born in the world, having grown in the world, now that I have overcome the world live as one not sullied by the world." These words of the Buddha characterize the meaning of the lotus flower as a throne. We shall encounter it in almost nearly every work of art.

Plate 17 is an example of a typical Buddha in the complete, fully developed iconography of Mahâyâna. Here we see the Buddha upon a magnificently gilded lion throne. Śâkyamuni was the "lion from the tribe of the Śâkyas", the one who proclaimed the teachings in a mighty voice like the roar of the lion. He is surrounded by an aura shining all around his body, the attribute of all those enlightened. This painting by a Tibetan artist, masterly in its harmony and balance, perfectly fits the words of an old Buddhist Sûtra, the Itivuttaka:

"Because in the whole world he recognized the whole world such as it is, he is totally liberated from the whole world, incomparable in all worlds. The hero conquering everyone and everything is freed from all fetters, he owns that supreme peace which has attained Nirvâṇa to which no terrors attach. This is the Buddha, free from influences, free from grief, he that has shattered doubt; he has achieved the annihilation of all activity and achieved freedom through annihilation of all Karmic actions. He is the exalted Buddha, he is the incomparable lion; for the sake of world with its gods he has set the wheel of doctrine rolling... Among the conquerors he is the conqueror of self, the best of them; he, the becalmed, is the seer among those who give calm; he, the liberated, is the first among those bringing liberation..."

An essential element in later Buddhism, therefore, is the elevation of the Buddha to a high, godlike plane and the associated doctrine that Buddhas possess infinite omniscience and an unlimited span of life. In this capacity the Buddha is also described as the Tathâgata in northern Buddhism. He is no longer a historical figure but becomes the concept of Buddha nature in itself. He is the one "who has thus come and thus gone". The Tathâgata is the Buddha of the Mahâyâna Sûtras, the teacher of the doctrines of the voidness, the supreme revealer of the doctrine. Reference is sometimes made to the Buddhas of the three ages: those of the past, present and future. In other Sûtras the Tathâgata proclaims an infinite cosmos of universal dimensions, in whose ten regions of the world countless Buddhas emerge in order to teach the doctrine. In all these worlds, according to the Sûtras, the exalted Tathâgatas appear for only one purpose, as pro-

58

claimed, for instance, in the Saddharma-puṇḍarîka-sûtra, the Lotus of the Good Law:
"It is difficult to understand the secret language of a Tathâgata. And why? The doctrine was proclaimed by me with various explanations, illustrations, parables and interpretations, in hundreds of thousands of different ways. The good teaching of the Tathâgata must be understood as a teaching without logic, beyond the sphere of logic. And why? With a single intention, in order to carry out a single thing only, does the Tathâgata, a sage, a perfect Buddha, appear in this world. And what is this great goal? Redemption, and the raising of creatures to the comprehension of Tathâgata knowledge..."

What was the goal of Buddha's disciples, those who followed his teachings and took monastic vows? It was the attainment of wisdom at the highest level, the fourth step of the path which leads, without rebirth, directly to Nirvâṇa. Such a sage was known as an Arhat: "He tried hard, he strove and he struggled, and thus he realized that the cycle of birth and death with its five constituents is in continuous motion. He rejected all conditions of existence which stem from a multiplicity of ties which, in their nature, fall apart and crumble, change or are destroyed... When he became an Arhat he had cast off all his ties with the three-fold world. For him there was no longer any difference between gold and a lump of earth. The sky and the palm of his hand were one and the same to him. He had attained knowledge, the higher knowledge and the power of discriminating understanding." That was the old ideal of the Buddhist sage, the ideal which was replaced by a new one in the Mahâyâna, by the Bodhisattva ideal.

The Buddhist Arhats are indeed encountered again, later, in Tibet and in China, but by then they were venerated as supernatural beings and were favourite subjects of the Tibetan artists. In Tibet a group of sixteen or eighteen Arhats were known who, according to tradition, had been charged by the Buddha with watching over the survival of the sacred doctrine. That is why, it was said, they had prolonged their lives and resided in secret places of the earth, invisible to humans, in order to watch over the Good Law of Buddhist teaching. At some future date they would once more manifest themselves in the world as reincarnations, in order to spread the doctrine anew. Only then, having discharged this task, would they leave the world altogether and enter into Nirvâṇa. Later still, after many more millenia, the Buddha of the Future would arise—Maitreya, who is already revered by the followers of Mahâyâna as the Buddha-to-come.

The Bodhisattva

Two principles of Mahâyâna Buddhism became the main themes of its teachings. They were the doctrine of the voidness recognizable in all phenomena and the doctrine of the path of knowledge towards a universal compassion with the entire world of living creatures, a world which in its totality must be led to redemption.

From the three great doctrinal currents of Mahâyâna—the Mâdhyamika, the Yogâcâra and the Vijñânavâda schools—a far-reaching system of philosophy, mysticism and ritualism was developed. A variety of possible paths to knowledge, not previously envisaged by Buddhism, including even principles of religious faith, were now offered to the followers. This broadening of the foundations and of religious means enabled Mahâyâna progressively to gain ground among the people and to enjoy the support of a numerous lay following. There was now a greater appeal than in the past to emotional and devotional needs, and the rituals were invested with a deeper meaning by symbolic action. Now the life of each individual, including the lay follower, might lead to perfect enlightenment through observance of the appropriate rules and correct attitudes. But the dynamic central idea which was now being developed by Mahâyâna was the doctrine of the Bodhisattva, the enlightened being. It was a noble ideal of active deeds, and an ideal which believers henceforward tried to emulate. The shining Bodhisattva ideal soon occupied the centre of all sacred writings of Mahâyâna, so that the concept of a Bodhisattva vehicle (Skr.: Bodhisattvayâna) was coined. By developing this ideal, which became the nucleus of all great Sûtras, Mahâyâna acquired the great and dynamic force which made it a universal religion spreading right across Asia.

We shall look more closely at this important aspect and examine its character since it is the foundation of all subsequent developments. The Bodhisattvas are future Buddhas. They are beings who, by their own initiative and free will, resolve to work through a seemingly un-ending chain of rebirths for the deliverance from suffering of all creatures, until all living nature is redeemed. The concept of help for the entire surrounding world was entirely opposed to the Arhat ideal of Hînayâna. The Arhat, after all, strove to obtain redemption only for himself in order subsequently to live in tranquil seclusion from the affairs of the world.

A Bodhisattva can either be a human or a "heavenly being". In either case the Bodhisattva has made a vow that he will systematically practise the six virtues (Skr.: Pâramitâs) in order to attain the highest Buddhahood in the future. The Bodhisattva, moreover, is a being striving for enlightenment. But when he has attained enlightenment he does not enter into Nirvâṇa but declines this state without rebirth until all living creatures without exception have been liberated through his work. The numerous vows of Bodhisattvas, handed down to us in the writings, are exceedingly impressive.

In the Bodhicaryâvatâra, the most famous didactic poem of the Indian teacher Śântideva of the seventh century, the Bodhisattva says: "I must annihilate the pain of my neighbour because it is pain such as my own pain; I must serve my neighbours because they are living beings such as I am. ... All suffering without distinction is without master; because it is suffering it must be averted and no reservation is justified."

This is certainly no easy decision to make, considering its far-reaching implications. But enlightenment and correct knowledge also produce strength for action, and to the Bodhisattva strength is "energy to do good". Sântideva: "Inertia stems from indifference to the sufferings of existence." It is necessary to plumb the full depths of the decision which marks the new Bodhisattva ideal to appreciate the powerful effect which Mahâyâna achieved among the people. There is a classic text passage about the heroic decision of the Bodhisattva of the Vajradhvaja Sûtra which has kept its impressive force to this day:

"And I take upon me the burden of all suffering, I am resolved to bear it. I do not turn back, I do not flee... and I am not faint-hearted... because I must at all costs take upon me the burden of all creatures. This is not my free will. The redemption of all beings is my vow; all beings must be liberated by me. The whole world of living things must be redeemed by me. From the wilderness of birth, from the wilderness of old age, from the wilderness of sickness, from the wilderness of death, from the wilderness of all kinds of misfortune, from the wilderness of bad forms of existence, from the wilderness of the whole cycle of rebirths... must I deliver all beings. ... I work for the strengthening of the incomparable realm of knowledge for all beings. ...

And no being must be cheated by me of the root of good. I am resolved to live in every single bad form of existence for uncounted millions of aeons. And just as it is in one bad form of exis-

tence, so the reason for the deliverance of all beings is in all bad forms of existence in all parts of the world without exception."

The quoted passages show that the great task of a Bodhisattva can only be fulfilled from a sense of all-embracing compassion. The great compassion (Skr.: Mahâkaruṇâ) with the suffering world thus became the moving and guiding idea of Mahâyâna. And this idea was realized in the example and living symbol of the Bodhisattva. "There is one virtue to which the Bodhisattva should fully surrender and in which he should dissolve: then all Buddha virtues will of themselves be present. Which is this one virtue? It is great compassion." The heroic objective of the Bodhisattva became attractive to a great many people. Through certain vows they were able, even in their earthly life, to tread the path of the enlightened being in accordance with Buddhist rules. Naturally, such Bodhisattvas existed also in the remote regions of the divine heavens, as we are frequently told by the writings. From there they were able to intervene in earthly affairs as redemptive deities. We shall encounter such Bodhisattvas later; the best-known among them are Maitreya, Avalokiteśvara and Mañjuśrî.

The requisite rules for the decision to follow the path of a Bodhisattva are handed down to us in the Prâtimokṣa Sûtra. The would-be Bodhisattva chooses a spiritual teacher and a Bodhisattva in order to take his vow of ordination in their presence:

"Before thee, Bodhisattva, I take the vow to

strive for enlightment and I accept all the Bodhisattva rules, the moral rules, the rule of self-restraint, the rule to do good works and collect merit, and the rule to care for the well-being of living things. ... And having confessed my errors I take threefold refuge to elevate and redeem the countless beings, to protect them from the sufferings of rebirth, and to lead them to the highest knowledge of omniscience. ... And by producing the idea of enlightenment [Skr.: Bodhicitta] I move on to supreme perfect enlightenment so that, in the world which is without refuge, without resting place, destination or recreation, I may be the one that gives assuagement, a refuge, a resting place, a destination and recreation. So that I may lead those to Nirvâṇa who are without Nirvâṇa, and that I may comfort those who are without comfort."

These examples clearly reveal the weighty decisions and the moral foundations upon which the Bodhisattva ideal rests. In all, the path of the Bodhisattva covers ten steps of perfection which he must surmount in order to develop into a perfect celestial Bodhisattva. The first of his decisions, while still an ordinary human on earth, is that of accepting the rules. For a long time he will practise the lower steps of the virtues, until he has transformed himself to such an extent that he can ascend to the higher steps.

The indispensable basis of a Bodhisattva's ethical attitude are the virtues of the six perfections (Skr.: Pâramitâs), which must govern his actions. These virtues are generosity (Skr.: Dâna), morality (Skr.: Śîla), patience (Skr.: Kṣânti), energy (Skr.: Vîrya), meditation (Skr.: Dhyâna) and wisdom (Skr.: Prajñâ). Only as a result of the continuous practice of these six Pâramitâs does the Bodhisattva attain the highest perfection, the perfection of wisdom (Skr.: Prajñâpâramitâ). This is what the famous Lankâvatâra Sûtra has to say about the practice of these six virtues:

"The Pâramitâs are ideals of spiritual perfection, designed to guide the Bodhisattvas along the path of self-realization. There are six of them, but they are viewed in a three-fold way, in accordance with the Bodhisattva's progress up the different steps. First of all, they are to be seen as ideals for worldly life, then as ideals for the emotional life, and finally as ideals for the spiritual and unified life."

Avalokiteśvara, the all-merciful Bodhisattva of compassion

The practice of all these virtues then leads the Bodhisattva along the path of the ten steps of spiritual purification and perfection. However, we shall content ourselves with these general observations on the Bodhisattva's nature in order to turn our attention to one of the most important forms of Bodhisattvas, one that in Tibet has been the subject of countless examples of artistic inspiration. The most popular Bodhisattva and the one most venerated in innumerable writings of all Buddhist schools is Lokeśvara, the Lord of the Worlds, or Avalokiteśvara, "the Lord

Fig. 7. Tibetan block-print for prayer banners (Tib.: rLung-rta) with Mantras and sacred symbols of Buddhist doctrine (printed in Bumthang).

18 Gilded bronze of the Buddha Śâkyamuni, clearly showing the gesture of earth-touching (Skr.: Bhûmisparśamudrâ): his right hand calling on the earth in witness of his enlightenment against Mâra. His left hand rests in his lap in the Dhyâna-mudrâ. The closely fitting monk's habit with the treble-folded cloth over his left shoulder and the tall stature combine to lend beautiful proportions to this fifteenth century bronze.

19 The Bodhisattva Maitreya is one of the group of eight great Bodhisattvas (Skr.: Mahâbodhisattvas). He is seated here in the Vîrâsana posture while his hands, in the Dharma-cakramudrâ, hold a Nâgakeśara blossom upon which a golden bottle (Tib.: sPyi-blugs) is balanced. This is the typical iconographic symbol of Maitreya. It is this Bodhisattva who, as the scriptures claim, resides in the Tuṣita heaven, waiting for the time when he can appear on earth as a Buddha-to-come. When he descends from the Tuṣita heaven he is called the Maitreya Buddha, the "All-Benign".

20 This early bronze of the Bodhisattva Lokeśvara as the lotus bearer (Skr.: Padmapâṇi) from the Kashmiri school of the ninth century shows the old Indian-style iconography. Here Padmapâṇi still holds the whole lotus flower with the long stalk in his left hand. Over his left shoulder lies the gazelle skin, and among his hair ornaments we can make out the Buddha Amitâbha as whose emanation Lokeśvara, the lord

of the worlds, has come into being. This bronze from Gu-ge reflects the influx of artists from Kashmir who came to the west Tibetan kingdom from the early tenth century onwards in order to work on the monasteries then being built. Such pictures from Kashmir soon became models for west Tibetan art, which had its full flowering from the tenth to the twelfth centuries.

21 In this three-headed and eight-armed deity we recognize the goddess Uṣṇîṣavijayâ, an emanation of the first Dhyâni-buddha Vairocana. The goddess possesses various symbols which are lacking here; they are, in her right hands, the Viśva-vajra, a Buddha on a lotus, and an arrow; in her left hands she usually holds a bow, a noose and a vessel with water. This late seventeenth century bronze still echoes the stylistic elements of west Tibetan art which reached its last peak in the art of Tsaparang between the fifteenth and seventeenth centuries.

22 Tibetan bronze of the Arhat Nâgasena (Tib.: kLu'i-sde), one of the sixteen Buddhist sages. Originally he held a bottle in his right hand and in his left the mendicant's staff (Skr.: Kakkara) carried by monks. He is seated, legs crossed, on a double cushion with a blanket overlay. The bronze, with exceedingly sensitive and meditative facial expression, shows remnants of ancient gilding in the folds of the garment. Circa sixteenth century.

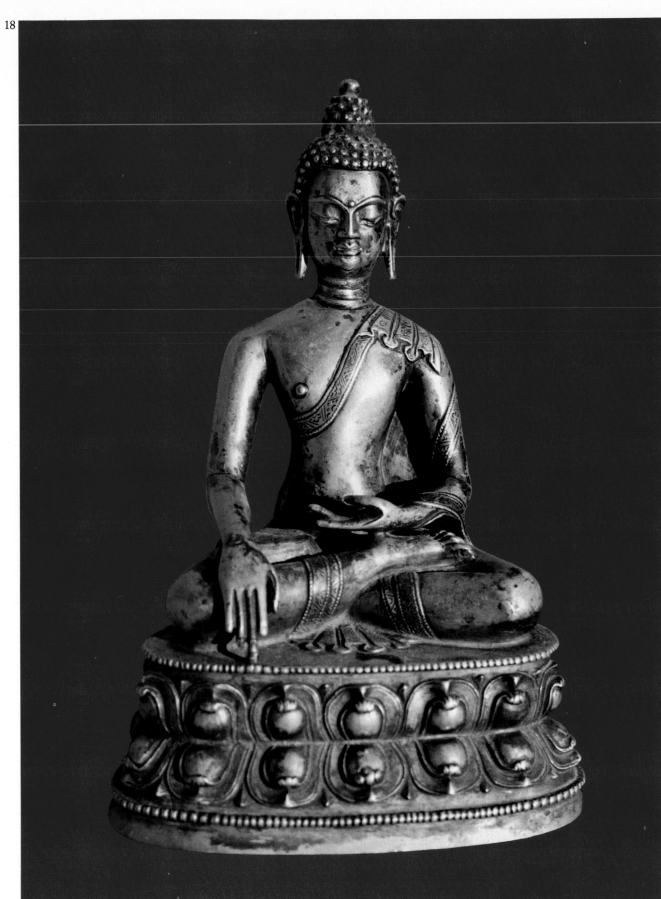

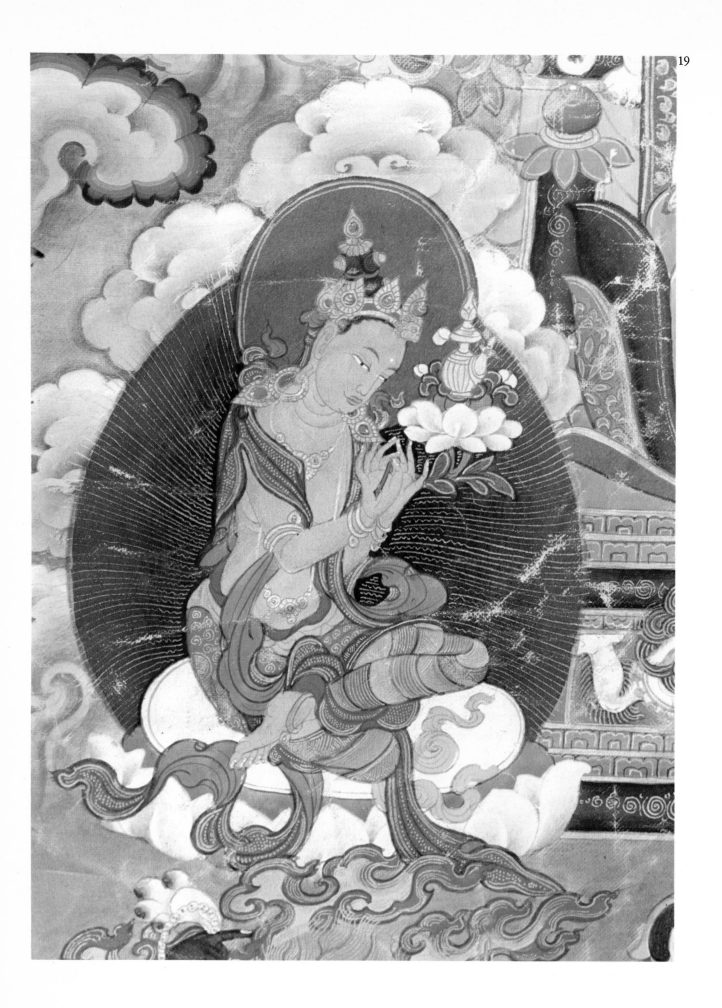

20

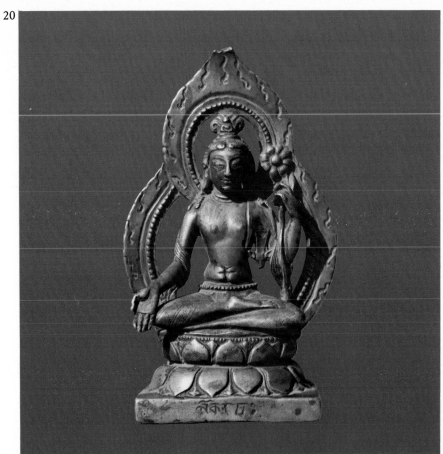

21

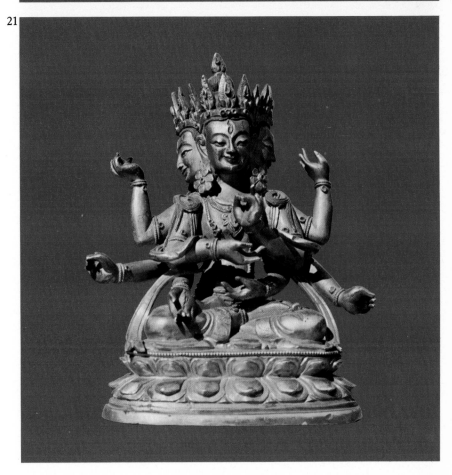

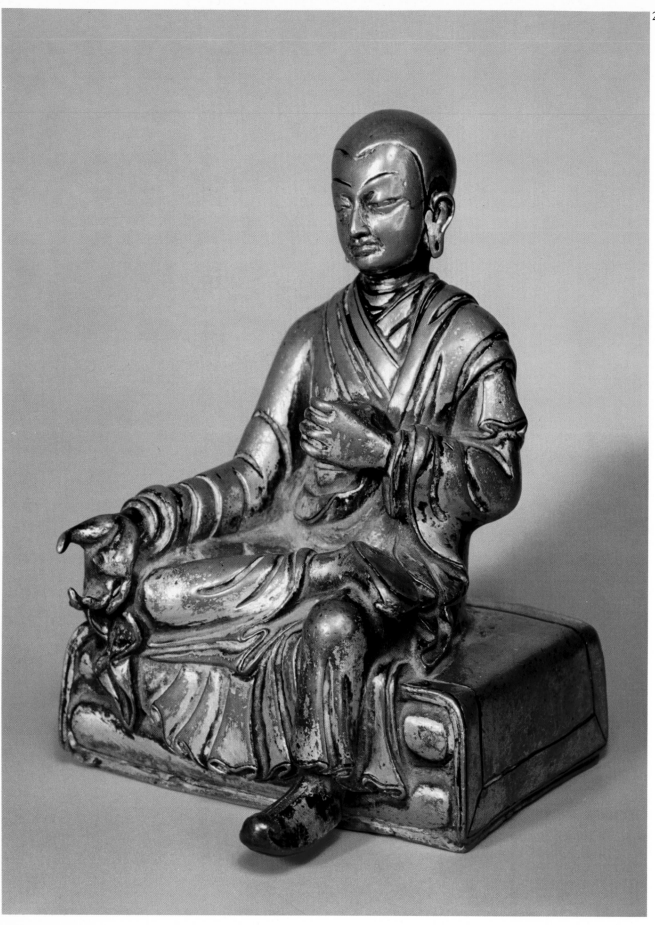

looking down". In all movements of Asian Mahâ-yâna Buddhism he became the most impressive symbol of the great virtue of compassion and goodness, as discussed on the preceding pages. To enable the reader to familiarize himself with Avalokiteśvara and his many forms of manifestation we reproduce here the four most important forms, the ones enjoying greatest popularity in Tibet.

Avalokiteśvara is regarded as an emanation of the Buddha Amitâbha. Amitâbha, the Buddha of Infinite Radiance, in his realm of the Western Paradise (Skr.: Sukhâvatî), after deep meditation caused the Bodhisattva Avalokiteśvara to emerge from a ray of white light which he let shine upon the earth from his right eye. Thereupon Amitâbha gave him the blessed task of working for the good of all living creatures. On this occasion Avalokiteśvara is reported to have uttered for the first time the famous Mantra *Om ma ni pad me hûm*. According to tradition Avalokiteśvara thus became the most important Bodhisattva created by the Buddha Amitâbha. In his crown or in his hair ornament above his forehead he traditionally wears the picture of his spiritual ancestor Amitâbha. The second symbol characterizing him is a lotus flower which he carries in his left hand (Plate 20).

In his two-armed form he is also frequently known as Padmapâni, the lotus-bearer. Avalokiteśvara is the Bodhisattva of the age between the historical Buddha Gautama and the Buddha of the Future, Maitreya. His emergence as a helper on the path to redemption thus acquired excep-tional importance for the development and spread of the Mahâyâna teachings. He was the first of the Bodhisattvas or enlightened beings voluntarily to renounce eventual entry into Nirvâna with a solemn vow to work for the redemption of all living creatures, to lead them to the path of enlightenment so that they should be delivered from the cycle of rebirths.

In the fulfillment of his vows the great Bodhisattva even went to the length of being ready to manifest himself in all conceivable forms in order to act as a helper in the six realms of the world of suffering. Indian believers sought refuge with the compassionate Lord of the Worlds (Skr.: Lokeśvara); in Tibet he was called the Protector of the World (Tib.: 'Jig-rten mgon-po). The formula *Om ma ni pad me hûm*, dedicated to Avalokiteśvara, has surely become the most famous incantation of Mahâyâna Budhism; it has been written and spoken a million times, it is made to spin in Tibetan prayer-wheels, it is chiselled into countless Mani stones piled up into heaps or prayer-walls along the pilgrimage routes in the Himalayas and in Tibet. There is not nearly enough space to list the great Bodhisattva's many names which pious men have compiled for him in their writings over the centuries. But we will quote a few of them because they illustrate his different aspects:

the Noble Ruler of the World,
the Protector of the World,
the Patron of the Land of Snows (Tibet),
the Noble King of Heaven,

69

the Mantra King with the Six-syllable Voice,
he with the Water-born Lotus in his Hand,
the All-Merciful Deity of Compassion,
Avalokiteśvara, the Light of Beings,
he that Guides the Beings of the Three Spheres,
Avalokiteśvara who Liberates from Suffering,
the Glorious Perfecter of Karma,
the Lord of the Path of Maturing and Libera-
 tion,
Sambhogakâya Avalokiteśvara to be seen in
 Reality,
Avalokiteśvara, the Great Treasure of Infinite
 Compassion.

However, Avalokiteśvara is known in Buddhist iconography also in other forms. From the two-armed form the doctrines of Mahâyâna and the Tantras soon developed others with four, six, eight, ten, sixteen, eighteen, twenty-four, forty-six, one hundred and eight and even one thousand arms; with three, four, six or eleven heads. Altogether the writings speak of the one hundred and eight forms of the Bodhisattva Avalokiteśvara. Many of these forms have been handed down to us in the Sâdhanas, the descriptive incantations to the Buddhas, Bodhisattvas and deities.

Another manuscript from the first period of the spread of the Buddhist teaching in Tibet, the Maṇi bKa'-'bum, can be described as virtually a collection of meditations on the Bodhisattva Avalokiteśvara. From this invaluable source on the origin and nature of Avalokiteśvara we quote the description of a vision of the four-armed Lord of All-Embracing Goodness (Tib.: Thugs-rje chen-po) together with the meditational instruction given there: "When one meditates upon the syllable Hrîḥ, standing on a sun-disc in one's own heart, the four-armed Avalokiteśvara appears. He is brilliant white with one face and four arms. His first pair of hands is held folded over his heart [Skr.: Añjalimudrâ], his second right hand holds the rosary with one hundred and eight pearls, and the second left hand a white eight-petalled lotus flower. Thus seated upon a lotus moon throne in meditative attitude [Skr.: Vajraparyaṅka] he gazes with benign eyes upon the six classes of beings."

The representations on the Tibetan Thang-kas and also the beautiful bronze in Plate 23 usually follow this description. The bronzes, however, were not painted in the iconographic manner. The full range of colours is found only in the paintings, or on sculptures in stucco, wood or clay. The four-armed Avalokiteśvara (Skr.: Ṣaḍakṣarî-Avalokiteśvara) was venerated in Lamaism as the guardian deity of Tibet, the more so since the Dalai Lamas were regarded as incarnations of Avalokiteśvara.

Let us now examine the two beautiful representations of Avalokiteśvara in Plates 24 and 25. The Tibetan Thang-ka (Plate 24) shows the eleven-headed Avalokiteśvara with eight arms in brilliantly coloured raiments and within a double gleaming golden halo on a blue ground. The large statue from a Lamaist monastery (Plate 25) represents the same Bodhisattva in his thousand-armed form. Since, except for the thousand

arms, the two iconographies are identical in their forms and symbols, they can be described here jointly. The multiple heads and multiple arms of these Bodhisattvas are the greatest possible pictorial multiplication of the Mahâyâna ideal of the great compassion at work in all six worlds. These "all-sided" forms, as it were, see the suffering in all spheres of the world simultaneously and can similarly extend helping hands in a thousand directions in symbolic intervention.

The origin of the eleven-headed form of Avalokiteśvara is explained in the following legend. Lokeśvara descended into the realms of hell and there brought the doctrine to the suffering, liberating them from their pain in order to guide them into the Western Paradise of the Buddha Amitâbha. But no matter how many creatures he succeeded in liberating, their place was invariably taken by the same number of other sufferers. Faced with this unending suffering he was seized by great despair and his head burst asunder into ten parts. But the Buddha Amitâbha fortified his courage, made the head of the Great Compassionate whole again by shaping the parts into ten heads and moreover added his own head as an eleventh so that Avalokiteśvara, his spiritual son, should now have eleven heads to contemplate all ways of helping others.

This and many other complex representations are typical of tantric Buddhism and are therefore a frequent aspect of Lamaist art. It should be remembered that all these Bodhisattvas and divine figures which we shall encounter on the next few pages are not gods or deities in the proper meaning of the word, but emanations from the void of the individual's own spirit which forms the primal ground of the world of phenomena and the spirit. Many of them must be seen as pictorial symbols of Buddhist virtues and of their attributes arising from certain doctrines; their prescribed forms are to promote the meditational process and its deeper content. That is also why, at the beginning of the following text from the Maṇi bKa'-'bum, we find the observation, as in so many writings, that all vision springs from the moment of the original void. From this void there unfold, first of all, the germinal syllables *A* and then *Hrîḥ*. This emits a white light whose rays cleanse all beings of vice and impurity. When the world has thus been symbolically blessed and purified, "the Bodhisattva Avalokiteśvara appears, in moon-white colour like the body of a young man. He has eleven heads, the central principal face being purely white, the right face green and the left face red; then follow, above, three faces, the middle of which is green, the one on the right is red and the one on the left is white; of the three further faces [above] the middle one is red, the one on the right white and the one on the left is green. All nine heads together are of peaceful character. With the benignly smiling eyes of his divine spirit he looks down upon all beings with infinite compassion. Then follows [above] a wrathful face with three ferocious eyes and reddish-yellow hair. Above is Amitâbha with a red and entirely peaceful face. The first pair of hands [of the Bodhisattva] is folded over his heart in

Añjalimudrâ, the second right hand holds the rosary, the third right hand shows the Mudrâ of wish-granting [Skr.: Varada] in order to dispense nectar to the Yi-dvags [the hungry spirits] to quench their thirst, and the fourth right hand holds the Wheel of the Doctrine [Skr.: Dharmacakra]; the second left hand holds an eight-petaled lotus flower by the stem, the third left hand holds a golden bottle, and the fourth left hand holds a bow and arrow. The other 992 arms—opening out like a lotus flower—show the Varadamudrâ, and in the middle of each hand is one eye. The Bodhisattva is clothed in a fine cotton garment and wears a crown of precious stones, jewels round his neck, on his arms and feet, and a brilliant white light emanates from him."

With this detailed account of meditation we can now leave the manifestations of Avalokiteśvara. We shall, however, come back to this important figure of the Buddhist pantheon in the chapter on "Visionary unfolding in the Maṇḍala" in connection with the doctrine of the six worlds of incarnation.

Mañjuśrî, the embodiment of wisdom

A chapter on Bodhisattvas would not be complete without Mañjuśrî, for he, too, is one of the most important figures of Mahâyâna. He is the living symbol of knowledge and wisdom, the indispensable virtues on the Mahâyâna path of perfection.

The Noble Mañjuśrî is invoked in Tibetan monasteries each morning: he is asked to grant to the monks the power of knowledge, of memory, of superior intelligence and, last but not least, of great oratory for their studies of the sacred doctrine and their spiritual progress. The text of these incantations, the Ârya-mañjuśrî-nâma-saṅgîti, is so important that it is one of the first which every monk has to learn to recite by heart. Mañjuśrî or Mañjughoṣa (Tib.: 'Jam-dpal-dbyangs), the "Bodhisattva with the Melodious Voice", is also known in several forms of manifestation. As Nâmasaṅgîti-Mañjuśrî, according to the text mentioned above, he is an emanation of the Buddha Akṣobhya whose picture, in iconographic representations, he usually wears in his hair toupet. The best-known Mantra of the Ârya-Mañjuśrî runs: *Oṃ a ra pa ca na dhî*. In his very common form of Arapacana-Mañjuśrî he is seated on a lotus moon throne in the Vajra-paryaṅka attitude; he is of white colour and wears the jewels of a Bodhisattva. In his right hand he holds the blue flaming sword of discriminating knowledge and in his left he carries the book of perfect wisdom, the Prajñâpâramitâ. The sacred five-peak mountain Wu-t'ai-shan (Tib.: Ri-bo rtse-lnga) in western China is regarded as his secret residence. From there, according to the Svayambhû-Purâṇa, Mañjuśrî once set out for Nepal in order to venerate the Âdibuddha who had manifested himself in the form of a blue flame above a lotus flower in a great lake. Svayambhûkṣetra, the sacred place of the Âdibuddha in the middle of the lake, howev-

72

er, was a spot that the followers could not reach. Mañjuśrî therefore cut a deep gash with his sword into the rocky barrier at the southern end of the lake, whereupon the waters of the Bâghmatî River drained away. Mañjuśrî and his followers thereupon reached the miraculous lotus flower and built a sacred shrine over the blue self-generated flame of the Âdibuddha. This legend describes the origin of the Katmandu valley which, prior to the appearance of Mañjuśrî, is believed to have been totally submerged.

The Bodhisattva of wisdom was venerated by all movements of Tibetan Buddhism. Various Grand Lamas were regarded as incarnations of Mañjuśrî and, since the eleventh century and the time of Abbot Sa-chen kun-dga' snying-po, the Sa-skya-pa sect has handed down a special doctrine which is still particularly sacred to the sect as revelations of the Bodhisattva Mañjuśrî (Tib.: Zhen-pa zhi-bral).

—

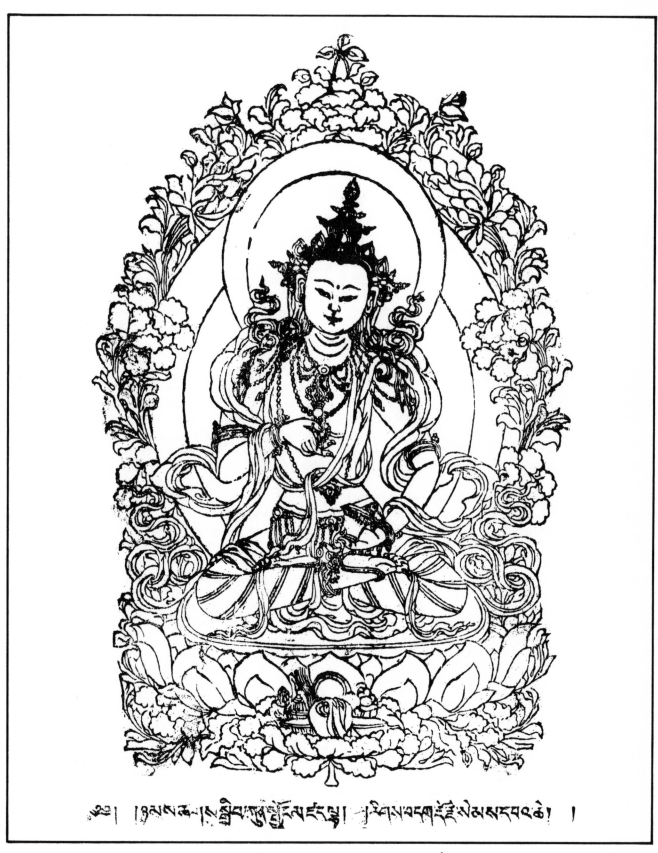

ༀ། །རྒྱལ་ཀུན་ཁྱབ་བདག་རྡོར་སེམས་དང་། །རིག་འཛིན་རྗེ་བཙུན་མར་པ་ལ། །

Fig. 8. Tibetan block-print of the white Buddha Vajrasattva, the active form of the Âdibuddha in the realm of Sambhogakâya.

23 Lamaist bronze of Saḍakṣarî-Avalokiteśvara (Tib.: sPyan-ras-gzigs phyag-bzhi-pa), circa fifteenth century. This form of the Bodhisattva with four arms was venerated in Tibet as the guardian deity of the Land of Snows (Tib.: Gangs-can mgon-po) and was probably Tibet's most important deity. The Dalai Lamas and other great lamas were regarded as incarnations of Avalokiteśvara. His first pair of hands is folded in the Añjalimudrâ, in his second right hand he is holding the rosary (missing) with 108 pearls and in his left the eight-petalled lotus flower (missing). A striking feature of this bronze is the magnificently worked Bodhisattva crown. At its top point we can make out the small icon of the Buddha Amitâbha, indicating the Bodhisattva's descent from the lotus family of Amitâbha. The face of the statue is painted with gold colour and his hair is the intense blue of the peaceful deities. This bronze strikingly reveals Indian stylistic influences introduced into southern Tibet by Nepalese artists.

24 South Tibetan painting of the eleven-headed and eight-armed Bodhisattva Avalokiteśvara (Tib.: Thugs-rje chen-po bcu-gcig zhal). It displays all the symbols and the complete colour pattern of Buddhist iconography, as prescribed for the great all-compassionate Bodhisattva in the meditational texts (see pages 70–71). Avalokiteśvara together with the Bodhisattva Mañjuśrî (bottom left) and the blue wrathful guardian deity Vajrapâṇi forms a trinity popular in Tibet; they are venerated as the three guardians of the Buddhist doctrines (Tib.: Rigs-gsum mgon-po). At the top on the left is Sitatârâ and on the

right the blue Buddha of medicine (Tib.: sMan-bla) with a healing plant in his right hand. Eighteenth century.

25 Large Tibetan sculpture from a temple in the western Himalayas. This is the thousand-armed form of Avalokiteś-vara (Tib.: sPyan-ras-gzigs phyag-stong spyan-stong). It is executed in the stucco technique much favoured for large-size sculpture. The stucco permits a soft modelling of all details which are then painted and gilded. In this iconography the Mahâ-yâna reached its peak of multiple statement and creativity. Each of the one thousand hands shows the eye of compassion with which Avalokiteśvara looks down on the world of suffering. The arms are subdivided into groups of eight, forty and nine hundred fifty-two; this division into three, according to the Trikâya doctrine, corresponds to the three manifestations of Avalokiteśvara in the Dharmakâya, Sambhogakâya and Nirmâṇakâya. Sixteenth century, at dGe-smur, Lahul.

26 Bronze of Mañjuśrî (Tib.: 'Jam-pa'i-dbyangs), the Bodhi-sattva of wisdom in the iconographic form of Mañjuvara. His hands, in the Dharmacakramudrâ, hold the stems of lotus flowers crowned with the sword of insight and the book of Prajñâpâramitâ. This sixteenth century bronze, whose narrow appealing eyes are inlaid with silver, comes from southern Tibet. But it clearly betrays the influence of Nepalese models, and echoes of Chinese elements can be observed in the shaping of the shawl round the shoulders and the rich brocade ornament of the garment.

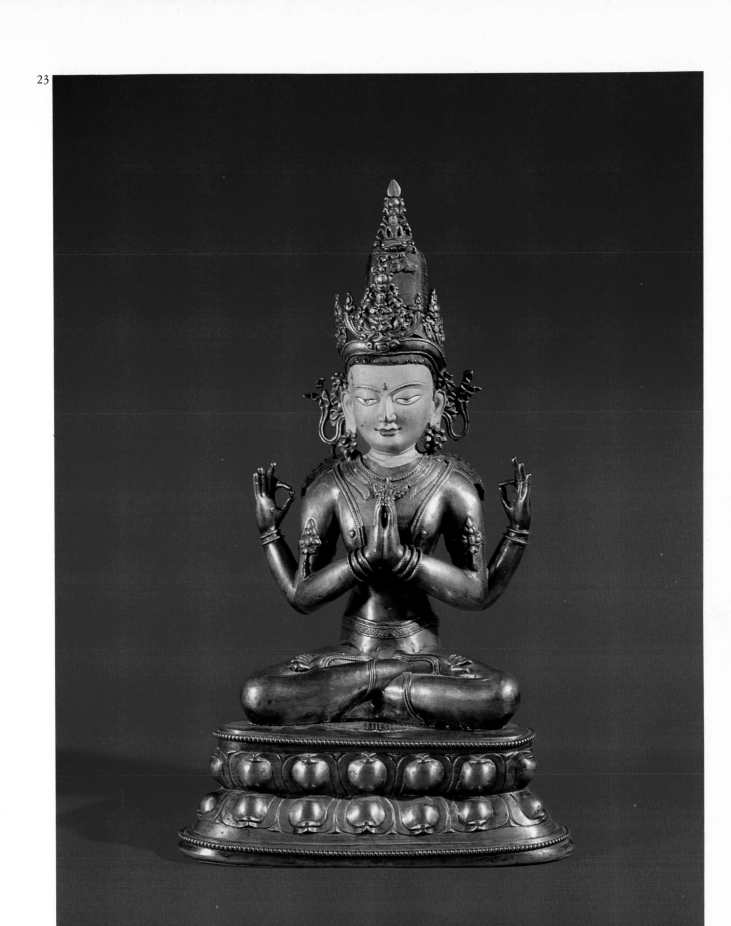

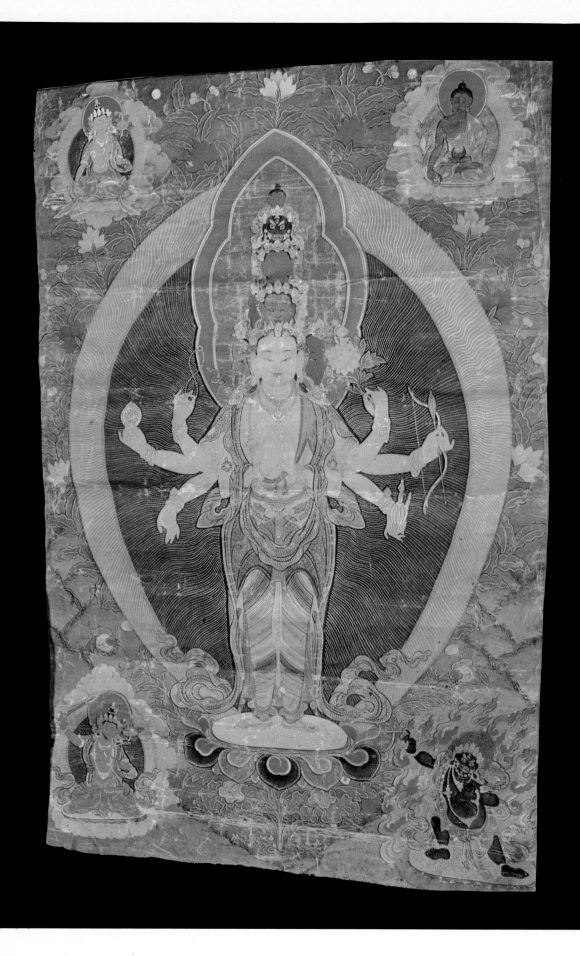

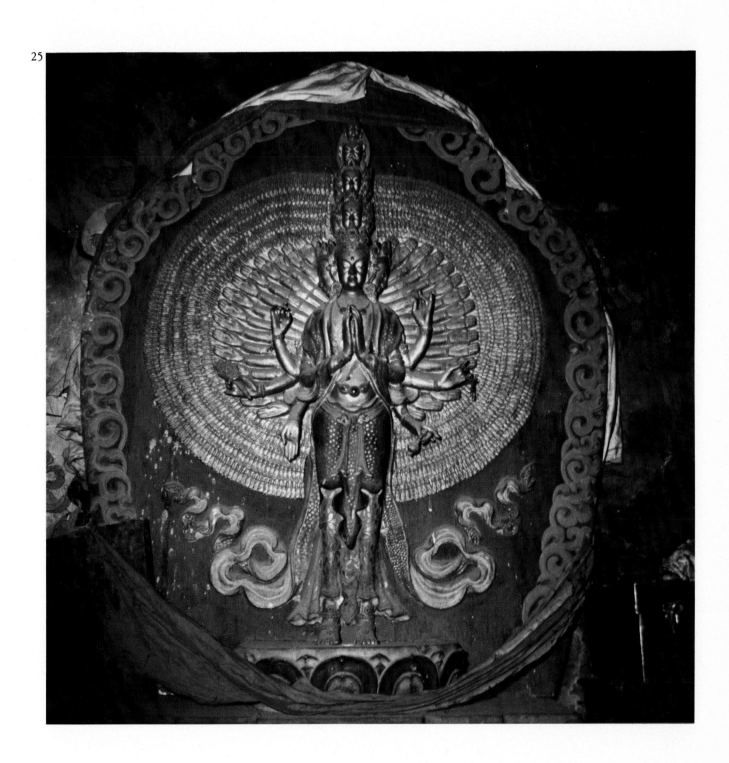

25

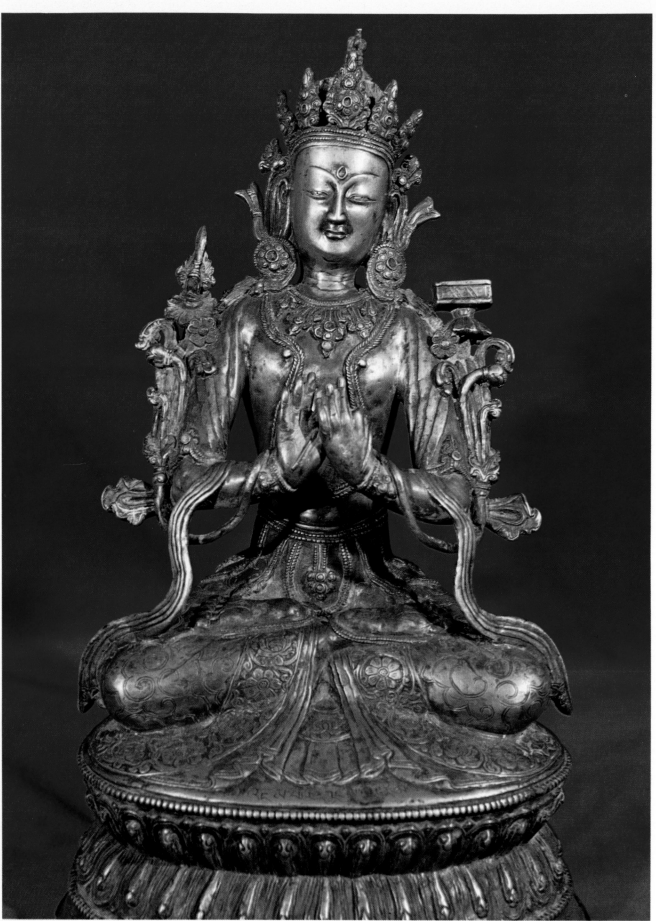

The Noble Art of Writing

The artistic endeavours of Lamaism were not confined to painting and sculpture but were applied in an equally generous measure to the art of writing which was highly developed in Tibet. Even a quick glance into the extensive monastery libraries convinces us that their collections of writings represent an entirely unique treasure. Judged by its very low population total, Tibet was a country exceedingly rich in books. Owing to the lively cultural contacts along the ancient caravan routes between Tibet, China and Mongolia, we frequently find the use of several languages and scripts, especially in documents, letters, charters and government decrees. Religious books were treated with particular care and, being regarded as precious objects, were stored on airy shelves mounted as high as possible above the ground: that is why many libraries were installed on the upper floors of monasteries or above the temple galleries. The shelves consisted of roughly square or rectangular partitions in which the writings, bound between strong wooden boards, were stored.

Books consisted of long narrow sheets, written or printed on both sides. They were loosely laid one upon the other, i.e. without a bound spine, and were wrapped in silk or other material. The book covers, sometimes elaborately carved and at other times painted, were then tied together with a ribbon. Before examining scripts and writing we should briefly consider their historical origins.

Until the seventh century Tibet did not have a script of its own. With the arrival of Buddhism and its promotion by the first Buddhist king Srong-btsan sgam-po more and more sacred writings were brought to Tibet across the Himalayas by Indian scholars. They were mostly written in the ancient Indian Sanskrit language. For them to be translated into the local language a script had to be created which was suited to expressing all the difficult forms of Buddhist Sanskrit in the Tibetan language. Several Tibetan historical works deal with the introduction of the script. One such account has been left us by the historians 'Gos-lo-tsâ-ba and Bu-ston. We once more quote an abridged excerpt from the Maṇi bka'-'-bum, describing the historic decision of the Tibetan king:

"King Srong-btsan sgam-po then reflected that although the teaching of the Buddha had already been introduced into Tibet, there was still no writing in his land. Having chosen among his faithful those of acute mind, he supplied the most greatly advanced in knowledge, to wit Thon-mi Sambhoṭa, the son of Anu, and a further sixteen companions, with gold and sent them to India so that they would learn the doctrine and the script. When Thon-mi arrived in India he was instructed by the most learned of the paṇḍits, Devavidyâsiṃha, in the doctrine and the writing of metric grammar, poetry and dictionaries; and having learnt all these things thoroughly and by heart, having progressed in them to the point of expert knowledge, he returned to Tibet in order to develop the Tibetan book-script [Tib.: dBu-can] from the Lantsha script, and the cursive script [Tib.: dBu-med] from the

Baṭula script. From the fifty Indian letters he created the thirty Tibetan letters."

He did all this in the Maru Temple in Lhasa, where he also compiled eight different grammars which have since served as the foundation of Tibetan literary work.

The major part of the writings handed down to us from ancient Tibet belong to the sphere of religious literature. But the vast store rooms also contained historical writings, popular epics, poems, treaties, letters, legal and political documents and administrative deeds of all kinds. The striking feature of all Tibetan writings is their careful and decorative calligraphy. Good manuscripts had to be written accurately, in straight lines and in perfect harmony. Countless books time and again testify to the good taste and entrancing clarity with which all writing was practised.

The oldest books were manuscripts, but after the fourteenth century block-books increasingly came into use and eventually accounted for entire libraries. In block-printing the writing of each whole page was carved in negative on to wooden plates. These were then inked and the paper pressed against them with a roller. Vast stores were needed for keeping the massive wooden printing blocks; they were heavy, usually rather long and required a lot of space. One block for the collection of canonic writings generally measured 25 cm (10 in.) in width and 75 cm (30 in.) in length. The storage of a single book of this kind thus required space for 400 or more wooden plates of the above dimensions.

The block-printed copies were regarded as particularly reliable and authoritative editions since they were only printed after correction and approval by the abbot of a monastery.

Tibetan manuscripts were written on very resistant fibrous paper; old sheets are strong and almost as leathery as parchment. Very ancient manuscripts of Sûtras and Mantras or Dhâraṇîs were also written on birch-bark (Plate 35). These bark-sheets, which are often wafer-thin, were obtained from certain species of birch occurring in the Himalayan countries and Tibet. From these trees wide strips of thin bark can be peeled effortlessly, and this flat white surface is very suitable for writing on with brush or reed pen. The pens used were thin bamboo canes whose points could be trimmed whenever necessary. When paper was used, the sheets, which like all Tibetan books preserved the narrow ancient Indian palm-leaf format, were often primed with a colour which then made it possible to write on them in gold, silver, white, red or black. Most of these sheets were primed black or indigo. Against this dark background the fine lettering in gold or silver clearly stands out, producing magnificent manuscripts. Whenever uncoloured Tibetan fibrous paper is used, the writing is usually in black ink or Chinese ink, while the title or important text passages are often made to stand out in red ink. This is what we find in the manuscript of the Prajñâpâramitâ (Plate 33), one of the fundamental works of Mahâyâna and regarded in Tibet as one of the most sacred books.

82

The Tibetan script is written from left to right. Each sheet is covered with writing on both sides. On the recto side of each sheet and to the left, set against the text, one finds the page number and a note giving the abbreviated book title or some other identification. The text of each manuscript page is usually enclosed in a black frame, rather like a printer's chase. The great canonical sciptures of Tibetan Buddhism are the multi-volume collections of the Kanjur (Tib.: bKa'-'gyur) and Tanjur (Tib.: bsTan-'gyur). Such writings are in the Tibetan capital script and for the most part are block-books.

The other major script is the minuscule script or cursive hand (Tib.: dBu-med), which was in daily use for letters, documents, etc. An elaborate form of it, in appearance not unlike our gothic block-letter, was frequently used for religious texts. This is the script still employed for Buddhist books nowadays. Its employment of greatly condensed forms makes possible the contraction of entire words and phrases so that extensive texts and repetitive phrases can be written almost like shorthand. In addition to these two forms there are also several variants of the 'Brutsha script and the exceedingly decorative 'Bamyig script which was a favourite style for ceremonial charters, decrees and monumental decoration. The ornamental Lantsha writing, however, was used for the decoration of architectural elements (Plate 37) even more than the 'Bam-yig script. In particular, the friezes around the architraves along the internal faces and along the galleries, and externally under the eaves were frequently adorned in Lantsha script in red, gold, white or other colours.

Block-books were always in capital script. The first internal titles and initial pages, as well as the final page of a book, were frequently decorated with miniatures or with printed vignettes of Buddhas, saints and deities of the Tibetan religion. Such miniatures are first encountered in ninth and tenth century manuscripts found in Tibetan monasteries, whereas others from this age, preserved in India and Nepal, are in the decorative Lantsha script. These miniature book illustrations provide valuable information on stylistic developments in Tibetan art, especially during the early period from which only a few Lamaist paintings have survived in Tibet.

Many of these small vignettes in Tibetan books are minor works of art in their own right. Particularly fine illustrations are found in the Vaidûrya dkar-po, a comprehensive work of Tibetan astrology written in 1683 by the Tibetan Regent Sangs-rgyas rgya-mtsho. The titles of Tibetan books are frequently arranged in three lines. The first line contains the title in Sanskrit in the decorative Lantsha writing, a refined variant of the Indian Devanâgarî script. The second line is a phonetic transcription of the Sanskrit title in Tibetan writing, and the third line is the Tibetan translation, the title proper in the Tibetan language. The particular value of these block-books is further enhanced by ornaments of intertwining foliage and dragon motifs. The book also contains extensive tables, symbols and diagrams designed to illustrate the complicated teachings

of Tibetan astrology. The diagrams confirm the relations and constellations of the eight astrological houses, which are known also from Indian astrology.

The folios kept in many monastery libraries were arranged and collected according to definite systems. A key work was the Kanjur, the canonic collection of Sûtras, Tantras, and the most sacred scriptures of Buddhism. It consisted of 108 large-size volumes of about 400 leaves each. Each of these volumes weighed several kilograms. The printing blocks for these gigantic volumes were kept in Tibet's famous monastery printing shops at Derge, Cone, Kumbum, Labrang, Narthang and Lithang. Of the same order of magnitude was the Tanjur, a collection of translations of various Buddhist commentarial texts, in 225 volumes. The most precious items, however, were the manuscript editions of the Kanjur, written in gold on black paper, such as the one prepared at the behest of the great translator bSod-nam rgyal-mtshan in southern Tibet in the fifteenth century.

In addition to these two categories of books many ancient monasteries also possessed extensive collections of indigenous Tibetan literature: the writings of abbots and teachers of the spiritual line, historical works, commentaries, religious poetry, astrology, iconography and books on Tibetan medicine. Charles Bell, in an account of the libraries at the sTag-lung monastery, says that the volumes were piled up in several rows, one behind another, each of them over 26 feet high; he estimated their number at 10,000 to 12,000 volumes. Much of the same collection was held by many other libraries: at Derge, Lhasa, in the ancient monasteries of Reting, Saskya and elsewhere.

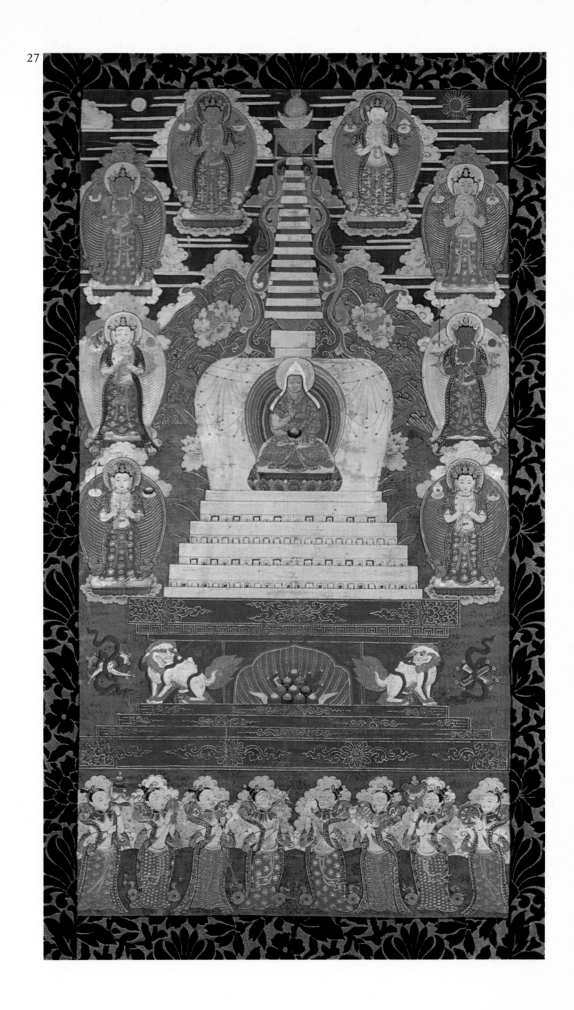

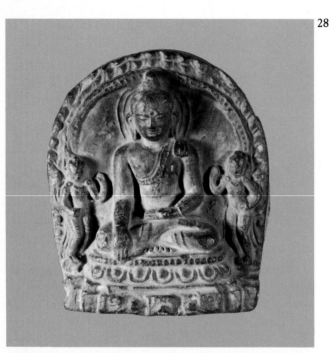

28

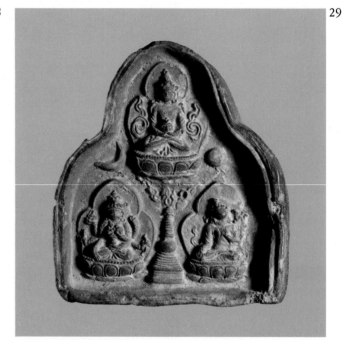

29

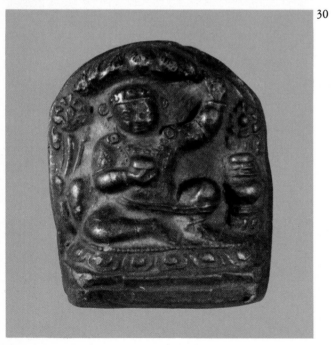

30

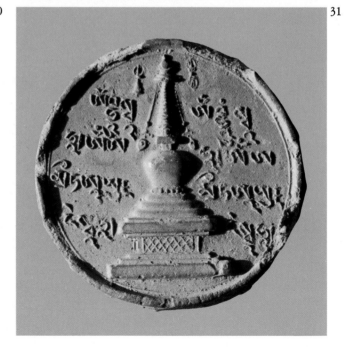

31

32

33

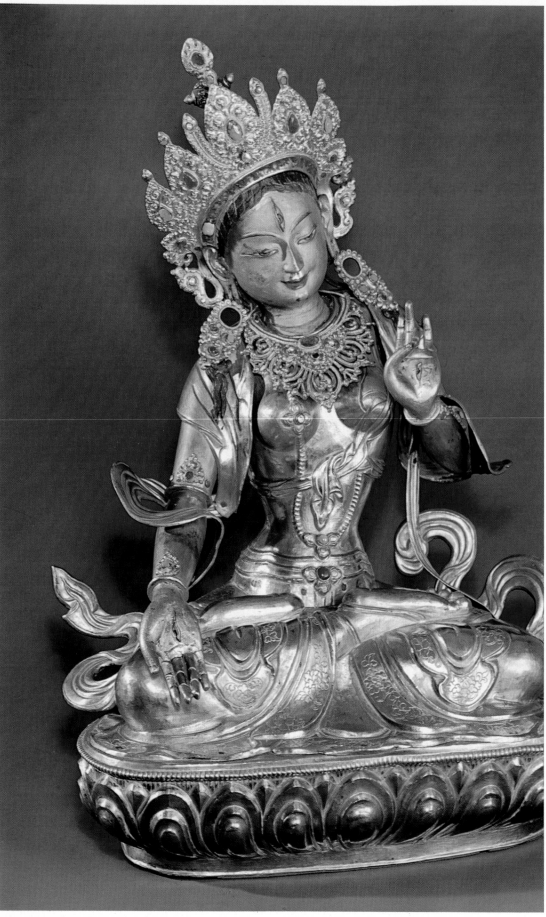

27 Lamaist painting with a central representation of a large Stûpa (Tib.: mChod-rten) and the eight Mahâbodhisattvas. The Stûpa, a symbolic structure and depository of the ashes of important lamas and Lamaist saints, shows, at the centre, the picture of a lama of the dGe-lugs-pa sect. The eight Mahâbodhisattvas are Avalokiteśvara, Maitreya, Mañjuśrî, Vajrapâṇi, Samantabhadra, Âkâśagarbha, Kśitigarbha and Sarvanivaraṇaviṣkambhin. In the lower part of the picture are the eight sacred symbols (Tib.: bKra-shis rtags-brgyad) as goddesses—reading from left to right: victory sign, fish, vessel of water of life, lotus, conch-shell, eight-fold knot, umbrella of dignity, and wheel of doctrine. The painting contains many elements and features of Lamaist art in Mongolia. Eighteenth century.

28–31 The Tsha-Tsha are small clay mouldings, pressed or cast from clay or loam, sometimes with the addition of the ashes of saints. These clay miniatures frequently reveal an astonishing skill and beauty on an area of usually no more than a few square inches. They are placed as votive offerings on the shrines of temples, on domestic altars, at sacred places of pilgrimage and in Stûpas. Plate 28 shows the Buddha in the Vajrâsana form (Tib.: Thub-dbang rdo-rje-gdan gtso-'khor-gsum) with two Devas, height 7 cm (2³/₄ in.). Lahul, casting of the fifteenth or sixteenth century. Plate 29 shows the three deities of long life (Tib.: Tshe-lha-gsum) Amitâyus, Uṣṇîṣavijayâ and Sitatârâ; casting circa sixteenth century. Plate 30 shows an Indian Mahâsiddha, probably Nâropa, who lived in the eleventh century and is venerated particularly in Lahul and Zangs-dkar. Casting circa fourteenth to fifteenth century, height 5 cm (2 in.), Lahul. The circular plaque in Plate 31 shows a very delicately cut Stûpa surrounded by Mantras in Tibetan transcription. Height 3.8 cm (1¹/₂ in.), Tibet.

32 Two pages of a Tibetan manuscript. The upper sheet is the title page, with large decorative letters of the capital script, announcing the book's Sanskrit title which follows overleaf. Many Tibetan canonic scriptures were written down on paper specially treated and primed with indigo or black lacquer. Against this dark background the magnificent writing in gold and silver ink stood out brilliantly. Here the silver writing has turned grey through oxidation.

33 Two pages of text from the Prajñâpâramitâ, one of the principal scriptures of Mahâyâna Buddhism. These are pages 2 and 3 of the Tibetan manuscript. The top of page 2, in red ink, bears the Tibetan transcription of the Indian Sanskrit title: Ârya-Aṣṭasâhasrikâ-Prajñâpâramitâ—in translation: "The Noble Prajñâpâramitâ in 8,000 Verses". This is the most ancient of many writings of this kind which have come down to us from the Sanskrit. Then follows the translation into the Tibetan language. The script here used is the Tibetan capital script (Tib.: dBu-can).

34 Large beaten bronze sculpture of the white Târâ [Tib.: sGrol-ma dkar-mo), as found at shrines in Tibetan temples. The white Târâ or Sitatârâ is regarded as one of the manifestations of Avalokiteśvara and has the rank of a Bodhisattva. Târâ, the redemptress, is one of the most highly venerated goddesses of northern Buddhism. According to tradition she emerged from a tear of the all-benign Avalokiteśvara. The two wives of the Tibetan king Srong-btsan sgam-po were regarded as incarnations of the white and the green form of the benign goddess Târâ. The white Târâ has seven all-seeing eyes of compassion, three in her face and one each on the palms of her hands and the soles of her feet. In her iconographic representation in paintings she is invariably of pure white colour, her right hand is turned outwards in the Varadamudrâ while her left hand, in the Vitarkamudrâ, shows a fully opened white lotus flower.

Mystic Experience in Tibetan Art

The Âdibuddha

One of the most basic ideas of Vajrayâna, one through which Buddhism was deepened into a doctrine of secret revelation, was the concept of the timeless presence of an Âdibuddha. By the tenth century—according to the testimony of Maitreyanâtha perhaps as early as the fourth century—Indian mystics of the diamond vehicle had arrived to proclaim the Âdibuddha or "primordial Buddha". The Âdibuddha (Tib.: Dang-po'i sangs-rgyas) is the supreme deity of Vajrayâna: it is from him that all the Buddhas and doctrines of pure Dharma arise. He is, as it were, the prototype of true Buddha nature as an all-embracing concept. He is regarded as the supreme personification of wisdom and the all-embracing void. Being the first manifestation from the void, he was seen as the origin of the first Maṇḍala of the five Dhyânibuddhas and of all deities stemming from them – deities which we shall consider later.

The Âdibuddha is called Vajradhara, the bearer of the Vajra (Tib.: rDo-rje-'chang). He is of deep blue colour because his nature is unchangeable and equally all-embracing as the sky itself. In his hands he carries the most important symbols of Vajrayâna—in his right the Vajra (Tib.: rDo-rje), the diamond sceptre and in his left the Ghaṇṭâ (Tib.: Dril-bu), the bell with the diamond sceptre-shaped handle. His hands are crossed on his chest in the Vajrahûṃkâramudrâ. The Vajra is the symbol of the absolute reality of the all-pervading voidness (Skr.: Śûnyatâ), and the bell symbolizes supreme wisdom (Skr.: Prajñâ). Further explanations of this important symbolism of Lamaist ritual objects will be given later. The crossing of the two hands in the Mudrâ signifies the supreme mystic unity or gnosis, attained through the permanent union of the void and wisdom (Tib.: Shes-rab stong-panyid). But let us first of all cite a few text passages to obtain a clearer picture of the incomparable manifestation of the Âdibuddha. When attempting to describe this Buddha we must remember that the Âdibuddha is a symbol of the pure and true self-nature of all Buddhas which, moreover, is present in latent form in every human. That is why recognition of the character of pure Buddha nature is nothing other than the realization of the individual's own abiding self-nature. It is in this sense that we must understand the lines written in the tenth century by the monk Tsi-lu-pa over the temple portals of the Nâlandâ monastery after he had first inscribed above the famous "mystic sign of the ten powerful" (Tib.: rNam-bcu dbang-ldan). These historic words are reported in the chronicle of Padma dkar-po as follows:

He that does not know the Âdibuddha
does not know the Kâlacakra.
He that does not know the Kâlacakra
cannot perfectly utter the (secret) names.
He who cannot perfectly utter the names
does not know the wisdom body of Vajradhara.
He who does not know the wisdom body [Skr.: Jñânakâya] of Vajradhara

does not know the Mantrayâna.
All those who do not know the Mantrayâna
are still wandering in Saṃsâra
and are cut off from the path
of the Noble Vajradhara.
That is why the supreme Âdibuddha must be
 proclaimed by
the holy masters and listened to by
the best disciples striving for liberation.

A large number of mystic doctrines are associated with the secret revealer Vajradhara. The most extensive of them are the writings of the Kâla-cakra Tantra, the "wheel of ages", brought to Tibet in the early eleventh century. The above-mentioned Mantrayâna is a special movement within the Vajrayâna in which secret incantations (Sanskrit: Mantras)—short magic formulas for the attainment of visionary images of deities and their immanent forces—represent the main contents of all ritual obeisances.

The next text passage, from a book of the bKa'-brgyud-pa school, contains the story of the Âdibuddha and the first masters of this sect in India and Tibet. It conveys an impression of the imagery of the Tibetan mystics, far transcending all concepts—it is these mystics who time and again have endeavoured to describe the secret nature of the Âdibuddha:

To the Âdibuddha, the Lord of all emanations,
I bow in reverence.
E ma ho!
I bow in adoration

to the Dharmakâya Âdibuddha,
to the Âdinâtha arisen
in the infinite Dharmadhâtu sphere
of inseparable Saṃsâra and Nirvâṇa
and in the equality of the three ages
beyond the transitory world
from wisdom and original consciousness,
the pure incomparable Vajradhara
arisen out of himself.

I bow in reverence to the indestructible wheel-
 jewel,
to him who is totally beyond
peaceful and wrathful paths; and to the
 supreme, unfading
and spontaneous great beatitude
rejoicing in the infinite wisdom of the heart
and to the nature of the void recognizable in all
 things.
I bow in veneration
to him with miraculous knowledge
of illusion and divine wisdom, the supremely
 perfect, the body
brilliant in the sacred sphere,
the protector of the victorious
and their sons in the three ages;
the emanation of the all-embracing universe,
 the all-pervading Heruka,
working in the animate and inanimate world.

The Âdibuddha was venerated in this way in many other writings—he was the origin and revealer of Buddhist mysticism, acknowledged as Supreme Being. It is important, however, to 92

remember that the Âdibuddha never was a historical figure but merely an exalted ideal of Buddhist philosophy. To the mystic he was a being that could be inwardly experienced and comprehended. The first manifestation of the Âdibuddha, according to a written source in Nepal, was in the form of a blue flame, spontaneously generated and burning in the middle of the surface of a lake. Above this flame the Svayambhû Stûpa was later erected and is still revered as one of the most important shrines of Nepal.

In Tibet, Vajradhara became the primordial guru (Skr.: Âdiguru) of the bKa'-brgyud-pa sects. His revealed doctrine was handed down through Tilopa and Nâropa to the Tibetan master Mar-pa of Lho-brag.

The above text shows how Vajradhara was understood as a symbol of the Supreme Being far beyond all conceptual differentiations and far removed from a dualist thinking in polarities. True self-nature, according to ancient Buddhist texts, is as indestructible as a diamond—that is why the nature of the Âdibuddha has the clear and immutable character of a diamond. When pure consciousness realizes the all-pervading void and remains in this state, then it experiences the boundless great happiness of enlightenment (Tib.: bDe-ba chen-po). Consciousness, the immanent void and boundless bliss—these three have the indestructible, brilliantly clear and immutable character of the diamond (Skr.: Vajra). It is this understanding, therefore, that has given the Vajrayâna doctrine its name and content.

The diamond nature of the perfect Âdibuddha is described in the most ancient Tantra, the Guhyasamâja. In this text, though, he appears as Vajrasattva. Vajrasattva was venerated by certain schools as the Âdibuddha, even though he did not reach the rank of Vajradhara. Other forms and names of the Âdibuddha, handed down to us include Buddha Mahâvairocana, Âdibuddha Samantabhadra (in the rNying-ma-pa sect) and Vajradhara in his aspect of Akṣob-hyavajra (Tib.: Mi-bskyod rdo-rje), who was raised to the position of the supreme Buddha of the Guhyasamâja Tantra. He is one of those complex tantric figures we shall encounter again in the tantrism of northern Buddhism. Akṣob-hyavajra is of dark blue colour and has three heads and six arms. In his hands he carries various symbols and—a key manifestation of the tantric doctrines—he holds in his embrace a female deity generally described as wisdom (Skr.: Prajñâ). This Prajñâ is the feminine opposite pole or correspondence of the Buddha. Frequent reference will be made later to the female aspect in the Tantras. At this stage only a fundamental observation will be made: that the harmonious unity of all polarities, including those present in the individual, represents the main goal of all endeavours and teachings of tantrism. Let us recall that the supreme Âdibuddha Vajradhara holds in his crossed hands the Vajra and Ghaṇṭâ: these two ritual objects of Lamaism testify to their great symbolic importance.

93

The symbolism of Vajra and bell

The Vajra is the active symbol of the spiritual ways and means of attaining the hoped-for realization of wisdom. The goal of the seeker, the mystic in Vajrayâna, is the inner self-realization of wisdom, culminating in the realization of the voidness. The bell (Skr.: Ghaṇṭâ) is the symbol of the truth penetrating the worlds with its ringing tone. The practical path of the mystic in the world of suffering, according to the fundamental teaching of Mahâyâna, is invariably the path of all-embracing compassion (Skr.: Mahâkaruṇâ), in accordance with the tasks of a Bodhisattva. The aim is union with the wisdom of the ever-present void. Vajra and Ghaṇṭâ, however, are also symbols of the unity of Saṃsâra and Nirvâṇa. The path through the experience of the world of suffering, Saṃsâra, in the search for Nirvâṇa and the eventual realization of Nirvâṇa as a tantric state of experience—these two, as path and goal, Saṃsâra and Nirvâṇa, Vajra and Ghaṇṭâ, must be seen as inseparable unities.

Thus the principal ritual objects of Vajrayâna, the diamond sceptre and the bell, are paired symbols of the gnostic unity which leads the mystic beyond all dualism. And only this fundamental union, which is hidden from the unenlightened, represents the state of true enlightenment and liberation. The polarity visible and comprehensible to the mystic in all phenomena is symbolized by the primal opposition and fundamental inseparability of male and female, Buddha and Prajñâ, god and goddess. The whole world is comprehended only by him who understands these pairs as equal aspects of The One. The Vajrayâna mystics express these aspects in their pictorial art by the gnostic union of divine pairs. Buddhas, Bodhisattvas, peaceful and wrathful deities, therefore, frequently appear in embrace with their female counterparts, described as Prajñâ (wisdom), Vidyâ (knowledge), Mudrâ (seal) or as Yoginî. Finally, we must recognize diamond sceptre and bell as polarity symbols. The Vajra is the indestructible diamond, symbol of appropriate and skillful action (Skr.: Upâya, Tib.: Thabs); it represents the masculine pole of the Buddha. The bell, on the other hand, has the all-pervading ringing character of the void; it is the voice of the supreme Dharma and symbol of wisdom (Skr.: Prajñâ, Tib.: Shes-rab), and represents the feminine pole of the Buddha. As a ritual object the bell is equivalent to the lotus symbol (Skr.: Padma). Lotus flower and bell are identical in tantric symbolism, and that is why the body of the bell bears a lotus flower.

To the tantrist, path and goal (just as Saṃsâra and Nirvâṇa) are merely two aspects of the same reality. That is why in the Vajrahûṃkâramudrâ the Âdibuddha merges the two symbols into a union, thereby personifying the ideal of tantric gnosis (Skr.: Prajñopâya).

In the Guhyasamâja Tantra, Vajradhara is "the heart of all Tathâgatas, the point of origin of all Tathâgatas, the Lord of the great happiness of the five wisdoms, the supreme creator of all Maṇḍalas and the (all-embracing) body of all assemblages of Buddhas."

94

Another quotation from the same Tantra leads us to consider the triple aspect, the three-fold sub-division of the individual which will then lead to a discussion of the essence of the Trikâya doctrine. The Guhyasamâja proclaims that Vajradhara symbolizes the inner unity-in-three of the Tathâgata, that is the essence of body, speech and mind. It is further stated in this text that the syllable *Om* is the body of the supreme Buddha, the syllables *Om, Âh* the path of the Buddha's word, and the syllables *Âh, Hûm* the closely guarded wisdom of the heart. The totality of the being, whether as a Buddha or a Yogin striving for perfection, is realized in three principal lotus centres (Skr.: Cakras) whose activity must be perfected by the preservation of the pure action (or body), the pure word (or speech) and the pure heart (mind). This trinity means that the entire human being is made the object of transformation, that thought, speech and action must be completely harmonized, and that only when all three planes of activity are pervaded by the spirit of enlightenment, the Vajra essence, can a higher, enlightened state be achieved.

As a pictorial symbol for the adamantine self-nature of all Buddhas, Buddhist iconography uses the "sixth Sambhogakâya, Vajrasattva" (Tib.: Longs-sku drug-pa rdo-rje sems-dpa') shining in pure white colour and, like the Âdibuddha Vajradhara, furnished with Vajra and Ghaṇtâ as symbols. His gestures, however, are different: the left hand with the Ghaṇtâ rests in his lap and the Vajra in his right hand is held over his heart. With this symbolism he unites within himself path and goal of the secret Vajrayâna doctrines. This form of the Âdibuddha again occurs in its esoteric version—known as "father-mother" (Tib.: Yab-yum) in the tantric representation—which shows Vajrasattva with his female counterpart, the Yoginî Vajrasattvâtmikâ. In her hands the female divine partner is holding a diamond knife (Tib.: Gri-gug) and a Kapâla filled with nectar. The knife symbolizes the severance of all roots of ignorance, and with the Kapâla the Prajñâ offers the blissful essence of enlightenment. In this tantric form Vajrasattva is the secret creator of Maṇḍalas, of all meditational deities and Buddhas produced

Vajra		*Ghaṇtâ*	
Means or Method	(Tib.: Thabs)	Wisdom	(Tib.: Shes-rab)
Spiritual Path	(Tib.: Lam)	Fruit	(Tib.: 'Bras-bu)
All-embracing Compassion	(Tib.: sNying-rje chen-po)	Voidness	(Tib.: sTong-pa-nyid)
Buddha (or deity)		Prajñâ, Vidyâ, Mudrâ or Yoginî	

And the great Unity of these is: Gnosis

by him as his emanations. He is of considerable importance in Tibetan ritual and frequently takes the place of the Buddha Akṣobhya who will be mentioned later. In Tibet it is chiefly the mystics of sMin-grol-gling, a doctrinal movement of the rNying-ma-pa sect, who follow the esoteric path of Vajrasattva. The table on p. 95 recapitulates the tantric symbolism of the Âdibuddhas insofar as we have discussed the concepts.

The rNying-ma-pa sect, as the most ancient Lamaist tradition, venerates the Âdibuddha Samantabhadra (Tib.: Kun-tu bzang-po). The successors to Padmasambhava's doctrines chose this Buddha as the supreme personification of all Buddhas and as the revealer of the secret doctrines of Atiyoga. A Tibetan text describes the timeless residence of the Samantabhadra as follows:

"To the Dharmakâya, in the three ages without origin residing in the spheric Dharmadhâtu palace of 'Og-min heaven, to him from whom all entirely pure doctrines have spontaneously emerged since eternity, to the father who from his heart creates all Buddhas, to the Dharmakâya Samantabhadra, I take my refuge."

This Âdibuddha of deep blue colour is represented seated in the Vajraparyaṇka position, without any attributes, without jewels and without raiments since he represents the qualities of the first manifestation from the void. Samantabhadra is without characteristics, and there is nothing in the world of relative concepts that could describe the supreme essence of this Buddha. In the iconography of the rNying-ma-pa sect and particularly in his function as supreme Buddha over the deities of the Tibetan Book of the Dead, this Âdibuddha appears in mystic union with his Prajñâ; she is pure white in colour and likewise without attributes. Reference will be made to this Âdibuddha in the next chapter since he is of importance in connection with the manifestations of the Tibetan Book of the Dead.

The Trikâya doctrine

In the preceding paragraphs we have been using concepts from the Doctrine of the Three Bodies (Skr.: Trikâya, Tib.: sKu-gsum) and these now require explanation. It is necessary to seek clarification of the important Trikâya doctrine, since it represents one of the foundations of Mahâyâna Buddhism with application in all meditational exercises. Moreover, the principles of this doctrine are an important aid to the interpretation of the imagery of Tibetan art.

In point of fact, the broadened ideas of the Trikâya doctrine were responsible for the emergence of the multiplicity of Buddhas and Bodhisattvas so typical of Mahâyâna. The historical Buddha Śâkyamuni was no longer regarded as a unique historical person but became the earthly (human) manifestation (Skr.: Nirmâṇakâya, Tib.: sPrul-sku) of the infinite law (Skr.: Dharma) which he promulgated. The doctrine, however, is identical with the Buddha-nature or the Buddha himself. Hence the Buddha-nature in its

96

universality of the pure law is described as the Body of the Law (Skr.: Dharmakâya, Tib.: Chos-sku). The Dharmakâya is a pure timeless body, indestructible in its essence. The Tibetan historian Bu-ston called the Dharmakâya a cosmic body which is all-pervading and the essence of all things. He continues: "The cosmic body [Dharmakâya] is that which represents absolute truth and unerring transcendental wisdom. The cosmic body, therefore, may be regarded as a substratum, an essence of all elements, as the absolute, divine and transcendental wisdom, neither created nor not created."

The Dharmakâya, as the supreme essence or truth, in effect coincides with the doctrine of the nature of the Âdibuddha, since he is devoid of form, timeless, all-pervading, all-present and all-knowing.

In his famous work "Jewel Ornament of Liberation" sGam-po-pa, a Tibetan scholar from the school of Mi-la ras-pa, described the most important characteristics of the Dharmakâya as follows: "The Dharmakâya, if viewed from different sides, may be characterized by eight properties: equality, depth, infinity, unity, harmony, purity, radiation and beatitude." In another passage he says: "There are three bodies because each one is necessary; the Dharmakâya for its own purpose, and the other two for the benefit of each other. The Sambhogakâya is for those who (still) require instruction but are already purified [from crudest ignorance]. The Nirmânakâya is for those who need instruction and are not yet purified."

This brings us to the definition of the other two bodies which, together with the Dharmakâya, form a unity. From the pure body of the law, according to the Trikâya doctrine, there are infinite possibilities of reincarnation in two planes—in the celestial and pure spheres as bodies of enjoyment (Skr.: Sambhogakâya), and in the earthly spheres as manifested bodies of incarnation (Skr.: Nirmânakâya). In the Sambhogakâya (Tib.: Longs-spyod rdzogs-pa'i-sku), one finds the Buddhas of the celestial world, the Dhyânibuddhas who enjoy the bliss of wisdom in eternal meditation. In one such enjoyment body, that of divine happiness, the Buddha of Infinite Radiance (or Boundless Light), Âmitabha, resides and rules over the Western Paradise (Skr.: Sukhâvatî).

The Sambhogakâya, whose nature is that of a brilliant light, can be seen also (as a vision) by the Bodhisattvas, by the saints and by those far advanced in the virtues. The Sambhogakâya is to be understood as a reflection of the Dharmakâya in the pure spheres of vision. The historian Bu-ston comments on this as follows: "Sprung from the immeasurable accumulation of virtue, the sons of the Buddhas stand on the ten steps [to enlightenment], and they preserve that body which enjoys the truth of the doctrines."

The Buddhas of the manifestation bodies (Nirmânakâya) appear from the Dhyânibuddhas (of the Sambhogakâya) residing in Akaniṣṭha heaven and manifest themselves as earthly transitory beings. "Nirmânakâya is the wisdom which works for the benefit of others." The Tibe-

tan master sGam-po-pa remarked that the Dharmakâya was the unassailable basis of the Nirmânakâya. "Its cause stems from the great compassion which desires the well-being of all men and beings. Its planes are the pure and impure realms." The Buddha in the Nirmânakâya proclaims the doctrine and shows the path to redemption; he is transient as are all other earthly beings, except that he is furnished with the "celestial eye and celestial ear".

All beings partake of the Dharmakâya; it is hidden and invisible, yet all-embracing. The Sambhogakâya and the Buddhas manifesting themselves there as reflections of the Dharma in the celestial spheres are those visionary Buddhas which can be seen in brilliant vision by the perfect Bodhisattva and the pure mystic. The manifested law on earth, however, reveals itself in the manifestation of human Buddhas (Skr.: Mânuṣibuddha).

A fourth concept was subsequently added to these three bodies and was to be understood as the great indivisible unity of the three bodies. This fourth body is described as "the self-existent body" (Skr.: Svabhâvakâya), or the body of pure self-nature (Skr.: Sahajakâya). This fourth body which arises from the conjunction of the three bodies and is "the spontaneously arisen" or "the simultaneously born", is of great importance in tantric mysticism. The three bodies and the pure body of true self-nature (Tib.: Ngo-bo-nyid-kyi sku) emerging from them are the foundation of all secret rites and of the initiations by which a disciple is introduced to the profound teachings of the Tantras by his master. In these ceremonies the Abhiṣeka rite (Tib.: dBang-skur)

Lotus Centre (Cakra)	Function	Consecration	Fruit of the Purified Body
Head centre	Body/Action (Tib.: Lus)	through the vessel (Tib.: Bum-dbang)	Nirmânakâya (Tib.: sPrul-sku)
Throat centre	Speech/Word (Tib.: Ngag)	through the secret (Tib.: gSang-dbang)	Sambhogakâya (Tib.: Longs-sku)
Heart centre	Mind/Thought (Tib.: Yid)	through knowledge of wisdom (Tib.: Shes-rab ye-shes-kyi dbang)	Dharmakâya (Tib.: Chos-sku)
Navel centre	Identity of three bodies (Tib.: Lus ngag yid gsum)	through the (secret) word or Mantra (Tib.: Tshig-gi dbang)	Svabhâvakâya (Tib.: Ngo-bo-nyid-kyi sku)

serves to symbolically purify the four planes of action—that of the body, speech, mind and these three as a unity—from all blemishes and obstacles, thereby raising planes of action of higher existence. These four planes of action in the world are the four lotus centres (Skr.: Cakra) in the body which the yogi is expected to perfect. When these centres are ritually transformed into pure spheres of enlightened thought, they are then experienced as the spheres of the four higher bodies. The four Cakras, which have to be purified to gain greater insight into wisdom, are experienced as being in the head, throat, heart and the region of the navel.

The well-known Indian Siddha Nâropa, one of the first gurus in the line of the bKa'-brgyud-pa, has left us a clear and orderly picture of the tantric initiation system which is shown in the table on page 98.

Sukhâvatî, the heavenly paradise of the Buddha Amitâbha

In addition to the doctrines of Mahâyâna Buddhism, many texts containing ideas of a world beyond also reached Tibet. None of these enjoyed greater popularity among lay followers or was reproduced more frequently in Tibetan art than the doctrine of the "Land of Happiness" (Skr.: Sukhâvatî, Tib.: bDe-ba-can), the "Western Paradise" of the Buddha Amitâbha. With the spread and the translation of the Sukhâvatî-vyûha Sûtra the Western Paradise came to be known in all lands of northern Buddhism, and the radiant Buddha Amitâbha came to be venerated in all countries from India to Japan. The Tathâgata, it says in the Sûtra, "now resides and preaches the law in the western realm, in the Buddha land, removed from this world by countless hundreds of thousands of Buddha lands, in the world called Sukhâvatî."

There, in an unimaginably magnificent paradise, resides the Buddha Amitâbha, surrounded by countless hosts of Bodhisattvas and disciples who are seated on lotus flowers. Amitâbha is the Buddha of infinite radiance, and "his light is so infinite that it is not easy to make out the limits of its extent." With this brilliant light he enlightens the countless hundreds of thousands of Buddha lands, of which there are as many as there are grains of sands in the Ganges. That is why the Sûtra concludes:

"There is not, O Ânanda, any instance of similarity by which the extent of the light of this Tathâgata Amitâbha could be comprehended. Therefore, O Ânanda, for this reason this Tathâgata is called Amitâbha."

In the same Sûtra the Buddha Amitâbha also appears in another aspect, as Amitâyus (which will be described in detail in the caption to Plate 45). Just as Amitâbha is radiant with infinite light, so "the duration of the life of this Bhagavat Amitâbha, the Tathâgata, is infinite, so that it is not easy to comprehend its duration." And because the extent of this Tathâgata's life is infinite he is also known as Amitâyus (Infinite Life).

35 In addition to paper, which was usually in very short supply, thin strips of birch-bark were also used in ancient Tibet for the writing of Mantras, Dhâraṇîs, Sûtras and other Buddhist texts. The use of birch-bark as a writing material was customary not only in Tibet but also in central Asia as early as the first few centuries A.D. From the sixteenth century onwards paper came into general use.

36 The deposition of stones or boulders with pious inscriptions, Mantras and invocations to the deities at sacred places of pilgrimage is a widespread religious practice of the Tibetan laity. The engraving of sacred formulas and Sûtras is regarded as a meritorious deed. This plate shows the green Târâ (Tib.: sGrol-ma ljang-khu) chiselled into the rock, surrounded by prayer texts and with the Mantra of the Târâ below the goddess's picture, reading: Oṃ tâ re tu tâ re tu re svâ hâ.

37 Capitals and beams in Tibetan monasteries display a variety of Tibetan scripts, principally the decorative styles. The cloud capital shows the famous monogram of the "sign of the ten powerful ones" (Tib.: rNam-bcu dbang-ldan) in gold with the syllables E and Vam. This sign is an important esoteric symbol of the Kâlacakra doctrines and represents the elements and forces of the micro- and macrocosmos. The beam above bears, in white Lantsha script (just as in the red script above), the invocation formula of the Guru Padmasambhava which is regarded as the most sacred Mantra of the rNying-ma-pa sect. It runs: Oṃ âḥ hûṃ Vajraguru Padmasiddhi hûṃ.

38, 39 The most important ritual objects of Vajrayâna are the Vajra (Tib.: rDo-rje) and the Ghaṇṭâ (Tib.: Dril-bu), the ritual bell with the Vajra handle. They are used in all rituals and initiations and are always handed together to a new in-

itiate or ordained monk. The five horns of the Vajra symbolise the order of the five Tathâgatas who form the principal Maṇḍala of Vajrayâna.

40 The mystic Buddha Vajrasattva is one of the principal deities of tantric Buddhism. He is regarded as the sixth Dhyânibuddha and as the priestly revealer of the Maṇḍalas. The mystery of Vajrasattva is the subject of a great number of initiations and also plays an important part in the ritual of the Tibetan Book of the Dead. We here see Vajrasattva, whose iconographic colour is pure white, in the typical ritual position of his hands, holding Vajra and bell. The small fourteenth to fifteenth century gilded bronze is surrounded, as by a halo, by a somewhat rigid shawl of a kind frequently found in ancient icons.

41, 42 Two iconographically different forms of the Âdibuddha Vajradhara (Tib.: rDo-rje-'chang), who has three possible forms of representation. The two plates show two different techniques of bronze casting. Plate 41 illustrates a dark bronze of the fine and smooth surface texture achieved only by the lost wax technique (cire perdue), a technique superbly handled by the Tibetans. The Âdibuddha holds Vajra and bell in his hands which are crossed over his chest. The Buddha's face and crown are covered with gold paint, and neck and crown jewels are inset with turquoise. Circa early seventeenth century. Plate 42 shows an overall gilded bronze of Vajradhara. Here the Âdibuddha similarly holds his hands crossed in the Vajrahûṃkâramudrâ, but the gesture is only symbolic. The ritual objects Vajra and Ghaṇṭâ stand by his side, each on a lotus flower. In spite of its gilding, the face of the bronze is additionally painted with gold paint. Arm, neck and leg jewels are rendered in a particularly sumptuous way with inlaid turquoise. Circa early sixteenth century.

35

36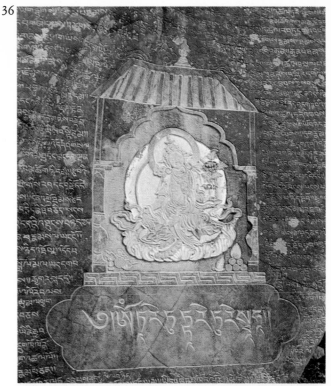

37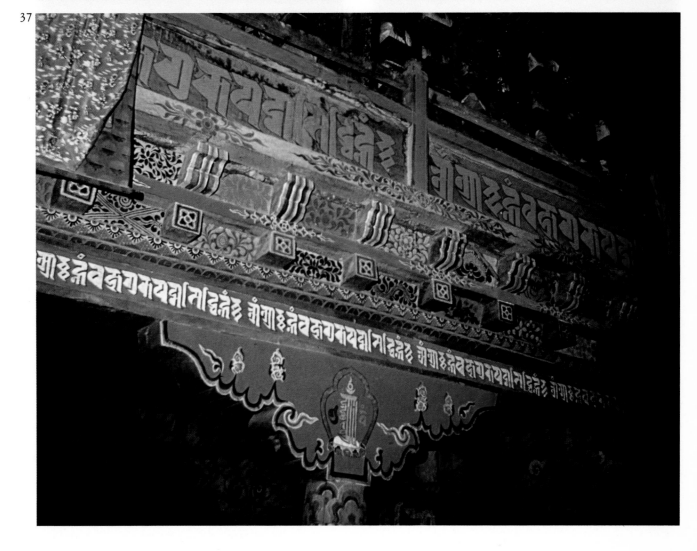

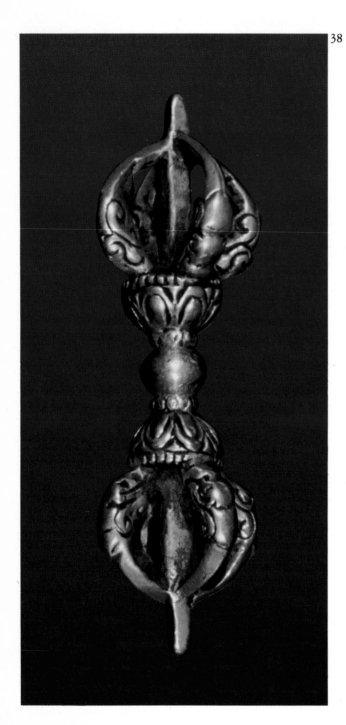

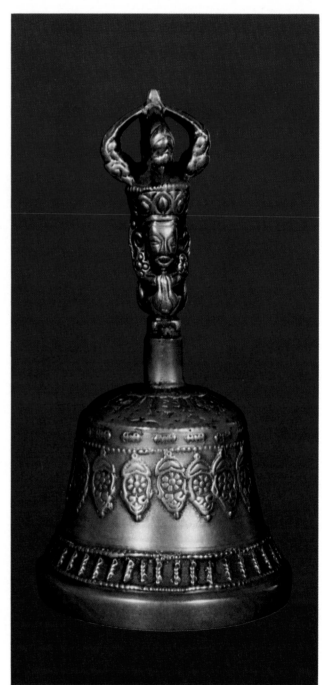

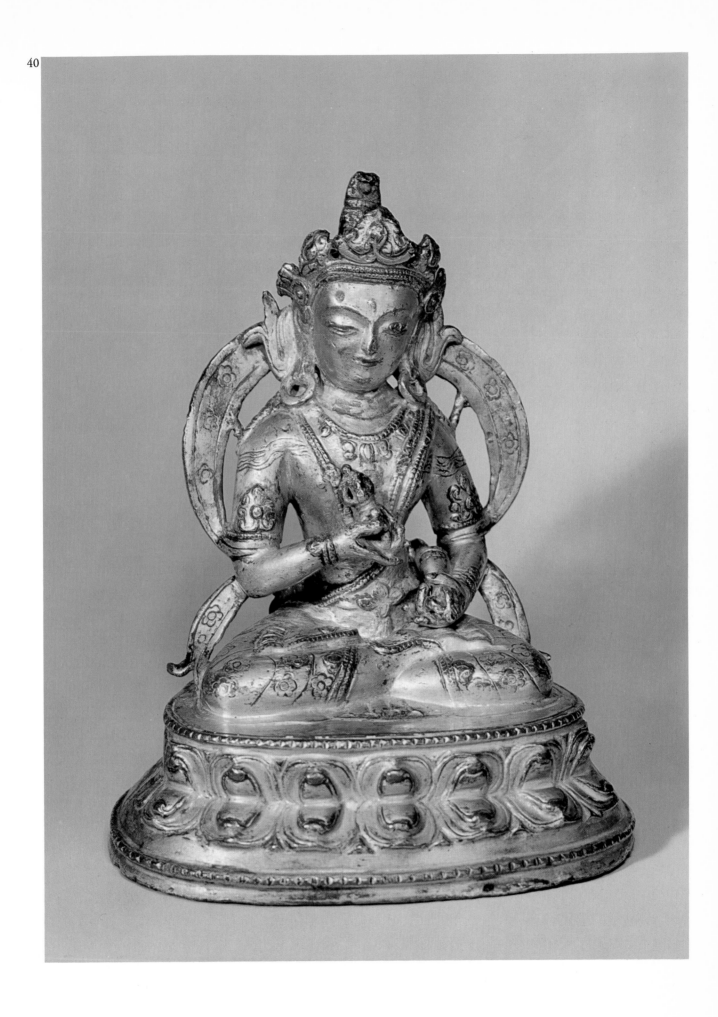

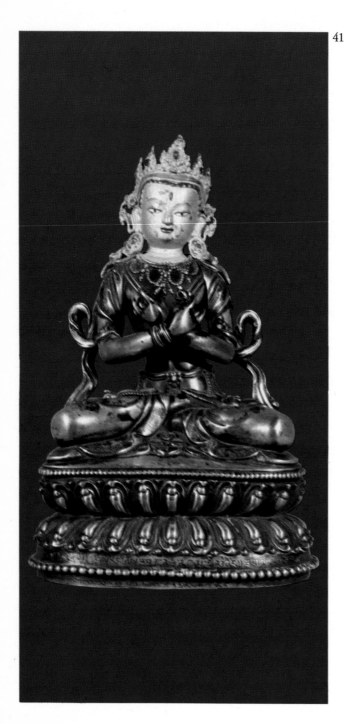

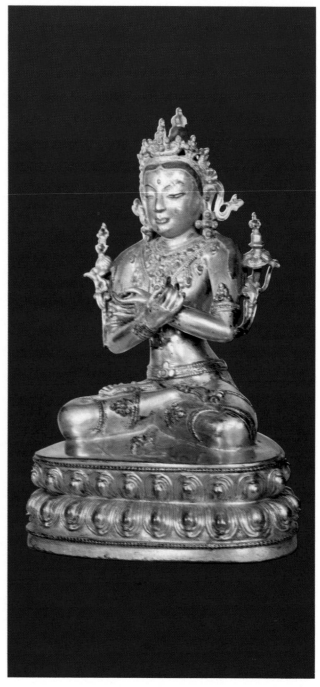

The descriptions of the paradisical worlds themselves are so rich and fantastic that there is probably nothing in literature to compare with the ideas here revealed. The world of Sukhâvatî is perfumed with various odours, rich in a variety of flowers and fruit, adorned with precious jewel-trees and enlivened by many kinds of sweet-singing birds. The trees are made of precious metals and crystals which gleam through the worlds; everything here is bright, radiant, and of penetrating light, and music sounds from the heavens. The world of Sukhâvatî is without darkness, without shadow and without night, it is a timeless place of bliss. All wishes of the creatures living in this world are instantly fulfilled, no matter whether for warmth, coolness, food or drink, and all creatures live there in peace and happiness.

It is not surprising that these paradisaical worlds held a great attraction for many people who could not follow the difficult path of strict self-discipline of the monastic order, the path of purification and knowledge. In China and Japan the mere belief in these worlds of the Beyond gave rise to special doctrines which exclusively proclaimed this world of Amitâbha as man's final goal. Plate 46 shows a Tibetan representation of the Buddha Amitâbha in the brilliant halo of the Sukhâvatî paradise.

In Tibetan painting we encounter a group of pictures representing a Buddha or a deity repeated a great number of times, always in the same form and even in the same colour. The painting in Plate 45 is a case in point and may help us to understand the background to this kind of pictorial work. This type of painting is not a schematic repetition but a deliberate numerical arrangement or projection of an inner vision of the multiplicity of a single aspect. In certain meditations this deliberately practised multiplication of a single image to an infinite number, as well as the practice of seeing a multiplicity of appearances in a single integrated unity, belonged to the foundations of meditative practice, and such exercises are part and parcel of the tantric possibilities of experiencing the relativity of the world of phenomena. The Tibetan painting (Plate 45) shows an excerpt from the multiple vision of the Buddha Amitâyus which, in this form, we can relate to an ancient Mahâyâna text. Grouped around the large central figure of Amitâyus are the 108 names (mantric syllables) of Amitâyus who attained great importance in Tibet as the "Buddha of Infinite Life". Amitâyus is associated with the "long life initiation" (Tib.: Tshe-dbang), which was imparted by the lamas according to a special ritual. The 108 names of the Buddha Amitâyus are symbolized by the 108 syllables of a Mantra which is the best known incantation Mantra of Amitâyus. In relation to our painting, each of the syllables of the Mantra, described as the names of Amitâyus, are represented by one of the small Buddha figures. The symbolic number 108, we might add, is one which occurs very frequently in Buddhism.

Let us look at the picture of Amitâyus, seated upon a lotus throne in infinite meditation, and let us consider some appropriate text passages

Fig. 9. Tibetan block-print of the three guardian deities of the Buddhist doctrine, with Mañjuśrî as the Bodhisattva of wisdom (left), Avalokiteśvara as the symbol of compassion (centre) and Vajrapâṇi as the deity of power over evil (right).

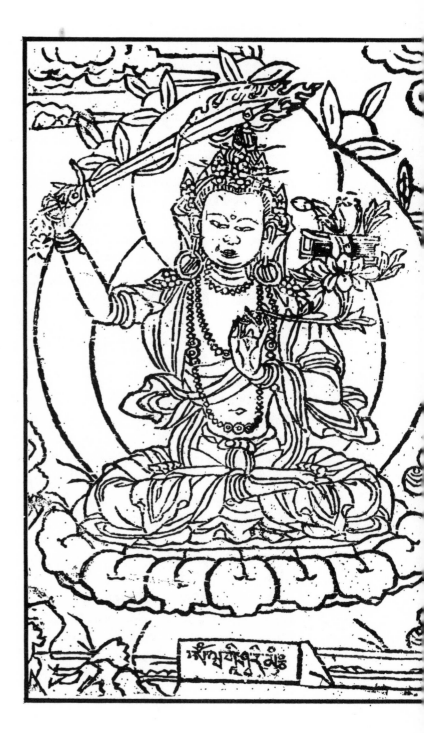

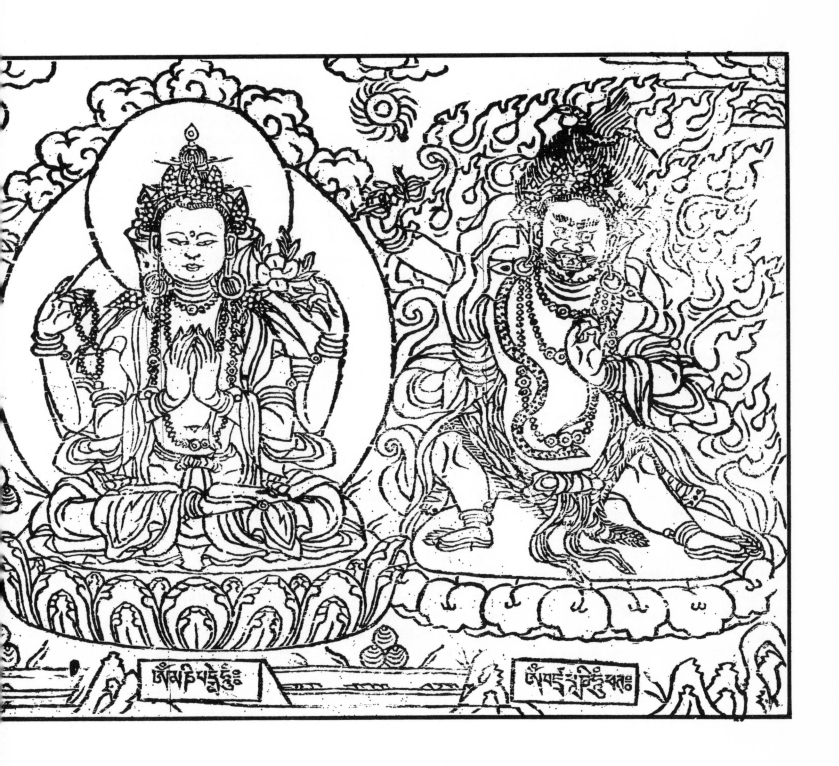

from the Aparimitâyur-jñânâ-nâma-mahâyâna-sûtra:

"There is, Mañjuśrî, at the place in the zenith a world element by the name of 'Accumulation of Immeasurable Virtue'. There dwells the 'Shining King Distinguished by Immeasurable Life and Knowledge', called the Tathâgata, a teacher of gods and men, an enlightened one; there he dwells and teaches the law to living creatures. ...These men of Jambudvîpa will have a short life, they will also live a hundred years, and much untimely death is reported from them. The creatures, however, Mañjuśrî, who will write the didactic text called 'Praise of the Virtues and Accomplishments of the Tathâgata Aparimit-âyuḥ' [name of Amitâyus]... or even merely hear his name... who will honour him with flowers, incense, sweet perfumes and garlands, they, when their life has elapsed, will endure again a hundred years. Moreover, Mañjuśrî, the creatures which remember the 108 names of the Tathâgata... they too will increase the span of their lives... and having departed from here they will arrive in the Buddha realm of the Tathâgata Aparimitâyuḥ and they will have unlimited life."

Then follows the text of the Mantras with the 108 syllables of the Buddha of long life, with each separate syllable symbolizing one aspect of Amitâyus. In another instruction for meditation, handed down to us in the Amitâyur-dhyâna-sûtra, a magnificent picture of the radiant Buddha Amitâyus is painted on the ninth step, roughly as follows: "You should know, o Ânanda, that the body of the Buddha Amitâyus is a hundred thousand million times more brilliant than the colour of Jâmbûnada gold from the celestial realm of Yama; the size of this Buddha is six hundred thousand Indian measures greater and more innumerable than the grains of sand of the Ganges.... The eyes of the Buddha are like the water of the four great oceans.... From the roots of his hair arise brilliant rays... and the aura of this Buddha is as great as a hundred million vast chiliacosmoses, and in this aura millions of Buddhas are created in a miraculous manner. His countless rays of light penetrate all spheres of the ten regions of the world and embrace all creation."

Mantras and germinal syllables

We have mentioned the concept of Mantras and the time has now come to gain an insight into their meaning and nature. Mantras are mystic syllables arranged in a special sequence. In purely linguistic terms, or in terms of a precisely translatable content, these Mantras frequently make no recognizable sense nor do they convey any connected meaning. Other Mantras have an esoteric, hidden, meaning which can only be discovered through special instruction by a guru. Nevertheless the Mantras play a very important part in Vajrayâna and are of fundamental significance in the practice of meditation. To begin with, the Mantras may be said to represent a concentrated short forms of tantric texts, Sûtras

and Dhâraṇîs. Moreover, they are believed to possess a concentrated power uniting all aspects of the deity to be invoked by the Mantra. To the mystic a Mantra thus becomes the carrier of divine spiritual energies set into effect by recitation. The yogi realizes the visionary image of the deity through attunement to the mantric content; at the same time the Mantra transfers its immanent power to him. Mantras were therefore regarded as the essence of Buddhist experiences and wisdom, and were transmitted by Vajrayâna teachers in strict secrecy; they were passed on as esoteric knowledge only to chosen disciples and successors. When deities were thus invoked by the appropriate Mantras, their powers and divine properties were believed to realize themselves within the yogi's consciousness, and to reside there in order to accept symbolic offerings. Simultaneously, the magic powers of the Mantras were to engender the living visionary image of the deities within the devotee's consciousness in the hope that this vision would help him acquire superior powers (Skr.: Siddhis). The gurus believe that the syllables of a Mantra produce vibrations which are identical with those of the invoked deity. And although all secret scriptures interpret the nature of the Buddhas and the deities, the Mantras of these texts are nevertheless considered the nucleus and the most effective essence of the doctrine. The Mantras alone are the secret formulas for the deliberate evocation of an inward visionary experience of the deities. Their value was rated so highly by the Vajrayâna masters and by the exponents of the Mantrayâna

tradition that they were thought to represent the shortest path to spiritual enlightenment and to liberation from the shackles of the world.

The point must also be made that the Mantras can be an important aid on the path to uninterrupted meditation. For only after intensive recitation of a Mantra, accompanied by simultaneous concentration on its real meaning, does the Mantra lead to a clear idea and vision of the deity invoked.

The Mahâsiddhas of India believed that recitation of Mantras enabled the devotee not only to recognize and see the deities but also to acquire their powers. That was why good guidance by an experienced master was necessary for a real activation and control of these powers. Each deity of the Buddhist pantheon, and frequently each specific manifestation, has its own Mantra assigned to it. Perhaps the best known is the famous Mantra of the compassionate Bodhisattva Avalokiteśvara, whose six-syllable formula *Oṃ ma ṇi pad me hûṃ* revolves in thousands of Tibetan prayer-wheels.

The shortest form of a Mantra is the germinal syllable (Skr.: Bîja) or the mystic seed. This term, in Mantrayâna, means the primal syllable, the primal note or creative word from which the Buddhas develop. Prior to any creation in substantial form, according to Indian philosophy, there was the primal, original word, the first sound in the vastness of space, the sound from whose vibrations all other things developed. From such germinal syllables, for instance, stem the five Dhyânibuddhas whose acquaintance we

109

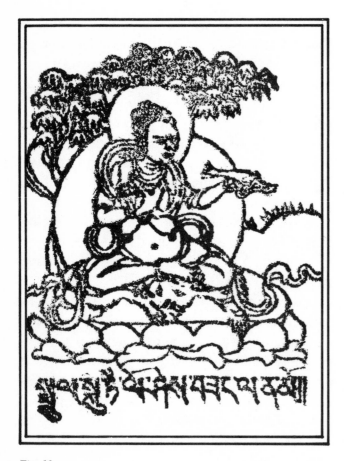 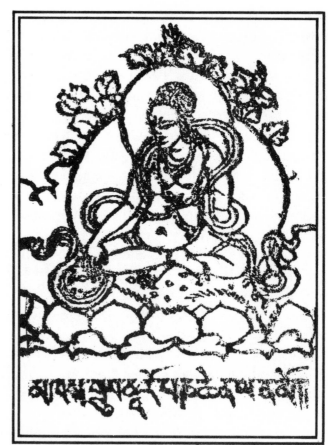

Fig. 10 Fig. 11

The Indian Siddhas Tilopa (left) and Nâropa (right), regarded as the first two gurus of the bKa'-brgyud-pa tradition.

shall make in the next chapter. From these germinal syllables, moreover, spring the Dâkinîs, the lights of wisdom or the elements of the cosmos. Examples of important germinal syllables are the well-known three *Oṃ, Âh, Hûṃ,* or the four *Ha, Ri, Ni, Sa* (belonging to the Dâkinîs). So much by way of introduction to Mantrayâna. It is important to realize that the Mantras reached their greatest importance in Lamaism, that they were part of the esoterically guarded knowledge of the Tibetan gurus, and that the real significance of all deities and symbols reached its highest concentration and magic intensification in the short mantric formulas whose correct application was believed to open up a direct path to liberation.

43 The divine couple embracing, symbolising the unio mystica, *is a typical feature of Buddhist tantrism in Tibet. This esoteric symbolism of the inseparable union of polarities, represented by the so-called "father-mother" symbolism (Tib.: Yab-Yum) is a main feature of tantric art. The unique bronze shown in this plate is probably the form of Avalokiteśvara known by the name of Guhyasâdhana-Avalokiteśvara (Tib.: 'Jig-rten dbang-phyug gsang-grub). The deity holds a lotus flower in the Vajrahûmkâramudrâ and embraces his female counterpart, the Prajñâ. In her hands she holds a Kapâla and Ḍamaru. The lotus base bears the Mantra of Avalokiteśvara: Oṃ ma ṇi pad me hûṃ. Tibet, eighteenth century.*

44 The Dhyânibuddha of infinite life is Amitâyus, one of the favourite figures of northern Buddhism. Amitâyus (Tib.: Tshe-dpag-med) is a form of Amitâbha and is of the red colour of the sun setting in the west. This fine bronze is richly decorated and represents fifteenth century south Tibetan art, probably from the cultural area of Gyantse.

45 This painting shows the complete iconographic colour scheme of the Buddha Amitâyus around whose central figure 108 further emanations are arranged. We can see that the figure of Amitâyus is based on a strict observance of exact iconometric measurement. Perfect equilibrium has been achieved in the relationship of all dimensions, to such an extent that the slight deviations in the treatment of the folds of the garment are scarcely noticed. Like the bronze in Plate 44 this painting also comes from the south Tibetan school, from the Gyantse region. Circa early eighteenth century.

46 In a five-coloured halo of light and surrounded by the eight Mahâbodhisattvas the red Buddha Amitâbha (Tib.: sNang-ba mtha-yas or 'Od-dpag-med), the Buddha of infinite radiance, emerges like a vision. His heavenly realm is the "Western Paradise" (Skr.: Sukhâvatî) where he resides in infinite splendour among the enlightened. Many texts describe the brilliant celestial world of infinite splendour (see pages 99, 105, 108). Tibetan painting, showing Nepalese and Chinese influences; late eighteenth century.

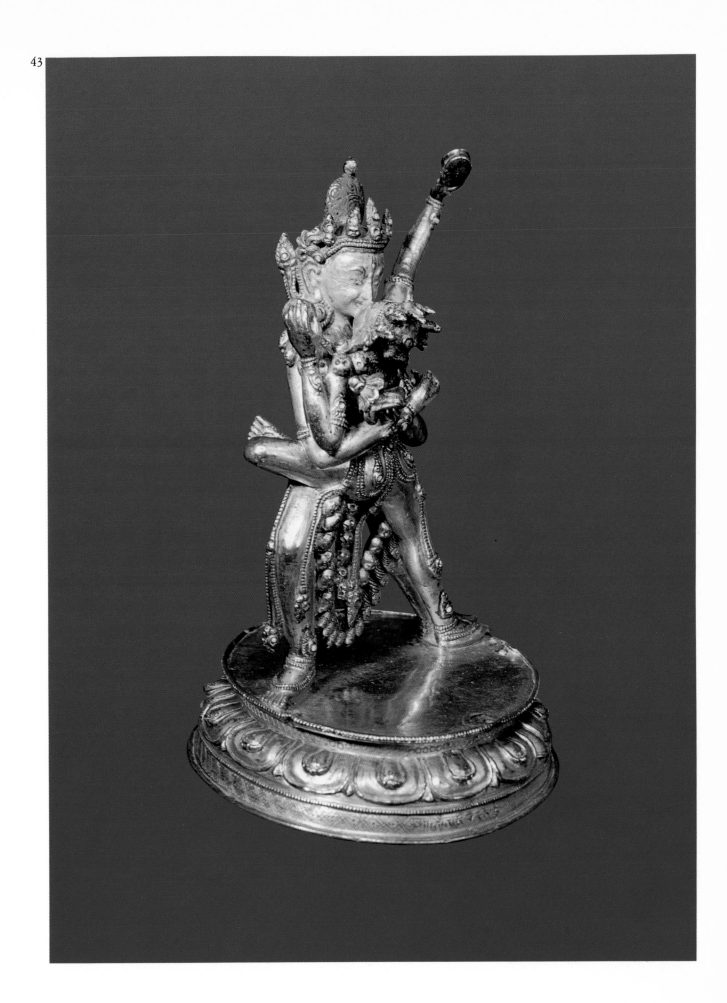

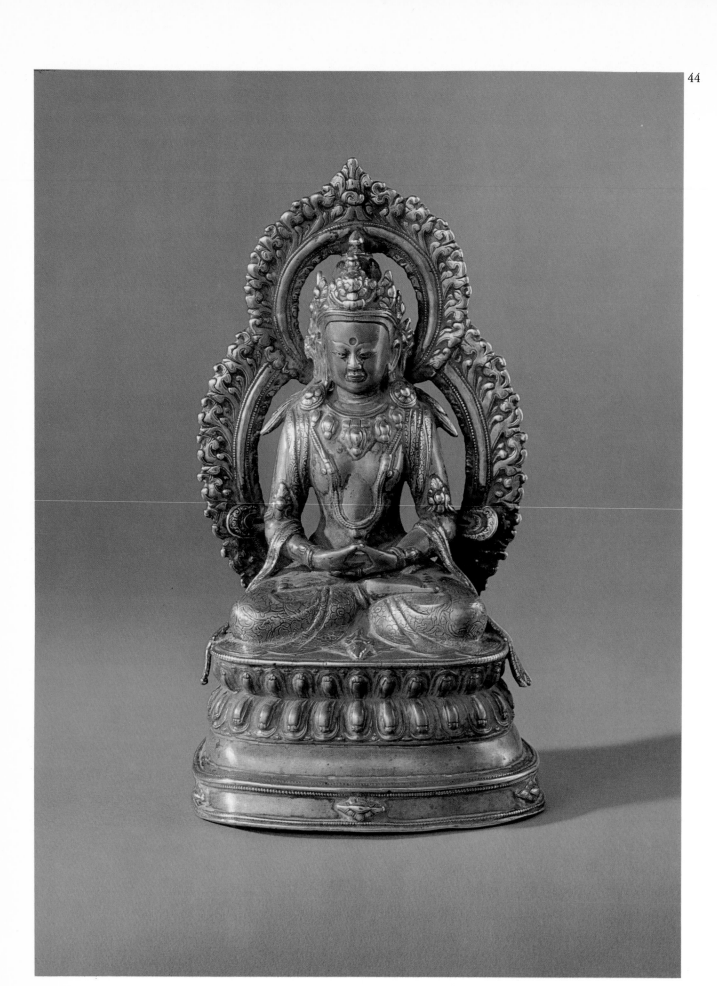

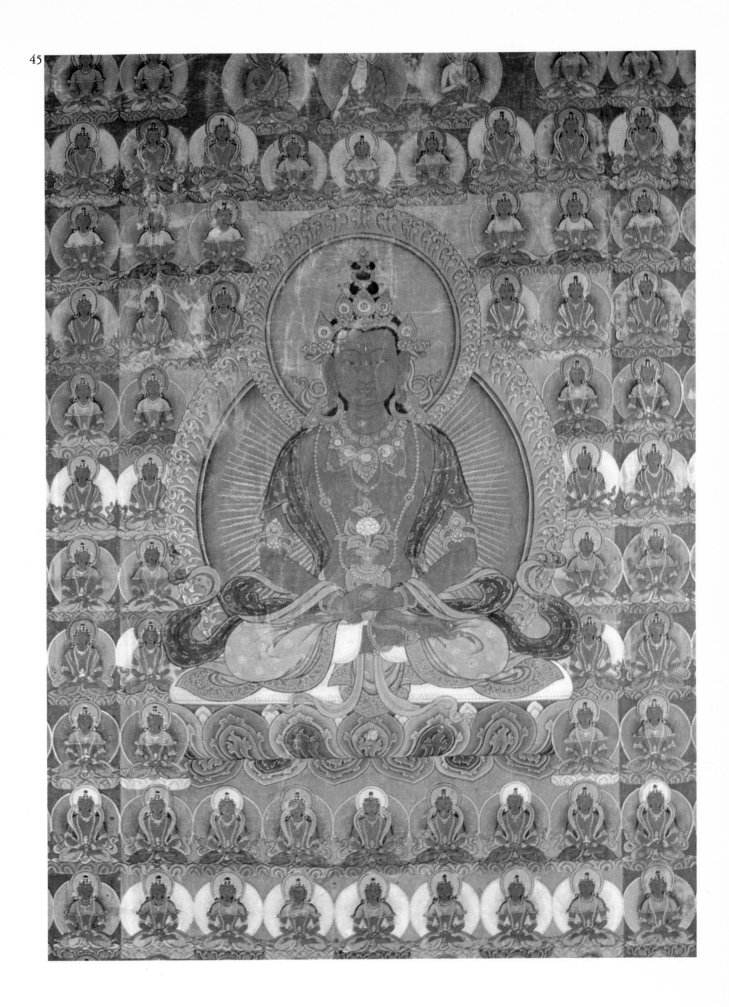

46

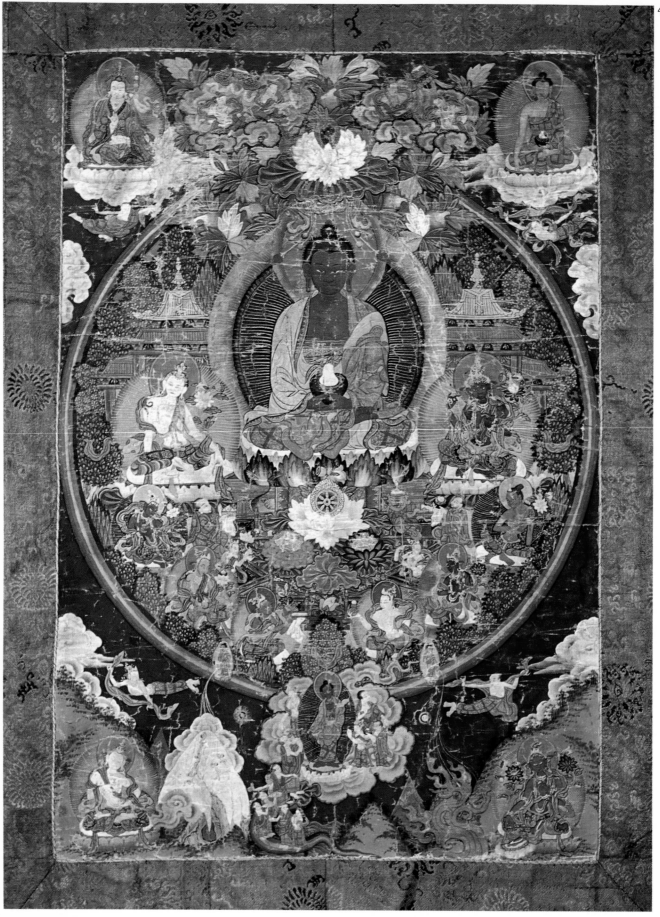

Visionary Unfolding in the Maṇḍala

The general basic scheme of the Maṇḍalas

At the beginning of all tantric meditation there is the conscious realization of the experience of the void. The idea of void is fundamental and must not be overlooked in our examination of the Maṇḍalas. Many tantric texts used in meditation on the aspects of deities, start off (after the first introductory preliminaries) with passages such as this: "Everything changes into the void, all things are devoid of real essence", or "From the perfect pure sphere of the void...", or other similes designed to produce that creative primal situation from which the visions can subsequently unfold.

The Indian tantrist Advayavajra taught that all deities were nothing other than manifestations of the void and have no existence by nature; whenever a manifestation occurs it is, in essence, void. According to another statement by Advayavajra, the process of meditative introspection has four stages: the first stage is the correct realization of the void; at the second stage the vibrations of the mantric germinal syllables (Skr.: Bîja) will prepare the third stage at which a visual manifestation of the deity dawns from the syllable, until at the fourth stage it manifests itself with all its external characteristics and emanations. This then, in simple terms, is the path of Buddhist pictorial meditation. Of course, the reality of meditational experience is much more lively and brilliant to the mystic than can be described here. According to the nature of the germinal syllables, whose vibrations first gave rise to multi-coloured rays of light emerging from the void, the mystic will experience various visions manifesting themselves in his consciousness. From the germinal syllables, the smallest and most highly concentrated symbols of the deities, rays of light originate and then condense into the forms and symbols of the deities until they become recognizable with the utmost clarity and brilliance.

From his knowledge of secret syllables the yogi thus projects the image of the Buddha in a pure "heaven-like" space which he has created in his own consciousness. In his state of concentration the yogi merges with the infinite space of the void and draws images of Buddhas which arise before his inward eye in a magic halo of light. Through concentrated recitation of Mantras all the invoked deities appear in a visionary halo as bright and spontaneous manifestations of the all-embracing void. Proceeding along this path of actualizing deities (Tib.: sGrub-thabs), the meditator can now become aware of all the attributes and characteristics of the deities so that they may help him towards inner perfection. All these visions which the artist attempts to represent in pictorial form of Maṇḍalas, therefore, originate in the individual's "own mind", in the yogic centres chosen as the active centre of concentration.

To understand the numerous manifestations of the Mahâyâna Buddhist deities it is important to realize that these must not be equated with real or presumed gods but that they are merely momentary creations of the yogi during his at-

tentive concentration, projections of the void before his inward eye. Their real meaning is the activation of certain aspects, insights and forces in man; these are symbolic phases represented by the deities. Such meditation should be practised in a state of "enclosed inwardness". The evolution of the vision should proceed evenly in all directions out of the germinal syllables "within the heart lotus", from a "drop of spirit essence" or "amidst heaven-like consciousness", (as it is described in the various texts). The sacred circle (Skr.: Maṇḍala) therefore is the most fitting artistic representation of this process.

The Maṇḍala (Tib.: dKyil-'khor) is a sacred circle surrounded by light rays or the place purified of all transitory and dualist ideas. It is experienced as the infinitely wide and pure sphere of consciousness in which deities spontaneously manifest themselves. Maṇḍalas, therefore, are chiefly realizations of symbolic processes experienced as the visionary image of deities emerging only for the duration of the pictorial meditation before being once more dismissed into the void. The wonderful Tibetan works of art, the paintings of Maṇḍalas reproduced in the plates in this book, are therefore merely a pale reflection of a far more brilliant and intensive experience by the mystic who is at any time capable of producing these transparent manifestations through yoga.

As will be shown later in detail, Maṇḍalas have to be seen as inward pictures of a whole (integral) world; they are creative primal symbols of cosmic evolution and involution, emerging and passing in accordance with the same laws. From this perspective, it is but a short step to conceiving of the Maṇḍala as a creative principle in relation to the external world, the macrocosmos—thus making it the centre of all existence. At the beginning of the meditational creation of the yogi the germinal syllable is seen as the origin and the centre of the visionary world. In a similar fashion, the centre of the Maṇḍala was generally regarded as the centre of the internal and external world (Axis mundi), subject to the same spiritual laws as meditation. The Maṇḍala, therefore, is the sphere cleansed of spiritual obstacles and impurities, it is the pure palace (Skr.: Vimâna, Tib.: gZhal-yas-khang) at whose lotus centre deities assemble. This is why we may describe the Maṇḍala as a symbolic temple of the heart (spirit) and as the sacred place of great mystery. It is not by accident that the centre of the sacred circle contains an archetypal picture of a divine city or holy temple in whose walls the visionary splendour of the Tathâgatas, the imaginary Buddhas of meditation, shall be received.

The diagram Fig. 12, which shows a simplified section of a Maṇḍala, will help us to demonstrate the elements which are almost invariably used in the same order as the basic plan of a Maṇḍala. Plates 49 and 51, moreover, show a multiple circle enclosing the square plan of the sacred palace proper. The outer circle (A) consists of a ring of brilliant flames in five alternating colours. This circle is the Mountain of Fire (Tib.: Me-ri) designed to deny access to the mys-

118

teries to the unenlightened spirit and the unini-
tiated. Symbolically these flames stand for the
burning consciousness which, in the process of
concentration, should consume all spiritual ob-
stacles, impurities, wrong-thinking and the
clouds of ignorance, permitting individuals to
proceed from dualist thinking to gnostic unity.
Then follows the second circle (B), which is on a
black ground and shows the symbols of the Vaj-
ra (Tib.: rDo-rje ra-ba). The Vajra symbolizes
the indestructible adamantine nature of pure
consciousness, and it is the strongest symbol of
the state of enlightenment that can be revealed in
the Maṇḍala. This enlightenment, however,
requires unity of spirit and the overcoming of all
individual activities of the eight forms of con-
sciousness. These eight consciousnesses are eso-
terically represented in the third circle (C) by the
eight cemeteries (Tib.: Dur-khrod brgyad). This
circle, however, is represented only in the
Maṇḍalas of the wrathful deities. With his eight
forms of consciousness (the planes of conscious-
ness of the five senses, of the intellect, of individ-
ual consciousness and of Âlayavijñâna) man is
tied to all phenomena and sensations of the in-
ternal and external world and therefore usually
lacks that concentration and "single-pointed-
ness" of the spirit required for meditation and
deliverance from suffering. The surrender of all
eight forms of consciousness associated with the
illusory world of Saṃsâra is symbolized by this
circle of eight cemeteries each of which has as a
Stûpa its principal symbol. Finally, a ring of
lotus petals (D) forms the inside boundary.

119

Fig. 12. Diagram showing the structure of the Maṇḍalas.

These petals signify the harmonious unfolding of spiritual vision which is possible only in a pure consciousness.

Having passed through the ring of flames and its stages of insight we now stand in proximity to the sacred area of the deities—the Maṇḍala proper. Its square plan shows the four gates (F) at the four points of the compass which are enclosed by the points of a crossed diamond sceptre (Skr.: Viśvavajra). The double Vajra is the symbolic foundation for the square-shaped area of mystery (see diagram). The walls of the temple are in turn sub-divided into five coloured bands and decorated with ornaments. In all Maṇḍalas the walls of the outer courts show victorious and propitious symbols, such as the seven symbols of the universal ruler of the world (Skr.: Cakravartin), the eight sacred signs of Buddhism (Skr.: Aṣṭamaṅgala), and others. The interior of the sacred city is equipped with the four gates and sub-divided by two diagonals into four triangles of equal size; it contains a further circle with Vajra symbols (G). This area encloses the lotus flower upon whose petals (H) the Buddhas or deities appear, arising as emanations from a primal Buddha at the centre (I). This centre of the Maṇḍala is the creative locus of mystery where shining visions of Buddhas originate from the rays of the void. It is the paradisaical visionary realm of the Buddhas which unfolds in the heart lotus of the yogi and can also arise as special insights and qualities in the consciousness of the disciple. The whole external Maṇḍala, therefore, is a model of that spiritual pattern which the meditating individual sees within himself and which he must endeavour to experience in his own consciousness, starting from the small germinal syllables all the way to infinite dimensions.

The Maṇḍala of the five Dhyânibuddhas

The most important part of the Maṇḍala to consider now is the square centre with its innermost circle. Here we encounter a whole series of systems based on the symbolical number of five; these can reveal to us the deeper meaning of the Maṇḍalas as tantric meditation devices. The square is divided into four equal triangles at the centre of which a circle, as a fifth spatial element, radiates. In this circular field the five meditation Buddhas or Dhyânibuddhas appear. This type of Maṇḍala is found in the most ancient Tantras from the earliest periods of Indic tantrism. This five-fold aspect of the first and oldest group of tantric Buddhas can also be represented by the five colours, the five symbols, the five syllables, Mudrâs or elements (to list but a few relationships from the same Maṇḍala). The origin of the five Dhyânibuddhas (Tib.: rGyal-ba rigs-lnga) can be traced quite impressively in the Guhyasamâja Tantra. These Buddhas are patterns of a purely imaginary experience—they never existed as historical figures. We therefore refer to them by the more general term of the Tathâgatas. A few meanings from the large group of the five aspects will be considered here, since the symbolism of the five Tathâgatas is of fundamental im-

120

portance to the structure and understanding of all Maṇḍalas.

First, from the void, the white germinal syllable *Oṃ* manifests—it is the symbol of a pure original consciousness, the Buddha Vairocana. He is the first or primal Buddha of the Maṇḍala, and here functionally corresponds to the Âdibuddha. Vairocana is of pure white colour and appears at the centre of the Maṇḍala surrounded by a halo of blue light. His lotus throne is supported by lions and his hands are held in the Dharmacakramudrâ. Vairocana is the "radiant", the original light of pure consciousness. Each of the five Dhyânibuddhas also personifies one of the five psycho-physical constituents which combine to make up the human personality. These five modalities of our being are corporality (Skr.: Rûpaskandha), consciousness (Skr.: Vijñânaskandha), sensation (Skr.: Vedanâskandha), perception (Skr.: Samjñâskandha) and volition or striving (Skr.: Saṃskâraskandha). We experience all our suffering in this world (Saṃsâra), as well as our possible emancipation, through these five modalities.

The second Tathâgata appears as an emanation of Vairocana through the vibrations of the blue germinal syllable *Hûṃ* and is the Buddha Akṣobhya (sometimes Vajrasattva)—the ruler of the sphere of corporality. Akṣobhya, the "Unshakable", is blue and appears in the east of the Maṇḍala on a lotus throne supported by elephants; his Mudrâ is that of touching the earth. It should be noted that Vairocana and Akṣobhya can also exchange places in the Maṇḍala; the table given below must therefore be seen merely as one version of the Maṇḍala patterns which vary a good deal according to school and text.

The third position in the Maṇḍala is held by the Buddha Ratnasambhava, emerging from the yellow syllable *Traṃ*. He represents the area of sensation. Ratnasambhava, "the jewel-born", is yellow and occupies the south of the circle, seated upon a lotus throne supported by horses. His right hand shows the Varadamudrâ.

He is followed in the west of the Maṇḍala by the Dhyânibuddha Amitâbha emerging from the red germinal syllable *Hrîḥ*. He is the Buddha of infinite radiance and rules over the sphere of perception. Amitâbha is red, holds his hands in the Dhyânamudrâ (meditation), and is seated on a throne supported by peacocks.

In the fifth and last place, in the north, the Tathâgata Amoghasiddhi appears from the green germinal syllable *Khaṃ*. He presides over the sphere of volition and karmic intention. Amoghasiddhi is green, his right hand shows the Abhayamudrâ (the gesture of fearlessness), and he is seated upon a lotus throne supported by Garuḍas.

This completes the Maṇḍala and illustrates at least part of this cycle. Plate 48 shows the five Tathâgatas with their characteristic Mudrâs in ancient Tibetan miniatures.

But we must go considerably further in our understanding of the five Dhyânibuddhas in order to appreciate the universal significance of this Maṇḍala. We have already seen that Buddhas

appear in five symbolically formalized colours and that they are pictorial models of the five modalities of the human personality. It follows, therefore, that these Buddhas are looked upon as beings whose activity will manifest itself through man himself. The Maṇḍala thus becomes a cosmic plan in which man and the world are similarly ordered and structured. These Tathâgatas are not only symbols of our personality but also are equally forces in the cosmic structure. Going one step further, we find that a whole well-ordered cosmological, spiritual and psychic order emerges from this basic Maṇḍala of the five Buddhas. This basic order becomes the model of many other creative cycles of divine emanations handed down to us in many different Maṇḍalas. They must all be understood, however, merely as visual manifestations originating from the five Tathâgatas. In their entirety they are nothing but reflections of the void into which they are once more dismissed when the visualization is over. In this sense the five Buddhas are described as the mystic creators of all other Buddhas and of the many deities which symbolize, as emanations of the five fundamental elements, all conceivable aspects of a whole visionary concept of the world which Lamaism developed from the basic Maṇḍala.

The five Tathâgatas are the heads of the five families, (Skr.: Pañcakula, Tib.: Rigs-lnga) of all the Buddhas and deities which have evolved as emanations from these Buddhas. Each of the Buddhas is therefore seen as lord over a group of deities, each labelled according to its special symbol. At the same time each of these Buddhas represents one of the five cosmic elements and its secret powers. According to the order laid down in the basic Maṇḍala, the Tathâgatas have the following symbols as their invariable characteristics: Cakra, Vajra, Cintâmaṇi, Padma and Viśvavajra. They rule over the elemental cosmic realms of ether, water, earth, fire and air. If we relate this symbolism to the basic colours white, blue, yellow, red and green, and additionally to the Maṇḍala's fixed compass points, then we begin to understand the greatness of this concept developed by esoteric Buddhism which endeavoured to make even macrocosmic events comprehensible in terms of spiritual images. In later Buddhism the Maṇḍala became a symbolic diagram or plan of the structure of the worlds. We shall return to this point later. Meanwhile, we must consider yet another important aspect of the Tathâgata Maṇḍala, namely the great tantric equations represented by the special attributes of the five wisdoms and by the female equivalents of the Buddhas, the Prajñâs or Yoginîs. Only if this dynamic aspect of the basic Maṇḍala is understood can it become an active factor of inward mystic experience and transformation. Only through this symbolism of polarity becoming unity can the Maṇḍala and its deities become an active force in man's spiritual life. We have thus arrived at the conviction that Maṇḍalas are not just graphic or artistic patterns of a purely theoretical kind but instead represent active schemas which involve a clear plan for practical

122

realization. Without this goal of realization they would be of no practical value.

The equation of the five components of the human personality with the nature of the Dhyâ-nibuddhas shows us straight away that the five mystic Tathâgatas are to be understood as parts of our own nature and that, as manifestations of the elements, they must moreover be seen as constituents of the physical structure of the cosmos. For the Mahâyâna follower the meditation Buddhas develop their beneficial activity only in the measure to which the initiate succeeds in recognizing and realizing these characteristics and symbolized forces within himself. The five Tathâgatas are regarded as symbols of the five components of man's personality and also of the five so-called fundamental evils which are understood as the great opposing forces of the five Buddha wisdoms.

It is the task of the tantric path to purify the five aggregates (Skr.: Skandhas) or spheres of action, to purify our personal existence of all karmically encumbering forces in order to transform them into their appropriate forms of insight or wisdom. Once again we encounter here the tantric method of not attempting to suppress a negative quality but rather recognizing it through discriminating insight which then instantly transforms it into a positive and better quality. The five-fold group of these negative forces, which are regarded as expressions of ignorant or unenlightened man and which keep him tied to the world, are: ignorance (Tib.: gTi-mug), hate (Tib.: Zhe-sdang), pride and self-seeking (Tib.: Nga-rgyal), craving (Tib.: 'Dod-chags), greed and avarice (Tib.: Phrag-dog). These principal faults are assigned as symbolic qualities in the basic Maṇḍala to the five Buddhas, i.e. to the components of the individual himself. This is why the Tibetan Book of the Dead (Tib.: Bar-do thos-grol) recommends meditation on the true nature of these five Buddhas so that the great wisdoms of these Buddhas may take the place of the five negative forces. The five great wisdoms of the Tathâgatas, as shining goals of spiritual transformation, are directly opposed to the five groups of individual and corresponding negative forces.

The white Buddha Vairocana personifies the wisdom of understanding the universal law (Tib.: Chos-dbyings ye-shes), in which pure consciousness and the total isolation of the void become identical. Here the last remnant of ignorance is dispersed in the infinity of the absolute. All wisdoms and all forms of higher insight are contained in the principle of the wisdom of the Dharma sphere.

Akṣobhya, the blue Buddha in the east of the Maṇḍala, is the embodiment of the mirror-like wisdom (Tib.: Me-long ye-shes). In mirror-like consciousness all manifestations become empty illusions of unreality. The mirror-like wisdom reflects all forms and leads to the realization of the illusory character of all forms. Here waves of hate do not strike real objects—they are extinguished or sink back into themselves.

The yellow Buddha of the south, Ratnasambhava, is the embodiment of the wisdom of fun-

123

47 At important historical centres of Lamaism, extensive monasteries and temple complexes, enlarged by numerous subsequent additions, developed over the years. The temple of Byams-pa lha-khang, at Bumthang in eastern Bhutan, goes back to the time of the kings of Tibet. Among its present six temples the most ancient is the one erected for the great statue of the Buddha Maitreya. This statue of Maitreya, the Buddha of the age to come, is several feet tall and surrounded by a magnificently carved halo. The rich carving includes two descending dragons and, flying at the top in the centre, the mythic bird-king Garuda flanked by two fairy deities. Maitreya is dressed in magnificent brocade garments and adorned with precious stones. The large statue was probably set up in the temple when it was restored in the seventeenth century.

48 Five miniatures in the delicate pastel shades of an artist's sketch may serve as an introduction to the nature of the Mandalas. These are the five Tathâgatas or Dhyânibuddhas of the first Mandala of Vajrayâna, as represented in the Guhyasamâja Tantra. Beginning top left, we see the white Buddha Vairocana (Tib.: rNam-par snang-mdzad), the blue Buddha Akṣobhya (Tib.: Mi-bskyod-pa), the yellow Buddha Ratnasambhava (Tib.: Rin-chen 'byung-ldan), the red Buddha Amitâbha (Tib.: 'Od-dpag-med) and the green Buddha Amoghasiddhi (Tib.: Don-yod grub-pa). Each Buddha is characterized by his colour and his different Mudrâs. The small watercolours

are 5 cm (2 in.) high. Circa fourteenth to fifteenth century.

49 All Mandalas develop from the basic principle of the first Tathâgata Mandala in which the five Buddhas are arranged according to colours, symbols, Mudrâs, cosmic compass points and meaning. All Mandalas, therefore, represent a single great evolution from a unique visionary plan which has developed according to the laws of the psychic experience of totality. This plate already shows a first derivation in the representation of the Mandala of the five Dhyânibuddhas and their female counterparts (Prajñâ), as mandatory for the visions of the Tibetan Book of the Dead. In this Mandala the initiate finds the forty-two peaceful deities of the Bardo Mandala, most of which are identifiable only as coloured dots. Only the five Buddhas (as tantric couples) are identifiable as icons. From a painting school of the rNying-ma-pa sect.

50 In certain rituals the lamas are themselves ritually present in the Mandala of the deities, when they symbolically represent the deities of the Mandala through meditation on their attributes. It is then that lamas wear the raiments and the crowns of the five Buddhas. These crowns consist of five petals in silver and gold, on each of which is painted one germinal syllable (Skr.: Bîja) or the picture of a Tathâgata. The plate shows lamas of the dGe-lugs-pa sect during the ritual for the deity rDo-rje shugs-ldan on the day of a lunar eclipse.

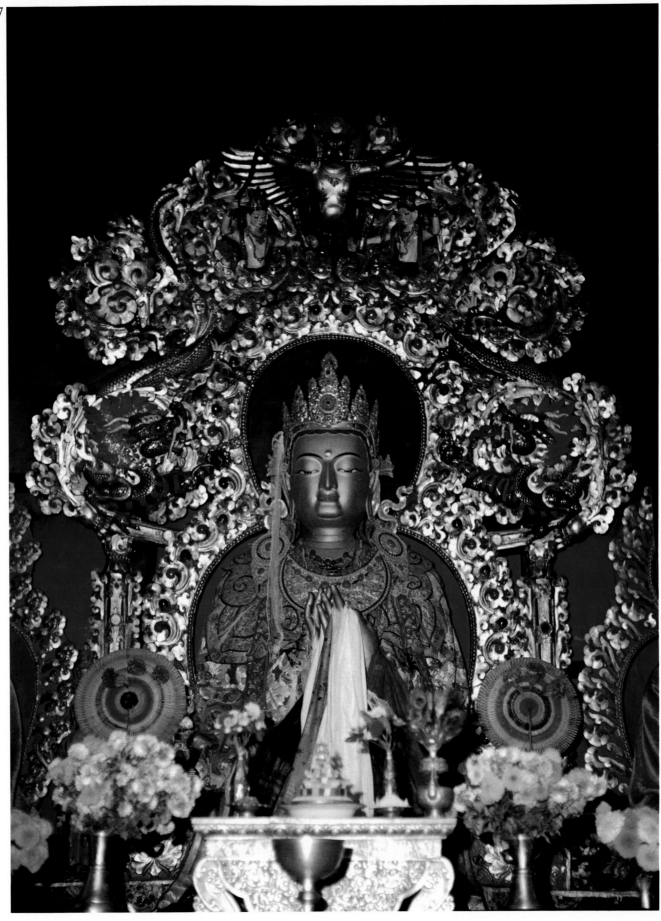

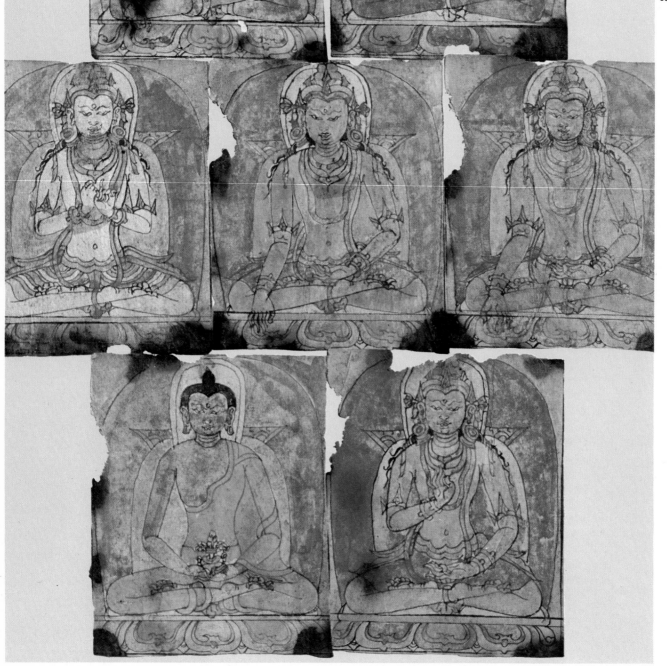

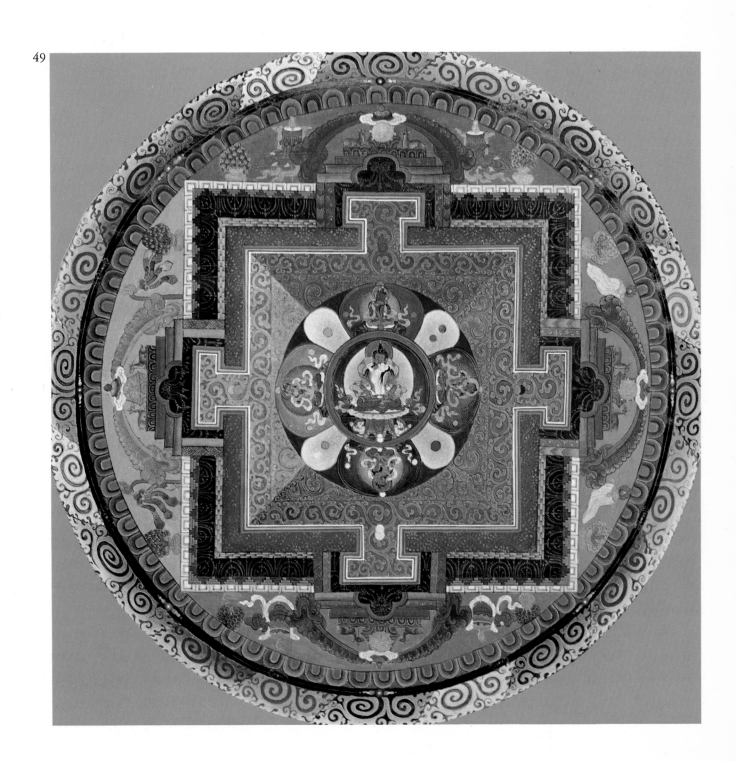

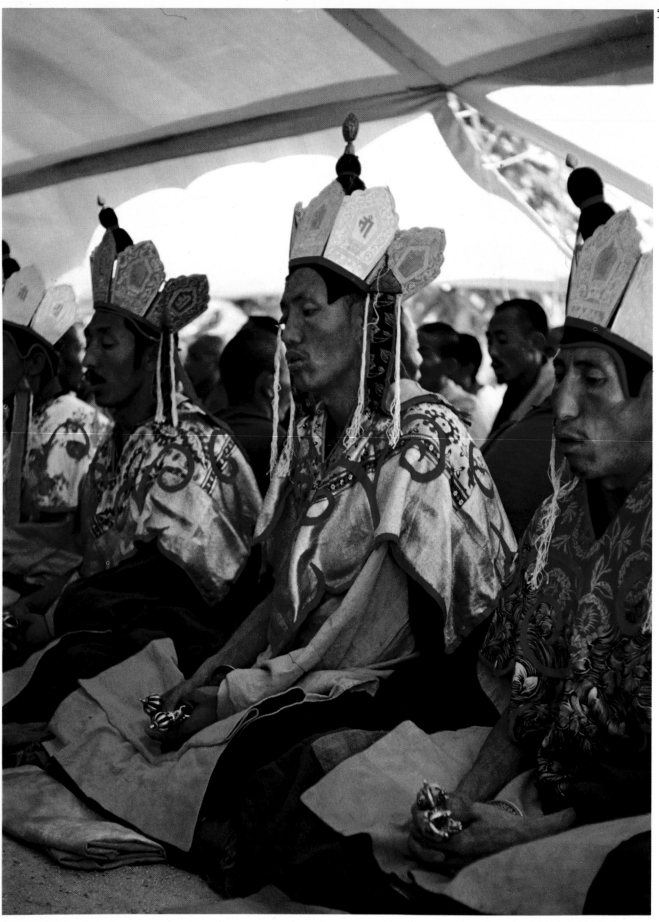

damental equality (Tib.: Mnyam-nyid ye-shes), in the face of which all things reveal their equal origin as things created and evolved. In the realization of this wisdom, all self-advancement, self-importance and over-bearing are annihilated.

In the west of the Maṇḍala is the red Buddha, Amitâbha, as the personification of the wisdom of all-pervading discrimination (Tib.: Sor-rtogs ye-shes). This wisdom of pure insight, or penetrating contemplation and discrimination of all aspects of existence, is an indispensable force and help for correctly recognizing human passions and cravings for things of the transitory world and for eliminating them from human thought.

Finally, Amoghasiddhi, the green Buddha in the north, is the personification of all-performing wisdom, the wisdom which accomplishes (Tib.: Bya-grub ye-shes), the wisdom which recognizes that all karmic strivings (Skr.: Saṃskâra) are to be completed and fulfilled (Tib.: Bya-grub), and that all fruits of karmically effective deeds will reach maturity.

The law of karma is inescapable; it operates in the rigidly defined sequence of cause and effect, a sequence continued through every action, spoken utterance and thought. We reap all the consequences of our actions; avarice becomes pointless with this realization because all ties merely create more karma which would further delay the possibility of liberation.

We already know that in the tantric system of Mahâyâna Buddhism all Buddhas and deities have their female correspondences, the Prajñâs, Mudrâs or Ḍâkinîs, with whom, in inseparable union, they form the divine pair in the symbol of the *unio mystica*. This fundamentally two-fold image of the individual, embracing the polarity of male and female, is clearly manifested also in the Maṇḍala of the Tathâgatas. The five Mudrâs, or female counterparts of the Buddhas, are here, in the same Maṇḍala order, Âkâsadhâtvîsvarî (or Locanâ), Locanâ (or Vajradhâtvîsvarî), Mâmakî, Pâṇḍarâ and Samayatârâ. They are described as wisdom (Skr.: Prajñâ) and as the divine supreme mother (Tib.: Yum-mchog), but their significance is still more profoundly linked with the entire symbolic world of the Maṇḍalas. The five female counterparts of the Buddhas constitute the group of the five fundamental elements of the cosmic world structure which, according to these doctrines, is made up of the elements of water, earth, fire, air and ether (consciousness). These five elements, on the other hand, are the foundation of the created world and also of the five groups which in the individual forms his personality. We thus have the five Tathâgatas as rulers over the five Skandhas through which we perceive all connections with the outer world, and confronting them, the five female figures which participate in cosmic events through the world of the elements (Skr.: Dhâtu, Tib.: 'Byung-ba). This brings us into the realm of the cosmic concepts of Buddhism according to the principles of the Maṇḍalas, and we shall presently realize the extent to which this basic Maṇḍala of the five Buddhas has become the centre of a fully devel-

	Symbolism	Vairocana	Vajrasattva-Akṣobhya	Ratnasambhava	Amitâbha	Amoghasiddhi
1.	Order in the Maṇḍala	Centre	East	South	West	North
2.	Germinal syllable (Bîja)	Oṃ	Hûṃ	Traṃ	Hrîḥ	Aḥ
3.	Prajñâ/Mudrâ	Âkâśadhâtvîśvarî	Locanâ	Mâmakî	Pâṇḍarâ	Samayatârâ
4.	Family	Moha	Dveṣa	Cintâmaṇi	Râga	Samaya
5.	Colour	White	Blue	Yellow	Red	Green
6.	Mudrâ (Gesture)	Dharmacakra	Bhûmisparśa	Varada	Dhyâna	Abhaya
7.	Symbol	Wheel of doctrine (Skr.: Cakra)	Diamond sceptre (Skr.: Vajra)	Jewel (Skr.: Ratna)	Lotus (Skr.: Padma)	Crossed Vajra (Skr.: Viśvavajra)
8.	Vehicle (symbolic animal supporting the throne)	Lion	Elephant	Horse	Peacock	Garuḍa
9.	Aggregate (Skandha)	Consciousness (Skr.: Vijñâna)	Body (Skr.: Rûpa)	Sensation (Skr.: Vedanâ)	Perception (Skr.: Samjñâ)	Volition, intention (Skr.: Saṃskâra)
10.	Five Poisons	Ignorance	Hate	Pride, self-seeking	Passions, craving	Greed and avarice
11.	Wisdom	Wisdom of the universal law	Wisdom of the mirror	Wisdom of equality	Wisdom of distinction and discernment	Wisdom acomplishing works
12.	Associated Bodhisattva	Samantabhadra	Vajrapâṇi	Ratnapâṇi	Padmapâṇi	Viśvapâṇi
13.	Element	Ether	Water	Earth	Fire	Air

oped and thought out doctrinal system whose profound teaching has had a lasting effect on the cosmology of Mahâyâna Buddhism. To discuss the structure of the Maṇḍala symbolism in greater detail would go beyond the scope of this book. But the noble beauty and seemingly impenetrable variety of the Maṇḍalas here reproduced make us realize the importance which must be attached to these extremely esoteric teachings and traditions of Buddhism.

The table on this page sums up the most important symbolic meanings and references of the Maṇḍala of the five Dhyânibuddhas in accordance with a group of texts from the extensive tradition of the Tibetan Book of the Dead (to which reference will be made later).

The world as a cosmic Maṇḍala

The arrangement of the Maṇḍala according to the five elements takes us from purely philosophical and soteriological spheres and speculations to the far-reaching cosmological concepts of the Tibetans. They built their monasteries and developed a symbolic world order created as a Maṇḍala of the universe. The best-known emblem of this cosmic concept of the involvement of the entire world in the spiritual and religious sphere, in Tibet and other countries of northern Buddhism, is the large number of Stûpas which line the roads of the pilgrims and dominate the monastery courtyards and sacred places.

The vast temple complex of bSam-yas was understood as a reflection of this Buddhist concept of the world; it was built in Tibet in the eighth century by the Indian masters Padmasambhava and Śântarakṣita. This structure, majestic by the standards of this early Tibetan period, corresponded in plan with the pattern of an ideal Maṇḍala at whose centre, symbolizing the world-mountain Meru, the central temple (Tib.: dBu-rtse lha-khang) rose. Originally, its three floors were built in three different styles—the lower level in the Chinese style, the second floor in the Indian style and the top floor in the central Asian style of Khotan (Tib.: Li-yi-lugs). Around this main temple, whose three (or, according to certain texts, four) floors contained the famous statues of the Buddha Śâkyamuni, the Buddha Vairocana and the Yidam Śaṃvara, one further temple was erected at each of the four cosmic points; these four additional temples were regarded at the symbolic locations of the four continents (Tib.: gLing-bzhi). In the east stood the 'Jam-dpal-gling temple, in the south the Âryapâlo temple, in the west the Byams-pa-gling and in the north the Sems-bskyed-gling. The eight minor continents (Tib.: gLing-phran-brgyad), which were assigned in pairs to the major temples (countries), were built in the form of small chapels. These small temples were to the right and left of the four large buildings. Moreover, the complex also included four large Stûpas (Tib.: mChod-rten), in their symbolic colours of white, red, blue (or black) and green (or blue). To the north of the central temple there were two additional small temples which were dedicated to the moon and sun (Tib.: Nyi-zla lha-khang). The entire complex was surrounded by a wall and thus constituted a model of a huge three-dimensional Maṇḍala, a symbolic centre of the world, from which the Buddhist doctrine was propagated in Tibet. The monastery complex of bSam-yas was therefore also known as the "Great Wheel of Doctrine" (Tib.: Chos-'khor chen-po); just as the wheel of doctrine was all-embracing, so this monastery, where the first Tibetan monks were trained, was all-embracing, representing all the treasures of Mahâyâna.

From the architecture of the cosmic Maṇḍala at bSam-yas it is easy to arrive at an understanding of the fundamental pattern of Buddhist cosmology which belongs to the essential foundations of the Tibetan concept of the world. The world

51 This Maṇḍala belongs to the Sa-skya-pa tradition of Ngor. It is the thirty-two fold Maṇḍala of the deity Akṣobhya-vajra from the Guhyasamâja Tantra. At the centre is the Âdi-buddha in his special tantric form of Akṣobhyavajra with his female counterpart; the centre of the Maṇḍala is enclosed in a ring of Vajras and a special ring of fire. The deities are spread out among the four cosmic points of the compass and the halfway points in between. Of interest to the psychologist of religion is the fact that in the east (white) and the west (red) of the Maṇḍala there are two deities each guarding the gates. Tibet, eighteenth century.

52 One of the most interesting deities of Buddhist tantrism is Hevajra (Tib.: Kye-rdo-rje). An entire doctrinal system is associated with the name of this initiation deity, handed down to us in the Hevajra Tantra and its extensive commentaries. The magnificent eighteenth century gilded bronze conveys a vivid impression of the flowering of bronze casting in Tibet.

53 By way of comparison with Plate 52, this tantric painting on a black ground represents the Yidam Hevajra with the deities of his Maṇḍala in the prescribed iconographic colour scheme (see pages 181f.). Hevajra has eight heads, sixteen arms and four legs; he is of deep blue colour and embraces a pale blue Prajñâ. Grouped around the deity are eight Ḍākinîs and above are the gurus of the Sa-skya tradition. At the top, centre, is the Âdibuddha Vajradhara, to the left the Indian

Siddha Virûpa and on the right the founder Sa-chen kung-dga' snying-po. Paintings on black ground were intended for the secret rites of the guardian deities and were concealed from the uninitiated.

54 A Tibetan painting with the Maṇḍala of Sarvabuddhaḍâ-kinî (Tib.: Na'-ro mkha-spyod-ma), showing the use of symbolic triangles which mutually intersect to form a hexagram. The meditational evocation of four further deities is indicated in the hexagram by four whirls of light in the four small lateral triangles. Meditations on this Ḍâkinî are likewise part of the most carefully guarded Tibetan secret doctrines. Sarvabud-dhaḍâkinî is a wrathful manifestation: her meditation and invo-cation demand the overcoming of the symbolic eight graveyards (Tib.: Dur-khrod-brgyad) which form the boun-dary of the inner Maṇḍala against the outside.

55 This picture shows the Maṇḍala of the Indian Mahâsiddha Maitrîpâda, a favourite Maṇḍala especially among the 'Brug-pa sect. The representation closely follows the text as repro-duced on pages 172–174. At the centre of the Maṇḍala is Śaṃ-vara with his red Prajñâ; standing upon the inner lotus circle are four Ḍâkinîs and four vessels with the water of life and the Kapâla. Together with the remaining deities of the square inner court and the four gates they form the thirteen-fold Maṇḍala of Śamvara.

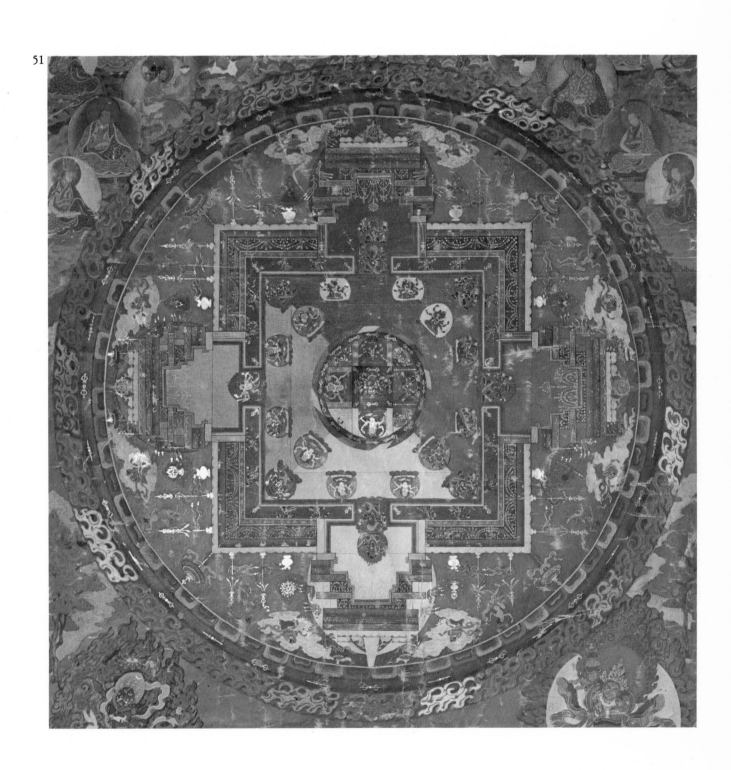

51

52

53

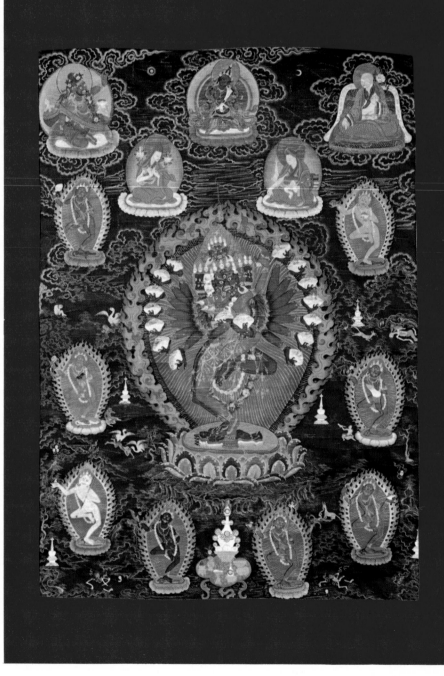

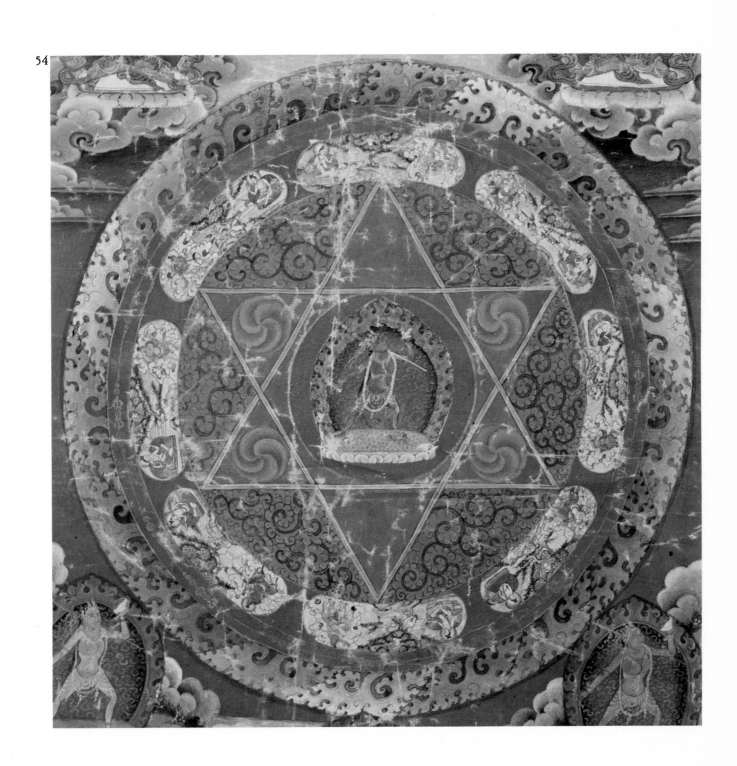

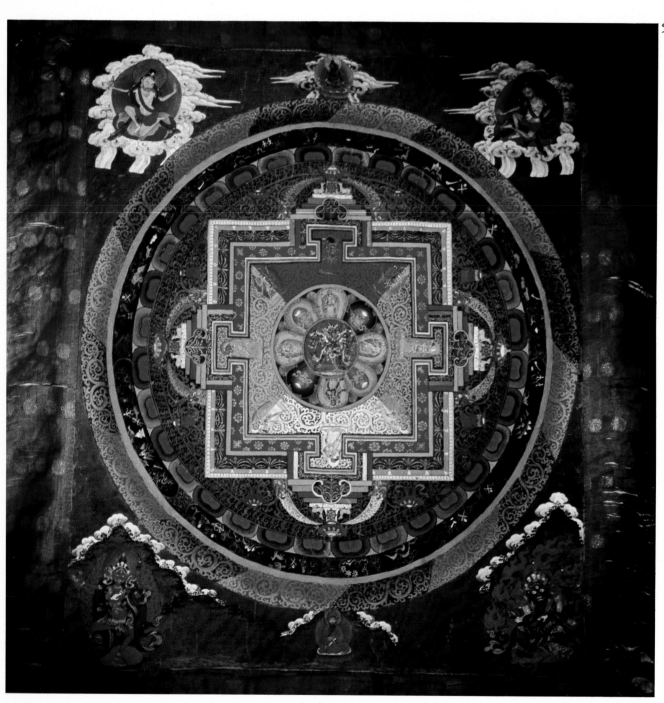

mountain Meru and, surrounding it, the world Maṇḍala with the continents at the four cardinal points, is the universal world symbol as a model of the countless worlds which Buddhism regarded as existing. That is why we encounter such representations of the Buddhist universe in almost every monastery, either as a fresco on a wall or as some other kind of painting to serve the pictorial orientation of monks and laymen. The diagram Fig. 13 shows a slightly modified representation of the Buddhist universe, which we may regard also as the model of the bSam-yas monastery.

Each universe is located in infinite space. It rises above a layer of pure air in the form of a crossed Vajra (Skr.: Viśvavajra). Above these airy spheres lie the realms of water, and upon these rests a ground of pure gold. Above the middle of the golden surface rises Mount Meru (see also Plate 58), and above it, reaching out farther and farther, are the immeasurable spheres of the twenty-eight different heavens. The world mountain Meru, the axis of the cosmos, has four sides: the eastern is of silver (white), the southern is lapis lazuli (blue), the western is ruby (red), and the northern is of gold (yellow). All around the world mountain, which is the holy place of gods and Buddhas, lie seven ranges of golden mountains and the same number of circular oceans of varying depth. Outside these mountains, in the vast spaces of a gigantic ocean, at the four points of the compass, upon a ground of pure gold, lie the four great continents with the eight lesser continents. Each of the four great continents is accompanied by two lesser continents. To the east of the world ocean we see the white and crescent-shaped Videha, in the south is Jambudvîpa, which is blue and shaped like the shoulder-blade of a sheep. Jambudvîpa is the world of humans, whereas the remaining worlds are inhabited by purely mythical creatures. In the west of the cosmos lies the country of Godânîya, a circular continent of red colour. In the north we see Uttarakuru as a square continent of yellow (or green) colour. Each cosmic world of this kind is lit by a sun and a moon, and above the world mountain Meru, the heavens of the different orders of divine creatures are spread out. The topmost and most extensive of all celestial spheres is the home of the Âdibuddha Vajradhara. Buddhists and Hindus used to venerate the sacred mountain of Kailash (in western Tibet) as symbolizing Mount Meru. It was regarded as the sacred centre of the world and even in the ancient period of Indian religions was thought to be the throne of the gods. For Hindus, Kailash was the home of Śiva, whereas in the Buddhist tradition the initiation deity Śaṃvara inhabited its summit.

The Stûpa as a symbolic piece of architecture and wayside shrine

The best known picture of the cosmos is the Stûpa (Tib.: mChod-rten); in fact, it might be called the symbolic form of Tibetan Buddhist architecture par excellence. Wherever one fol-

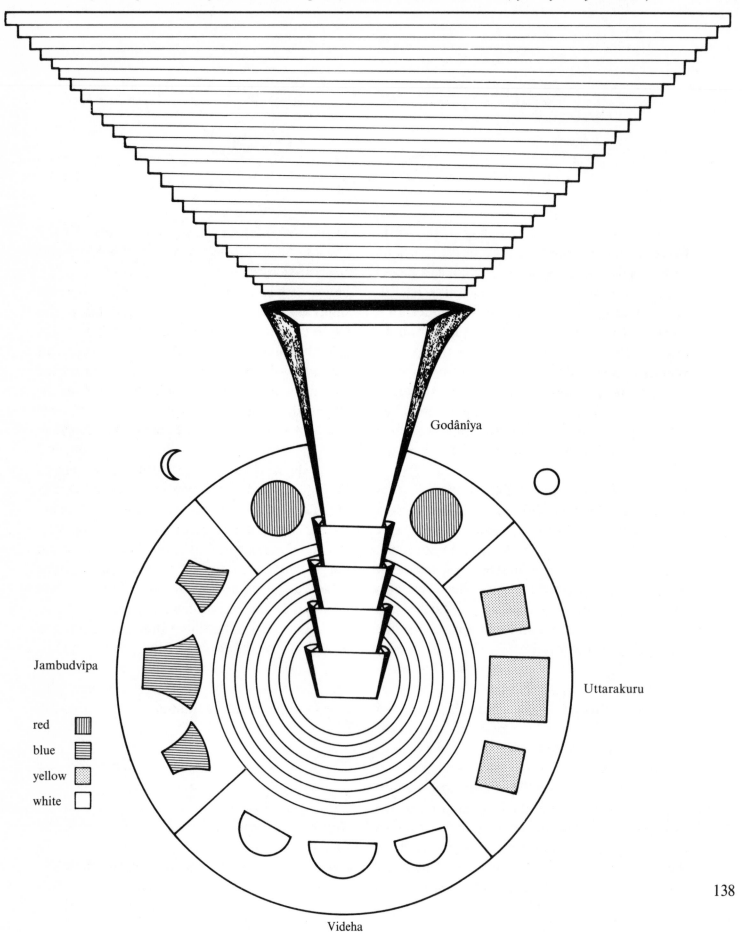

Fig. 13. *Representation of Buddhist cosmological ideas: the world mountain Meru (after a fresco from Lahul).*

Godânîya

Jambudvîpa

red

blue

yellow

white

Uttarakuru

Videha

138

lows a pilgrim's path through the Buddhist Himalayas (Plate 56) to Tibet, at places of pilgrimages, outside caves of meditation, in hermitages, and within the precincts of every monastery—everywhere one encounters the Buddhist Stûpa. It originated as the monument on the Buddha's tomb, it has served as a repository of the relics of the Buddha or his disciples, and in Tibet it has acquired a wider significance as a symbolic structure and sculptured Maṇḍala. It was used for a variety of purposes: marking the spot where the ashes of lamas and saints were buried, serving as a consecrated shrine for the preservation of sacred scriptures, pictures of the Buddha or votive tablets (Plate 56), or as a landmark along the pilgrimage tracks, in token of the ever-present Âdibuddha who resided at the centre of the Stûpa. At the same time, the Stûpa was an image of the cosmos, a symbol of the five elements of which all created things are composed. The Stûpa became a reminder of the law of transience which applies to everything made up of the five elements including life itself.

Illustration 14 clearly shows us the composition of the Stûpas from the five elements. Beginning with the physically heaviest element of earth, the structural elements rise in clear symbolism towards the transcendental sphere. The yogic flame of the ethereal points upward, above the symbol of mystic union of sun and moon, into the invisible nature of enlightenment and Nirvâṇa. Thus the elemental structure of Lamaist Stûpas becomes an architectural model for man's path; from earth-bound and deluded

stages to higher stages of existential awareness of the spiritual which has cast off all material fetters. All elements of the cosmos are changeable and have no abiding reality; they are merely principal symbols of a temporarily limited state and emerge in the Maṇḍala from the mystic germinal syllables. If we compare the colours of the elements with the basic colours of the Maṇḍala, we once more discover the meaning of the nature of the five Tathâgatas or Dhyânibuddhas, a

Symbols	Germ. Syll.	Colours	Elements	Tathâgatas
	Khaṃ	Blue	Ether	Vairocana
	Yaṃ	Green	Air	Amoghasiddhi
	Raṃ	Red	Fire	Amitâbha
	Vaṃ	White	Water	Akṣobhya
	Laṃ	Yellow	Earth	Ratnasambhava

Fig. 14. Cosmic symbolism of Buddhist Stûpa in Tibet.

139

meaning which is effective through all phases of Buddhist symbolism. The Tathâgathas are present in the Stûpa as the all-embracing unity of the Âdibuddha, whose nature has found an eternal abode in the spherical centre of the Stûpa (Tib.: Bum-pa). This centre, which also represents the elemental water (the primal ocean) and universal consciousness, is the symbolic location of the Âdibuddha or the pure Buddha essence. That is why in the great holy places of Nepal, in the Stûpa of Svayambhûnâth and elsewhere, only the four Dhyânibuddhas of the Maṇḍala are visible in the chapels at the four cardinal points. Vairocana, the middle and first Buddha, abides hidden in the middle of the great dome of the Stûpa.

To sum up, we recognize that the Stûpa, especially in its Lamaist form, is not only a cosmic Maṇḍala of five elemental symbols reduced to their most essential form, but is simultaneously the spiritual and religious world structure of a human spirit which realizes and orders these forms through its experiences. In the Stûpa we recognize the ideal model of a universal form of Buddhist symbolic architecture, a form in which the nature of matter and its cosmic order, as well the spiritual nature of all-embracing insight, are joined in a single form.

Avalokiteśvara, the redeemer in six worlds

Of considerable importance along the Buddhist path of purification is the so-called Wheel of Life (Tib.: Srid-pa'i 'khor-lo), which shows the six spheres of existence within which the sorrowful lives of non-enlightened beings take place. As we shall presently see, those six spheres of existence are by no means a merely theoretical contruct. They must be seen as living examples of certain vices or wrong basic attitudes of the human character. These representations of the Wheel of Life go back to the ancient Buddhist teachings, according to which humans dwelling in the world of craving, hate and delusion are time and again lead back to a sorrowful existence. Ignorance, in contrast to enlightenment, keeps man chained to the existence of the six-fold world of wandering. Liberation from these worlds is the main goal of Buddhist teaching. That is why, according to the Mahâyâna tradition, the great Bodhisattva of compassion (Avalokiteśvara), transformed into a Buddha and descended to the six spheres of worldly existence in order to show all creatures the path of liberation. This path of the Bodhisattva is described in its various aspects in the long treatise Maṇi bka'-'bum, that important work of the Tibetan king Srong-btsan sgam-po. Equally important is the doctrine of transmigration through the six worlds, as described in the writings of the Tibetan Book of the Dead, where it was developed into a major theme. We time and again find as a recurrent motif in these scriptures—the famous six-fold formula of the Bodhisattva Avalokiteśvara—*Oṃ ma ṇi pad me hûṃ,* whose syllables are assigned to each of the six worldly realms.

Because of its clear and impressive didactic con-

tent the Wheel of Life is painted on a wall in a prominent place in nearly all Tibetan monasteries, or else it is found hanging in the temple as a meditational picture (Plate 59). The six realms of existence are those of the gods, titans, humans, animals, hungry spirits (Pretas) and denizens of hell. These worlds share a common centre which may be described as being the three fundamental poisons which give rise to sorrowful rebirth. The three fundamental poisons (Tib.: Dug-gsum), as mentioned before, are desire, hatred and ignorance. They are symbolized at the centre of the wheel by the cock, the serpent and the pig, respectively. All other vices, which lie at the foundation of the six worlds, arise from these three fundamental faults. For these six realms are the worlds of suffering which must be overcome if the right path to liberation is to be followed—a lesson which is quite clearly conveyed by the Tibetan Book of the Dead.

The world of the gods (Tib.: Lha) is full of self-assurance, pride, and the pleasures of previous good karma; yet it is of the same impermanent nature as all other forms of existence. For even a limited sojourn in celestial spheres and pleasures ends with a relapse into vices as soon as the merits of good karma have been exhausted. The world of titans and semi-gods (Tib.: Lha-ma-yin) is characterized by the sufferings of perpetual strife, caused by the boundless envy of creatures. The human world (Tib.: Mi) is marked by sickness, old age and death, an inescapable suffering stemming from craving and passions. In the brute realm of beasts (Tib.: Byol-song) it is

141

fundamental ignorance that gives rise to apathy, lethargy, unthinking instinctive action and spiritual incapacity. The Pretas or hungry spirits (Tib.: Yi-dvags) suffer permanent hunger and thirst in a world characterized by the vice of avarice. The worlds of hell (Tib.: dMyal-ba) are places of suffering from the fiery heat and the icy cold, features typical of hateful beings. It is these realms, the places of the six kinds of suffering and six cardinal vices which cause suffering, that Avalokiteśvara, the Bodhisattva of compassion, entered. He adopted one of the manifest forms of the six Buddhas in order to teach the virtues which would bring liberation from the cycle of sorrowful rebirths.

Only deliverance from all six forms of existence (not being reborn into Saṃsâra) leads to the supreme redemption of Nirvâṇa beyond the cycle of rebirth. That is why Avalokiteśvara, as the proclaimed Buddha, brings a specific teaching to each of the six realms, a teaching designed to overcome the condition of suffering.

The Buddha who manifests to the gods (Tib.: Lha-dbang rgya-byin) is white in colour and carries a lute in his hand. Its fading tone is to remind the gods of the limited duration of their existence. Just as the tone dies away, so the effect of all good deeds must end. And lest pride in their exalted existence should topple them into disaster, the white Buddha recommends to them the virtue of meditation (Skr.: Dhyâna-Pâra-mitâ). In the realm of the titans (Skr.: Asûras), who are divided in strife from envy over the fruit of the wishing tree, the green Buddha (Tib.:

Thag-bzang-ris) appears in warrior's armour with a flaming sword in his hand. Thus he instructs the titans to put an end to their mighty struggles and proclaims to them the virtue of moral restraint (Skr.: Sîla-Pâramitâ) through which they may regain internal peace. In the human realm Avalokiteśvara appears in the shape of the yellow Buddha Śâkyamuni. He carries the begging bowl (Skr.: Pâtra) and the mendicant's staff of the Buddhist monks in order to preach to humans the virtue of turning away from craving, self-seeking and passions. In the cycle of the worlds the human stage is the highest and most important, for only as a human is a being truly in a position of choosing his deeds and freely deciding for himself. And only in this "human world hard to be gained" will perseverance and willpower lead him to find the path of liberation from the fetters of a purely material existence. That is why the yellow Buddha teaches, above all else, the virtue of willpower and indispensable energy (Skr.: Vîrya-Pâramitâ) which men need in order to find the path of enlightenment for good. In the animal world, on the other hand, one experiences lethargy and the spiritual incapacity of a life governed by low in-

Six syllables	Six colours	Six realms	Six kinds of suffering	Six causes of suffering	Six Buddhas of the realms	Symbols of the Buddhas	Path of the six great virtues
Oṃ	White	Gods	Relapse into vices and karma	Pride	White Buddha (Tib.: Lha-dbang rgya-byin)	Lute	Meditation Dhyâna-Pâramitâ
Ma	Green	Titans	Strife	Envy	Green Buddha (Tib.: Thag-bzang-ris)	Armour and sword	Morality Śîla-Pâramitâ
Ṇi	Yellow	Humans	Old age, sickness and death	Craving and passions	Yellow Buddha (Tib.: Śâkya thub-pa)	Pâtra and beggar's staff	Energy Vîrya-Pâramitâ
Ṗad	Blue	Beasts	Ignorance and lethargy	Ignorance	Blue Buddha (Tib.: Seng-ge rab-brtan)	Book of Wisdom	Perfection of wisdom Prajñâ-Pâramitâ
Me	Red	Pretas	Hunger and thirst	Greed and avarice	Red Buddha (Tib.: Kha-'bar-ma)	Vessel with nectar	Generosity Dâna-Pâramitâ
Hûṃ	Black	Hell	Heat and cold	Hate	Indigo Buddha (Tib.: Chos-kyi rgyal-po)	Fire and water	Patience Kṣanti-Pâramitâ

stincts. Here the Bodhisattva in the shape of a blue Buddha (Tib.: Seng-ge rab-brtan), with the Book of Insight in his hands, teaches the beasts the virtue of perfect wisdom (Skr.: Prajñâ-Pâramitâ) necessary for gaining entry to the realm of knowledge into the cosmic laws. The Pretas (Tib.: Yi-dvags) or hungry spirits live in the fifth world; through greed and insatiable avarice they suffer the torments of unending thirst and hunger. That is why the red Buddha (Tib.: Kha-'bar-ma) appears here with the vessel of celestial nourishment as a gift to the Pretas to appease their sufferings. To enable them to overcome their bad existence the red Buddha preaches the doctrine of the virtue of generosity and readiness for sacrifice (Skr.: Dâna-Pâramitâ). The world of hell is the darkest realm of the six worlds of suffering. Cold-hearted hate and burning anger brought the creatures to this world of incarnation where they must now suffer the torture of fiery heat and icy cold. Here the indigo Buddha Dharmarâja (Tib.: Chos-kyi rgyal-po) appears with water and fire, the means of purification, proclaiming to the suffering creatures the virtue of patience (Skr.: Kṣânti-Pâramitâ), i.e. the virtue capable of smoothing the waves of hate.

The Wheel of Life thus reveals to us a wide field of Buddhist teachings and we have here touched upon only one aspect. We have seen the progress of the helpful Bodhisattva through the six realms of existence in which he is represented by one syllable of his Mantra for each realm. For this reason the syllables of the great Mantra of Avalokiteśvara *(Oṃ ma ṇi pad me hûṃ)* have the same colours as the six Buddhas appearing as his incarnations. We can understand therefore why the recitation of the great Mantra locks the doors to the six-fold world of peregrination, as is explained in the Maṇi bka'-'bum. The six Pâramitâs are the great virtues of the Bodhisattva which we have already encountered as the foundation of Mahâyâna ethics on page 62. Further explanations of the Wheel of Life are given in the caption to Plate 59; here we merely want to set out in conclusion a tabulated survey of the pattern of the teachings.

The visionary world of the Tibetan Book of the Dead

The teachings of the Tibetan Book of the Dead, as handed down to us in certain Tibetan traditions, embody a comprehensive world of spiritual experience. These teachings represent the unity of the most essential doctrines of Mahâyâna Buddhism and of the experiences of ancient Tibetan masters, a self-contained doctrine which represented an independent category in Tibetan literature. Only a few examples survive of Tibetan representations of the world of Bardo visions. The luminous and visionary character is readily perceived in these works of art—especially in the paintings—since the manifestations of this after-death world are most commonly represented in the form of a sequence of different Maṇḍalas (see Plates 61–63). In a sequence ordered down to individual groups, the 100 (or

56 *These five Stûpas (Tib.: mChod-rten) stand in the western Himalayas, on the ancient pilgrimage route from Kashmir into the Ladakh region and western Tibet. Stûpas such as these, serving either as repositories for the ashes of saints or as symbolic structures of the Lamaist concept of the world, are found everywhere at places of pilgrimage, monasteries and hermitages. They can also be seen at the entrances to inhabited areas, on mountain passes, at crossroads or on exposed paths along steep declivities (see also pages 137f.).*

57 *This picture of the white Buddha Vajrasattva amidst a field of miniature white Târâs illustrates the technique of Tibetan painting on gold ground (Tib.: gSer-thang). Only the central figure of Vajrasattva, adorned as Sambhogakâya, is executed in colour; the background merely consists of an area of mat gold on which the small pictures of the Târâ are drawn.*

58 *The cosmological concepts of the Tibetans are based on ancient Indian doctrines. The idea of a central world mountain, Mount Meru, surrounded by contients, again gained in importance in Mahâyâna Buddhism. This Tibetan painting surrounded by a flag-like brocade, shows the world mountain rising at the centre above seven rings of world oceans and seven rings of golden mountains. All around, as in a Maṇḍala, is another world ocean in which the four great continents (each accompanied by two lesser continents), are floating. The world inhabited by humans is located (in this picture) on the extreme left at the foot of the mountain where small trapezoid areas can be seen in the water. In the Buddhist concept it*

takes many thousands of such cosmic worlds to make up a world system (see also pages 131, 137).

59 *A representation of the Buddhist Wheel of Life (Tib.: Srid-pa'i 'khor-lo) is found in many Tibetan temples, usually near the entrance. This picture comes from the monastery yard of Punakha-Dzong (Tib.: sPung-thang bde-ba-can), the ancient capital of Bhutan. It shows the cause of suffering and rebirth in the six worlds—desire, hatred and ignorance—symbolized (at the centre) by a pig, a snake and a cock. The six realms of incarnation are those of the gods (top centre), titans (right), the human world (left), the animal world (bottom right), the world of the Pretas (left) and the realm of hells (bottom). In each of these realms the all-compassionate Avalokiteśvara appears in the shape of a Buddha to show the path to redemption. The outer ring shows the chain of the twelve Nidânas, the casual chain of linked dependencies (Tib.: rTen-'brel bcu-gnyis) which give rise to the cycle of the unenlightened in the six-fold world of Saṃsâra (see also pages 140–143).*

60 *This golden shrine is a particularly holy object in a great temple in Bhutan. It is erected over a Maṇḍala. On certain religious days, when the texts of this Maṇḍala are recited and the initiation ritual of the deities begins, the heavy studded doors are lifted from their hinges. For the duration of the rites the Maṇḍala then lies open to view under the sumptuous canopy. During that time it is the centre of the symbolic creation process of the Buddhas and deities of Lamaism and hence also the ritual centre of the world.*

56

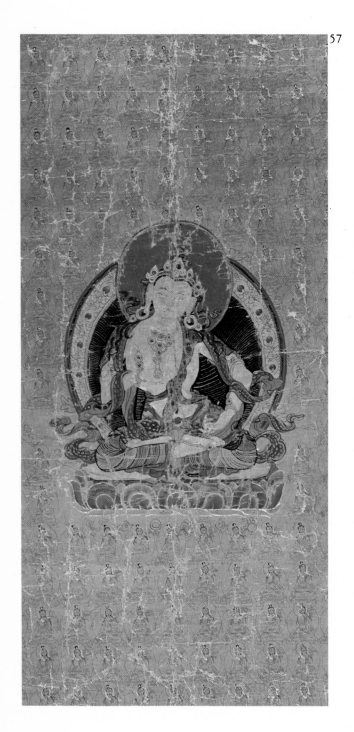

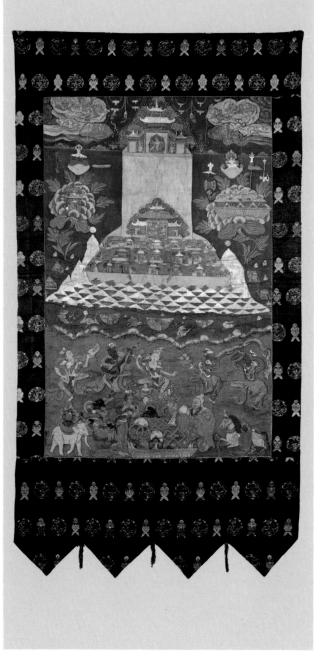

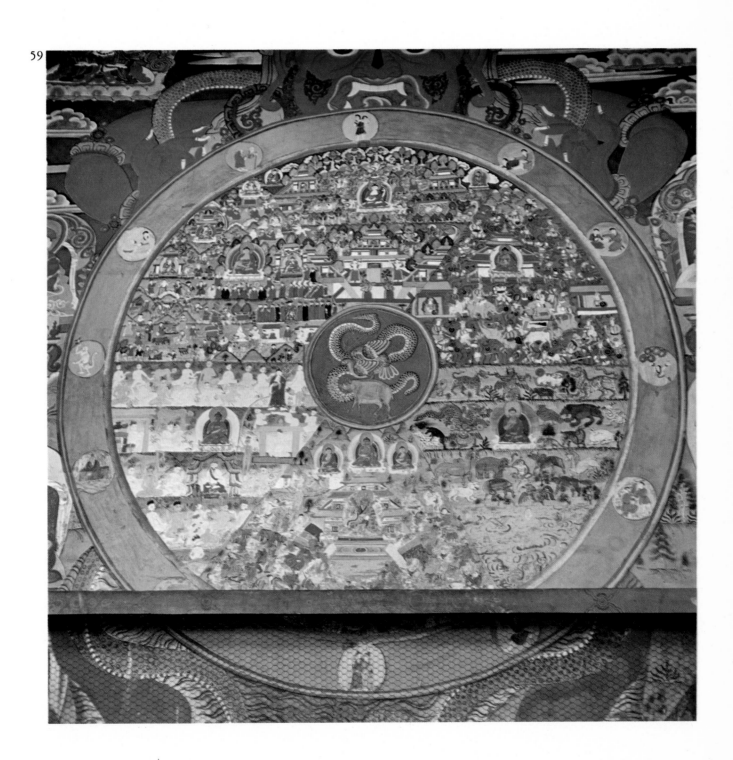

59

110) peaceful and wrathful deities appear, grouped together in ordered sequences of separate Maṇḍalas which are bounded by five-coloured rays of light.

We lack sufficient information on the precise origin of the tradition of the Tibetan Book of the Dead. What seems certain is that Guru Padmasambhava, who is venerated as the author of the Book of the Dead by the rNying-ma-pa sect, did have a hand in the creation of the most ancient texts. Others that must be named from the same school are Vimalamitra (born 740) and the gTerston ("treasure-finder") Karma-gling-pa. In addition, there is another doctrinal system, substantially different from the one named above, which dates back to the great Indian scholar Nâropa. His teachings have come down to us in the "Six Doctrines of Nâropa" (Tib.: Nâ-ro chos-drug).

The Tibetan Book of the Dead proceeds from the concept that after death the deceased wanders through the world of the intermediate state between the two lives (Tib.: Bar-do) for a period of forty-nine days before appearing as an incarnation in one of the six worlds of Saṃsâra.

During this period the consciousness of the deceased experiences, in a special (fine-substance) after-death body, the karmic effects of his former spiritual deeds which now manifest themselves as light, sounds or deities. The strivings of his intellect, burdened with the effects of the karmic inheritance from his former life, now result in his seeing peaceful and ferocious deities which menace him as he tries to avoid them. This is

why it is the duty of the Tibetan lama, at least for the period of a fortnight, to read the Book of the Dead as a reminder and spiritual signpost for the deceased, to enlighten the deceased about the processes and meanings of ensuing visions. In this connection it is most important that all visions of deities, which appear first in peaceful form and then increasingly in terrifying shapes, be recognized by the deceased as unreal reflections of his own spirit. A clear-sighted comprehension of the imaginary deities means that the deceased may find the path towards liberation or into the paradisaical worlds. However, fearful escape from the menacing deities and lights of the six realms of incarnation drives the straying wanderer deeper and deeper towards one of the six worlds which corresponds to his karma.

Thus the Tibetan Book of the Dead, read by the mediating voice of Buddhist monks, becomes for the deceased a guide to possible insights into the Bardo world. Time and again the reader tries to make contact with the deceased in the other world in order to explain to him the nature of his fears and help him find a good rebirth. More than any other work of world literature, the Book of the Dead abundantly describes and actively influences the subtle hidden processes of life after death, and it does so with an assurance that fills us with admiration for these experiences from the ancient knowledge of Asia.

This is not the place to plumb the full depth or content of the tradition of wisdom of the Book of the Dead. We shall therefore consider the individual Maṇḍalas each in its specific meaning in

order to gain, in an abridged form, a general idea of the significance of all visionary deities.

At the beginning of all Maṇḍalas of deities in the Tibetan Book of the Dead, one invariably finds the enduring Âdibuddha. The first reverence is addressed to him, for it is out of him that all Dharmas, the pure laws of the world, have spontaneously originated since "infinite time", and it is through his ceaseless meditation that all Buddhas arise. That is why the texts of the various Books of the Dead open with the following incantation:

I pay respect to the Âdibuddha,
the ever-enduring body of light,
enthroned on the diamond seat and coloured as
 the heaven;
the Lord of all wisdoms and Buddhas,
the Samantabhadra in Dharmakâya.

In nearly all representations of the Tibetan Book of the Dead (and in tantric paintings) the Buddhas appear in mystic union with their female counterparts. This is true also of Samantabhadra, who is usually found at the very top in the centre of the paintings in mystic union with the white Prajñâ Samantabhadrâ. The white Samantabhadrâ is, in the words of the texts the "mother producing all Buddhas of the three ages".

Then follows the Maṇḍala of the five Dhyâni-buddhas whose significance in Buddhist mysticism we have already mentioned. They are the bearers of the five wisdoms, and their female partners (the Buddhamudrâs) personify the structure of the cosmos. In the death ritual the deceased is given the initiations of the five Buddhas, with consecrated water which is used for the Abhiṣeka rites. This is what the reciting lama says of the vessel (Tib.: Bum-pa) used for this consecration: "Hûṃ, in this hallowed sphere of this precious vessel resides the divine assembly of all victorious, peaceful and wrathful deities." He then imparts to the deceased the five initiations for the attainment of the five superior bodies and the five Buddha wisdoms. In the name of the Buddha Akṣobhya he administers the consecration of holy water (Tib.: Chu'i-dbang), in the name of Ratnasambhava he administers the consecration of the Buddha crown (Tib.: dBu-rgyan-gyi-dbang), in the name of the Buddha Amitâbha the consecration of the Vajra (Tib.: rDo-rje'i-dbang), in the name of Amoghasiddhi the consecration of the Ghaṇṭâ (Tib.: Dril-bu'i-dbang) and in the name of the Buddha Vairocana he administers the consecration of the diamond name (tib.: rDo-rje ming-gi-dbang). These Buddhas are peaceful aspects in the realm of the intermediate world; we shall encounter them later under a different name, since all deities of the Book of the Dead appear not only under the tantric polarity of the male-female aspect but also in the juxtaposition of peaceful and wrathful nature (Tib.: Zhi-khro).

The lama next introduces the deceased to the nature of the eight Bodhisattvas who appear in union with their Yoginîs inside the Maṇḍalas of the five Dhyânibuddhas. Among the many Bodhisattvas the most important are the eight great 150

Bodhisattvas (Skr.: Mahâbodhisattvas). They and their Yoginîs stand in a specific relationship to the symbolism of human qualities whose planes of action are to be purified through the initiation of the Bodhisattvas. The Bodhisattvas are assigned to the eight forms of consciousness and the Yoginîs to their appropriate functional areas, as shown in the table below (note the caption to the table). Through the consecration ritual of these deities all obstacles (karmic impurities) preventing progress towards liberation through the Bardo world are removed from the eight spheres. All Buddhas and Bodhisattvas, and their female counterparts, appear as visions in the intermediate state during the first five days after death. On the sixth day they are joined by the six Buddhas from the six realms of incarnation as emanations of Avalokiteśvara and the four door-keepers of the Maṇḍalas with their Ḍâkinîs.

We have already discussed in some detail the six Buddhas as emanations of the all-compassionate Bodhisattva Avalokiteśvara. They recommend to the various beings the appropriate path of inner transformation, helping them to renounce their principal vices in order to practise the six great virtues of a Bodhisattva. Knowledge of the six worlds and their sufferings must be seen as worlds or forms of action of the human character. These worlds and the path of purification through the six great virtues (Skr.: Pâramitâs) occupy a key position in the Book of the Dead as aids to redemption. That is why the lama reminds the deceased in the Bardo not to let himself be attracted by the various impure rays of light from the six realms (Skr.: Lokas), since these are deceptive lights shining from the very spheres of existence which he has only just escaped. It is the more important to urge the dead to strive continually to make his way upward, to

Bodhisattva	Kind of consciousness	Yoginî of the Bodhisattva	Functional area
Kṣîtigarbha	Sight	Lâsyâ	Eye
Âkâśagarbha	Hearing	Mâlâ	Ear
Avalokiteśvara	Smell	Gîtâ	Nose
Vajrapâṇi	Taste	Gandhâ	Tongue
Maitreya	Body	Puṣpâ	Past thought
Nivaraṇaviṣkambhin	Intellect	Naivedyâ	Present thought
Samantabhadra	Awareness of self	Dhûpâ	Unborn thought
Mañjuśrî	Universal consciousness	Alokâ	All thought still emerging in the uncertain

151 This table is only one version taken from different texts of identical contents.

61 The doctrines of the Tibetan Book of the Dead constitute a self-contained system and are represented, according to certain principles, as Maṇḍalas resulting from the progressive development of visualizations. This painting contains all one hundred and ten deities of the great Bardo Maṇḍala. Above the centre of flames the forty-two peaceful deities appear within five-coloured light centres. In the light of this cosmic radiance of the five elements the Tathâgatas appear with the Dhyânibodhisattvas, the five Vidyâdharas and the four door-keepers—all with their Dâkinîs—as well as the Buddhas of the six realms of existence. Within a double circle of flames with a radiant light centre are the fifty-eight wrathful deities. They dawn from the eighth day of the intermediate state in the Bardo until the fourteenth day. All one hundred and ten deities are emanations of the Âdibuddha Samantabhadra, who can be seen in the centre at the extreme top of the picture. The six wrathful Herukas of the middle centre of radiance are forms of the most peaceful Tathâgatas and of the Âdibuddha. The dawning of the deities from the light of the cosmic radiance of the elements is conveyed here in a particularly impressive manner.

62 Representations of the after-death visions are frequently divided into two pictures by the Tibetan artists—the first showing the forty-two peaceful deities, and the second the fifty-eight wrathful manifestations. This painting (from Bum-thang) shows the forty-two peaceful deities in harmonious form, distributed over the picture in accordance with the system of the Maṇḍala. At the centre is the Âdibuddha Saman-tabhadra with his white Prajñâ, below is Vairocana, with the remaining Tathâgatas and their Buddhaḍâkinîs at the four cardinal points. In the corners of the painting are the four door-keepers of the Maṇḍala with their Ḍâkinîs in an aura of red flames. The forty-two peaceful deities appear during the first seven days of the after-death state, before the dawning of the wrathful deities (see also pages 150–151). Painting, eighteenth century.

63 The second section of the visions begins with the eighth day of the state of Bardo and lasts until the fourteenth day. During these seven days the terrifying Buddha Herukas appear, one after the other, as wrathful forms of the Tathâgatas (as shown in the inner circle of the picture), as well as the eight Ke'u-ri-ma, the eight Phra-men-ma, and the twenty-eight powerful animal-headed Ḍâkinîs (seen in the outer circle) (see page 159). Painting of the 'Brug-pa sect from Zangskar (Ladakh province).

64 This miniature, from an initiation chart (height 11 cm = 4⅟₂ in.), conveys a striking impression of the dynamism of the visionary representations. It shows the group of the eight Phram-men-ma deities. Each of these animal-headed deities appears in an aura of flames and with symbolic Mudrâs. These charts contain a detailed arrangement of all the deities of the Bardo visions and serve a particular initiation ritual of the Book of the Dead according to the doctrines and directives of the gTer-ston ("treasure-finder") Karma gling-pa.

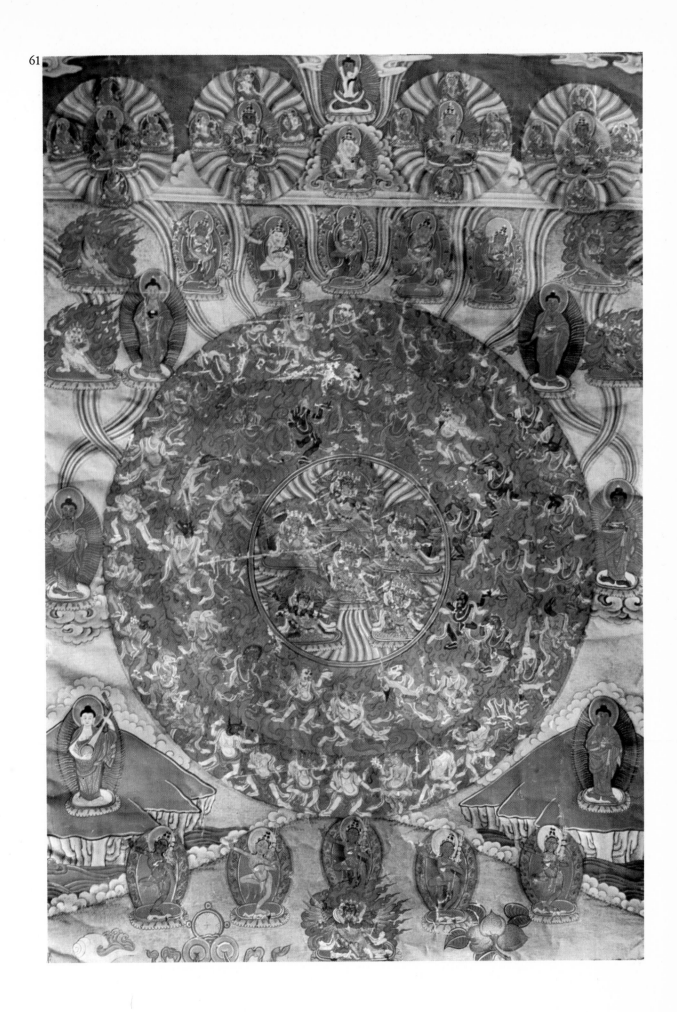

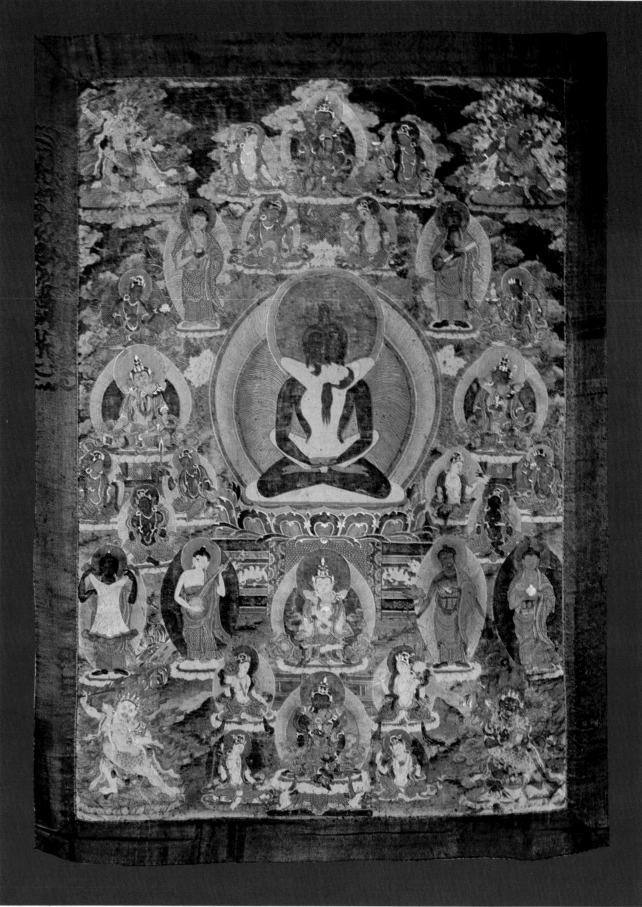

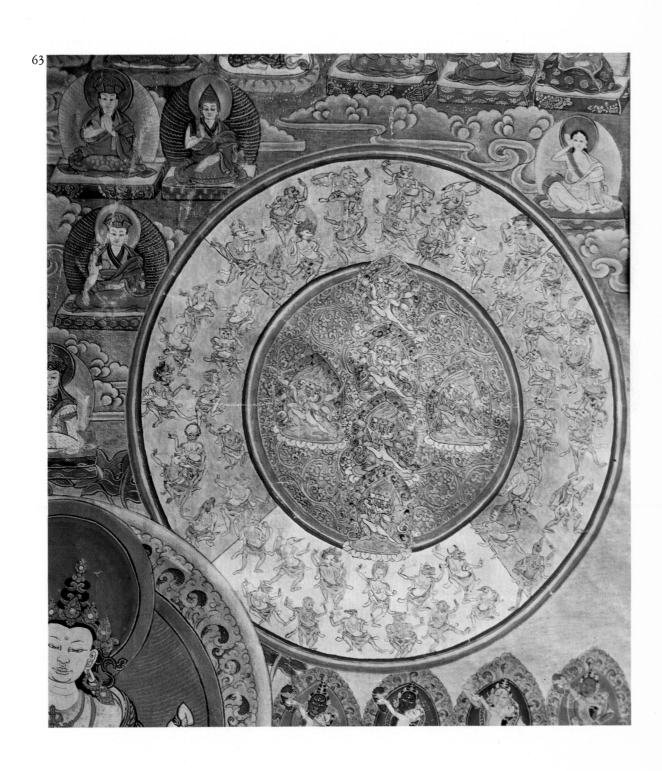

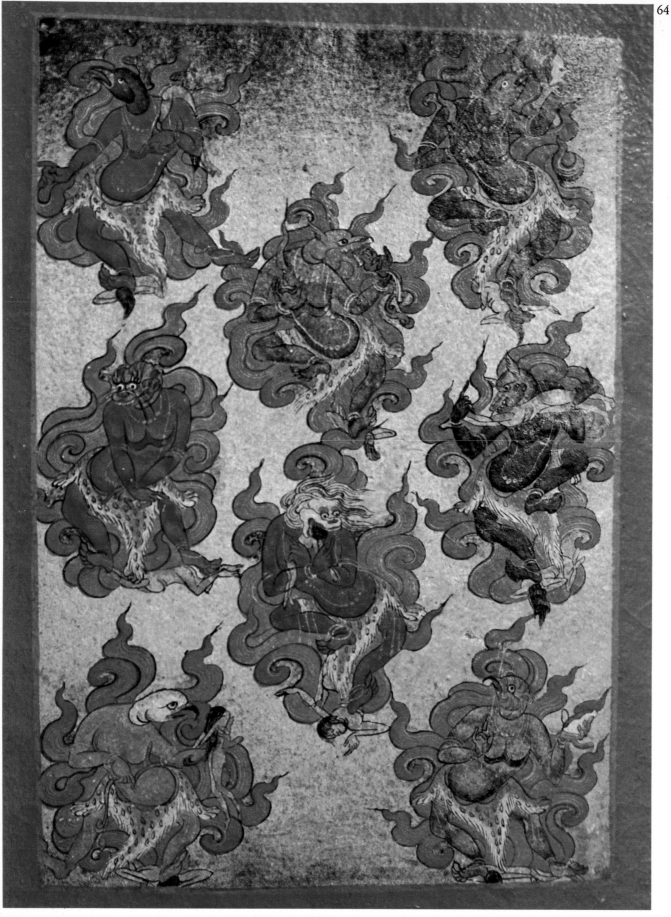

follow the true path of enlightenment of the Buddhas whose rays of pure light shine down upon him as a redeeming vision. We shall illustrate this by quoting an excerpt from the translation of one of the most important prayers in the Tibetan Book of the Dead. This prayer is read repeatedly during the ritual in order constantly to direct the pilgrim between the two worlds towards the path of light which leads to liberation from the confinement of Bardo (Tibetan text: Bar-do 'phrang-sgrol-gyi smon-lam):

Reverence to you, assembled gurus and
 Ḍâkinîs!
Out of your great love lead us on the path!
When wandering through delusion in Saṃsâra
May the heroic Knowledge-Holders lead us
On the bright light-path of the Simultaneously-
 born Wisdom;
May the bands of Supreme Mothers, the
 Ḍâkinîs, be our rear-guard;
May we be led safely through the dreadful am-
 bush of Bardo,
May we be transported
To the realm of perfect Buddhahood.

When wandering through Saṃsâra because of
 intense hatred,
May we be led on the bright light-path of Mir-
 ror-like Wisdom
By the Bhagavân Vajrasattva;
May the Supreme Mother Locanâ be our rear-
 guard;
May we be led safely through the dreadful am-
 bush of Bardo,
May we be transported
To the realm of perfect Buddhahood.

When wandering through Saṃsâra because of
 intense ignorance,
May we be led on the bright light-path of Dhar-
 ma-sphere Wisdom
By the Bhagavân Vairocana;
May the Supreme Mother Âkâsadhâtvîsvarî be
 our rear-guard;
 May we be led safely through the dreadful am-
 bush of Bardo,
May we be transported
To the realm of perfect Buddhahood.

When wandering through Saṃsâra because of
 intense pride,
May we be led on the bright light-path of the
 Wisdom of Equality
By the Bhagavân Ratnasambhava;
May the Supreme Mother Mâmakî be our rear-
 guard;
May we be led safely through the dreadful am-
 bush of Bardo,
May we be transported
To the realm of perfect Buddhahood.

When wandering through Saṃsâra because of intense craving,
May we be led on the bright light-path of Discriminating Wisdom
By the Bhagavân Amitâbha;
May the Supreme Mother Pâṇḍarâ be our rearguard;
May we be led safely through the dreadful ambush of Bardo,
May we be transported
To the realm of perfect Buddhahood.

When wandering through Saṃsara because of intense envy,
May we be led on the bright light-path of All-Performing Wisdom
By the Bhagavân Amoghasiddhi;
May the Supreme Mother Samayatârâ be our rear-guard;
May we be led safely through the dreadful ambush of Bardo,
May we be transported
To the realm of perfect Buddhahood.

Door of the Maṇḍala	Door-Keeper	Colour	The four frontiers of	Ḍâkinîs of the Door-Keepers	The four places of birth
East	Vijaya	White	Birth and death	Goad holder (Skr.: Ankuśâ)	Supernatural manner
South	Yamântaka	Yellow	Immortality and dissolving	Noose holder (Skr.: Pâśadharî)	Womb
West	Hayagrîva	Red	Being and non-being	Iron chain holder (Skr.: Vajraśriṅkhalâ)	Egg
North	Amritadhâra	Green	Appearance and void	Bell holder (Skr.: Kinkinidharî)	Warmth

The procession of deities of the peaceful Maṇḍala is concluded on the sixth and seventh days of sojourn in the Bardo by the four door-keepers and the five knowledge-holding deities (Tib.: Rig-'dzin) and their Ḍâkinîs. The symbolism of the small group of the four door-keepers of the Maṇḍala reveals to us how, very purposefully, all deities are meaningfully harmonized with various events of life or spiritual activities. The four door-keepers are assigned to the realms of the four ways of contemplating the frontiers (of human thought) which must all be crossed if the boundless state of Nirvâṇa is to be experienced. The four Ḍâkinîs of the door-keepers guard the doors to the four birthplaces where rebirth may take place (see table p. 158).

On the seventh day the manifestations of the peaceful visions come to an end. On that day the lights of all forty-two pacific deities shine down together upon the deceased. There are still paths open to him to strive upwards, because from the eighth to the fourteenth day he will see the manifestations of the ferocious deities which arouse terror and fear, so that escape into the realms of rebirth seems unavoidable. And yet the lama reciting the Book of the Dead, with his constant urgent reminders to the deceased, intervenes in his progress through the Bardo. He keeps reminding the deceased that all visions of the after-death world, the peaceful and the wrathful deities, are nothing other than emanations (projections) of his own intellect, that all deities are merely transitory states of a seeming reality whose intensity and aggressive character the de-

ceased must experience in accordance with his own karma. If he comprehends these visions as forms of his own intellect and if he understands his terrifying passage as the experience of manifestations from his own consciousness, then the path of purification is still open to him. All visions are in reality void, devoid of all existence of their own, once one has stepped from the darkness of ignorance into the light of knowledge. The terror aroused by the fifty-eight wrathful deities is in fact only a transitional stage through the experience or suffering of part of one's own nature.

That is why the symbolic manifestations and meanings of the fifty-eight wrathful deities correspond to those of the peaceful forms. The five Dhyânibuddhas now appear as the five horrific blood-drinking deities of the Heruka type (Tib.: Khrag-'thung khro-bo), and the Ḍâkinîs of the Herukas are nothing else but the tantric exponents of the five female counterparts of the Dhyânibuddhas. They are followed by the eight Kerimas (Tib.: Ke'u-ri-ma) of human shape, by the eight Tamenmas (Tib.: Phra-men-ma, Plate 64), and by the twenty-eight powerful deities (Tib.: rNal-'byor dbang-phyug) as animal-headed creatures crowding the large outer circle of the Maṇḍalas of the wrathful deities (Plate 63). The eight Kerimas and the eight Tamenmas assume the functions of the eight peaceful Bodhisattvas and their Yoginîs. The twenty-eight animal-headed powerful deities appear in order to purify all thought relationships and karmic burdens. So long as these manifestations continue to

159

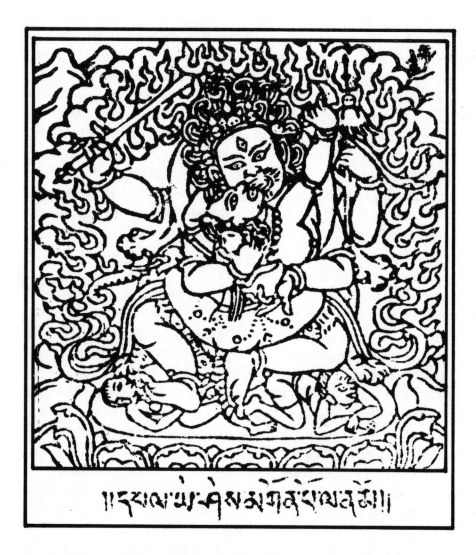

Fig. 15. Illustration from the Maṇi bka'-'bum: the four-armed Mahâkâla with his Ḍâkinî.

be regarded as real and existing, the consciousness in the intermediate state of the Bardo declines into the cycle of rebirths. This is why the Tibetan Book of the Dead keeps emphasizing that all visions must be clearly understood as no more than passing states of one's own consciousness and therefore need not be feared. This insight gained by the conquest of fear, the resultant penetration of the empty manifestations, and the complete overcoming of opposing aspects lead to the path of liberation. As soon as the stage of the void without visions and without images is attained the liberated being has arrived beyond the need for returning to the

160

realm of six-fold rebirth. Comparison with Western analytical psychology, as represented by C.G. Jung, shows that the deities of the Tibetan Book of the Dead and their described attributes resemble the archetypal images which emerge from the unconscious. These primal images also have profound and often unfathomable meanings in the processes of psychic perception and their self-portrayal in dreams—meanings with which the conscious mind must become familiar. While these primal images, the positive or negative unknown factors, remain unclarified to the conscious mind, or unable to be creatively integrated, they represent a factor of insecurity and a threat to a person's psychic equilibrium. Thus ancient Asian experience and that of modern Western psychology reveal a large measure of agreement and help us correctly to assess the meaning of the Tibetan Book of the Dead.

The Book of the Dead, therefore, teaches that stepping out from the cycle of existences, or unending rebirths, is the only true goal of redemption. Each reincarnation is the result of an as yet unachieved detachment from the transitory world of phenomena and its power of opposing forces. As an effective emanation of divine forces, a polarity in the interplay of internal strivings within man's nature, these manifestations of the great Bardo Maṇḍala are structured in accordance with a philosophical and psychological system designed to make visible through a dynamic and inseparable union of opposites the harmony of a seemingly dualistic universe. The main task consists in continually extending one's conscious insight into one's unconscious, thus liberating oneself of the power of the unconscious and its action which, like the power of ignorance, attempt to block the path to enlightenment.

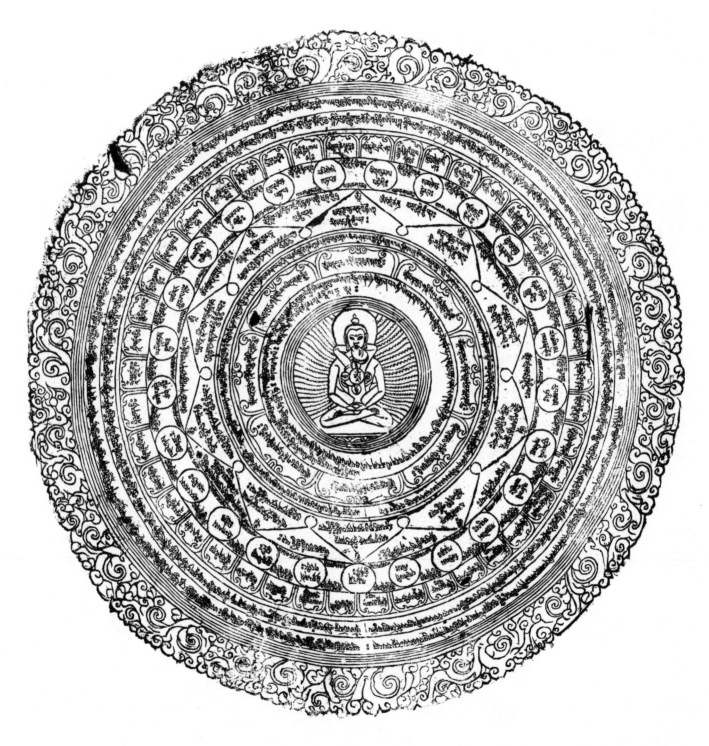

Fig. 16. Tibetan block-print of the Maṇḍala of the peaceful and wrathful deities according to the doctrines of the Tibetan Book of the Dead. At the heart centre of the Âdibuddha Samantabhadra is the syllabic Maṇḍala of the five Dhyânibuddhas. Maṇḍalas of this type belong to the large group of mantric diagrams in which the deities appear only in the form of syllables or Mantras.

163

65 Gilded bronze of the guardian deity Vajrapâṇi. Among the wrathful deities the Dharmapâla Vajrapâṇi is one of the most important. In his right hand he holds a Vajra (missing) and his iconographic colour is bluish black. His flaming hair, as with all wrathful deities, is red. Vajrapâṇi is an emanation of the Dhyânibuddha Akṣobhya. Tibet, early eighteenth century.

66 This tantric Maṇḍala of the God of Death Vajrabhairava (Tib.: rDo-rje 'jigs-byed) or Yamântaka again reveals the influence of Nepalese art which found a fruitful soil for assimilation in Tibet. The painting contains marked stylistic and technical elements from Nepal. Southern Tibet, circa second half of sixteenth century.

67 One of the guardian deities in the special pantheon of the rNying-ma-pa tradition is a wrathful dagger deity known by the name of Guru Drag-dmar. This is a winged Heruka of red colour; in place of his legs his abdomen ends in a magic dagger. Guru Drag-dmar is revered as a wrathful manifestation of Padmasambhava and is considered an important deity by the 'Brug-pa bka'-brgyud-pa sect. Typical of this Heruka is the scorpion in his left hand. Deities of the magic dagger, such as the one here reproduced, are characteristic of the old Red Cap sect of Tibet. Painting of the 'Brug-pa sect in the east Tibetan style of the eighteenth century.

68 Gilded bronze of a tantric guardian deity. This is the six-armed Hayagrîva (Tib.: rTa-mgrin) with three faces. Hayagrîva is an ancient deity which was also venerated in India. In Tibet it was known in a number of different forms. A clear iconographic identification mark is the invariable horse's head in his flaming hair; the three-headed forms show three such horse's heads. The form of this bronze is that of rTa-mgrin gsang-sgrub; the hand symbols are usually the Vajra, Khaṭvânga, sword and lance.

69 Among the wrathful guardian deities the lion-headed Ḍakînî Simhavaktrâ (Tib.: Seng-ge'i gdong-ma) is of particular interest. This is a demonic goddess of the eight graveyards and is represented, as in the bronze reproduced, in her manifested form of Sambhogakâya. "From the radiance of manifestation and the void", it is stated in the texts, "there emerges an inverted triangle of the element of water. In its centre a lotus sun-moon throne takes shape and upon its centre there appears the lion-headed Ḍâkinî. In her right hand she holds a chopper with a Vajra haft and in her left hand a Kapâla with the heart blood of life and death. Across her left arm she usually carries a trident (here missing). Simhavaktrâ is "the Ḍâkinî overcoming pride and self-seeking". Tibet, sixteenth century.

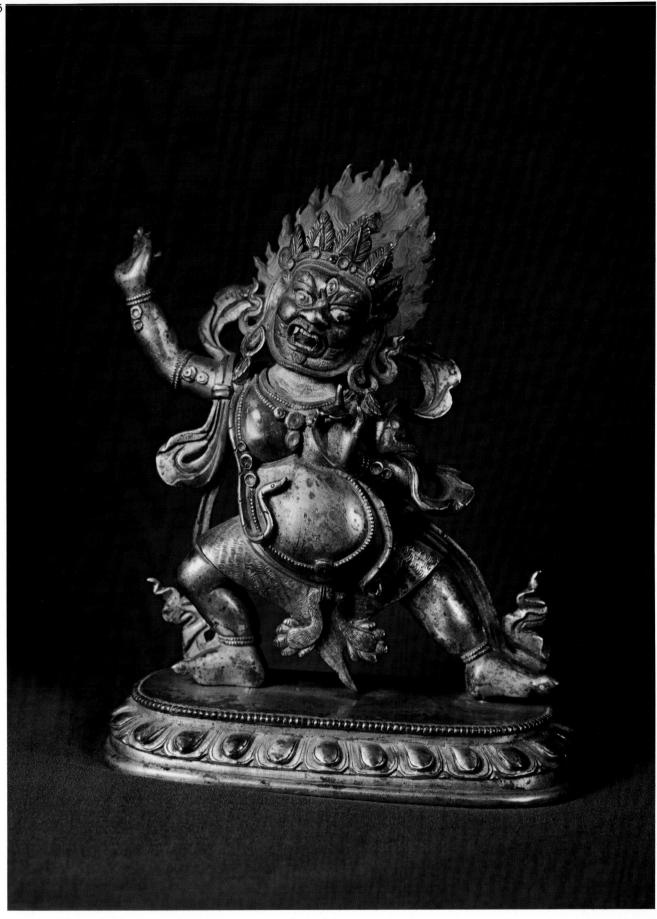

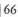

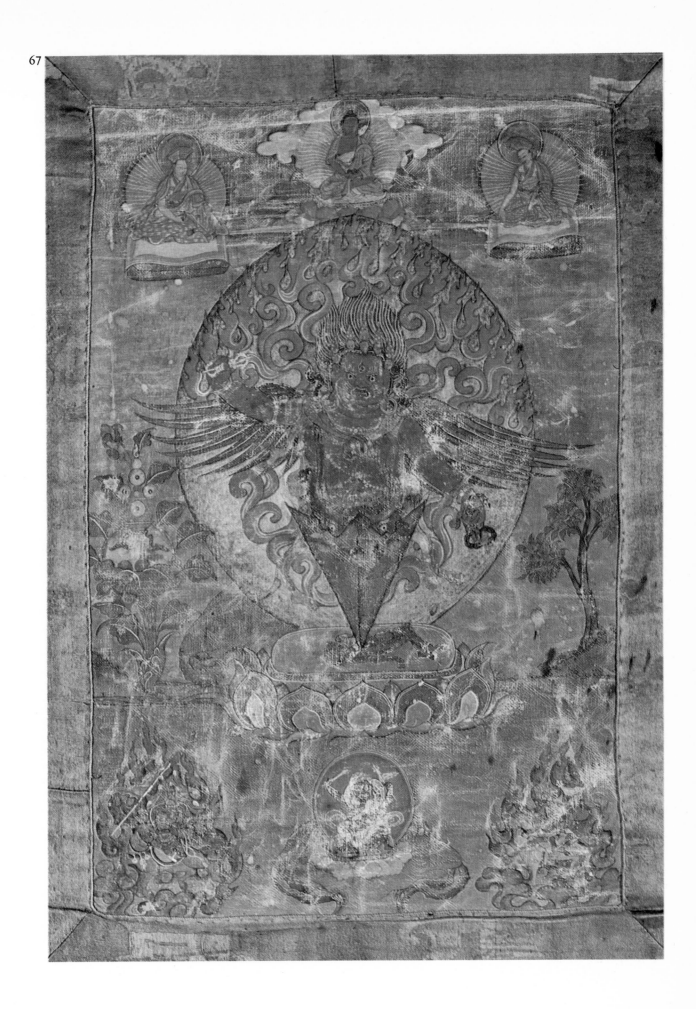

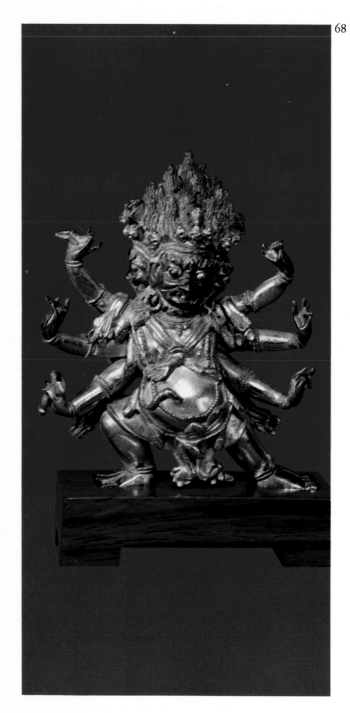

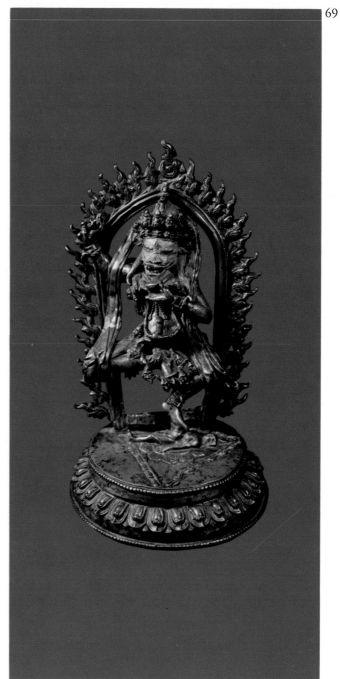

The Manifestations of the Guardian Deities

The guardian deities as essential elements of tantrism

Our discussion of the deities of the Tibetan Book of the Dead has already shown us that the wrathful deities represent an essential characteristic of tantric Buddhism. The more insight we gain into the iconographic traditions of northern Buddhism, the more we encounter what appears to be an unlimited multiplicity of guardian deities. To begin with, there are the clearly distinct groups of the Dharmapâlas, the guardian deities or tutelaries of the Buddhist doctrine, and the group of personal guardian deities (Tib.: Yidam). We shall discuss the nature of these Yidams in greater detail and consider specific examples. The Dharmapâlas (Tib.: Chos-skyong) are of wrathful and ferocious aspect; they have a third eye and flaming red hair. As their name implies, they are regarded as powerful guardians of the sacred doctrine and as defenders of the law against demons and heretical enemies of Buddhism. The best known group among the Dharmapâlas are the "eight dreadful deities" (Tib.: Drag-gshed-brgyad). A great many forms are also known of the Dharmapâlas: Mahâkâla, Vajrapâni, Yama, Hayagrîva and dPal-ldan lha-mo, to name but a few.

The tutelary deities of the Buddhist doctrine are also frequently encountered in their dual, tantric aspect, that is in union with the Dâkinîs who, as a rule, greatly resemble one another. The Dharmapâlas may also occur in complex form, i.e. with many arms, heads or legs and with a number of different symbols in their hands. The colours of these deities also differ a great deal and each have a definite symbolic connotation according to their elementary origin in the Maṇḍala (corresponding with the formalized order of the five Dhyânibuddhas). Most rituals include invocations of the guardian deities who are asked to keep the sacred place of action pure from harmful influences, evil forces or the obstacles of impure thoughts. That is why the pictures or paintings of these guardian deities are always found near (on both sides of) temple entrances or in the vestibules. Their menacing presence symbolically fends off all harmful influences from the shrine.

The other type of guardians is known by the name of Yidams or personal guardian deities. They are a quite specific kind of purely tantric deity whose significance must be understood on several planes. Since the tantric teachings associated with these deities are of great profundity and strongly esoteric in character, the Yidams may also be described as initiation deities. Each individual initiated into the secret doctrines of the Tantras chooses one particular personal guardian deity whose name he must always keep secret. In addition, the disciple receives from his guru the invocation Mantra of this guardian deity and this, too, is handed down in secrecy. The individual forms of the principal Yidams are usually associated with an extensive tradition of esoteric tantrist literature into which the disciple had to be initiated by his teacher. Without such an initiation into the knowledge of a Yidam's

secret powers, no real understanding of their nature could be gained. To the initiate, on the other hand, the initiation deities were visible symbols of quite definite tantric doctrines whose contents were available to him at any time in the encoded form of the deity.

Iconographically, the Yidams are more commonly represented with their tantric counterparts, the Dâkinîs. But we also find male and female Yidams as separate beings. The best known Yidams, as complex guardian deities, are Hevajra, Śaṃvara, Guhyasamâja, Kâlacakra, Yamântaka, Mahâmâyâ and the Dâkinî Vajravârâhî. But peaceful deities, such as the Bodhisattvas Avalokiteśvara and Mañjuśrî or Târâ, can also be chosen as guardian deities. The esoteric initiation deities, sometimes also known in the literature as "mystic Buddhas", are often highly complex figures. They can have several heads, arms and legs and carry in their hands both peaceful and wrathful symbols. The tantric writings associated with these deities are sometimes of considerable length, running to many hundreds of pages. Numerous Tantras, Sâdhanas and their commentaries, as well as long philosophical or ritual treatises about the Yidams have come down to us. In Tibetan art the Yidams are also frequently represented in the Maṇḍalas—those mystic circles which are a symbolic image of the whole consecration process and the doctrine concealed beyond the manifested image of the deities.

Over the course of the centuries Buddhist tantrism evolved a large number of wrathful deities, images which should be seen as emanations of Buddhas and Bodhisattvas. The wrathful character can occur either in a moderate or terrifying appearance. The moderate or semi-wrathful aspect is found in certain forms of Târâ, Avalokiteśvara, Vajrapâṇi, Vaiśravana and many of the Dâkinîs. A wrathful and, at the same time, terrifyingly ferocious aspect is found with various forms of Vajrapâṇi, Hayagrîva, Yama. Mahâkâla and the deities of the Tibetan Book of the Dead.

We have already encountered the laws of polarity and their dynamic unity in tantric yoga. We can therefore understand that an inseparable relationship exists between peaceful and wrathful nature. The more peaceful or benign and compassionate a deity of Mahâyâna Buddhism is in its virtues, the more wrathful and terrifying must be the appearance of its opposite aspect. The amount of benign helpfulness and active compassion mobilized by a Bodhisattva for the liberation of suffering creatures can similarly be mobilized by him in his wrathful emanation for the fight against evil hostile powers, against deception, delusion and ignorance, against doubt, hate and evil intentions.

In order to understand the nature of the wrathful deities we must transfer all events into the centre of our own consciousness. In the words of the Buddha, quoted earlier, "the universe is in consciousness." To comprehend correctly the background of these deities as psychological phenomena (in the sense of the tantric doctrines) we must realize that they symbolize peaceful and

170

wrathful characteristics or forces. These psychic aspects are figuratively represented by these deities and are invariably found, in both forms, in every human being—at times manifesting as extreme opposites. That is why the Tibetan Book of the Dead states that all deities are merely certain manifestations of our own thoughts and feelings. It is they who clash within ourselves whenever the inner equilibrium of the middle way is disturbed by the attachments of passions. We may use all our energies in order to walk the path of liberation and enlightenment, yet equally strong opposing forces (lethargy, temptation and ignorance) presently arise within us as enemies bent on diverting us from the right path. These hostile forces in consciousness are of demonic nature. This is a general human and psychic reality. That is why the Tibetan Book of the Dead repeatedly reminds us that the terrifying aspect must be correctly and promptly understood and penetrated. Only this realization can provide the strength for return and reversal. For that reason the terrifying aspect in tantrism invariably reveals two alternatives of experience—either menace and resistance, or the force which rouses the deluded spirit to inward contemplation and reversal, to purification and, after the conquest of fear, a safe passage through terror. Power and terror in the aspect of the wrathful deities lead to the strengthening of fearlessness and intrepidity which are among the foremost virtues of a Bodhisattva.

These greatest imaginable contrasts are clearly revealed to us in the iconography of northern Buddhism, for example in the two-fold aspect of the meditating blue Âdibuddha Samantabhadra. On the one hand we have the peaceful, motionless, inward-looking mystic figure of Samantabhadra and on the other his wrathful and exceedingly terrifying emanation, the three-headed and six-armed Che-mchog Heruka with wings, appearing in flaming clouds of smoke as the leader of the wrathful deities in the Bardo world. An equally extreme contrast is found in Mañjuśrî, the Bodhisattva of wisdom with the melodious voice, whose wrathful emanation is Yamântaka, the bull-headed god of death. He has nine heads, thirty-four arms and sixteen legs. Above his eight terrifying heads, amidst the flaming hair, is the peaceful meditatively transfigured face of Mañjuśrî.

The concept of "demons" or even diabolical deities which the earlier Western literature applied to the Buddhist guardian deities totally misses the true significance of these manifestations. In Buddhism the Evil One, the devil in our sense, is referred to only when Mâra is meant. And Mâra, the Evil One, is only one single figure. Mâra is a personification of evil because he is the powerful tempter who tries to make men love the world of earthly life with all its attachments to transitory things more than the path towards enlightenment and emancipation from earthly fetters.

The key to understanding the wrathful nature of the deities, therefore, lies much deeper than the conscious and deliberate experience of events within the human consciousness. The correct (tantric) understanding is that peaceful and

wrathful (terrifying) appearances are merely two aspects of one and the same reality. In this respect the wisdom of the Tantras and their symbolism has reached a peak of human empirical insight. Tantrism fuses into a single dynamic and inseparable whole the polarities of male and female, peaceful and wrathful, unity and multiplicity. The opposites do not exclude each other but imply each other. The Buddhist doctrines, too, do not exclude these opposites but deliberately acknowledge their existence so they can be reconciled and harmonized. In this lies the particular strength of tantric thinking—its ability to harmonize opposites through continuous discrimination such that they then find unity. It is this insight that Nâgârjuna developed in his Middle Path between opposites (Skr.: Mâdhyamika). Equipped with this knowledge we can now reflect on the principal tantric equations which we have been encountering in various forms and which, in these short formulas, represent the essence of all doctrines underlying the tantric Buddhism of Tibet:

Saṃsâra and Nirvâṇa (Tib.: 'Khor-'das)
Appearance and void (Tib.: sNang-stong)
The path of compassion (Tib.: Thabs snying-rje chen-po)
 and
The wisdom of the void (Tib.: Shes-rab stong-pa-nyid)
Buddha and Prajñâ (Tib.: Yab-Yum)
Peaceful and wrathful deities (Tib.: Zhi-khro)

Let us now turn again to the personal guardian deities of Tibetan Buddhism, the ones we have already mentioned by the name of Yidams. They are altogether the most important symbolic deities of the Tantras and it seems necessary, therefore, to examine some of their aspects more closely. Three of the most important Yidams are represented in the following illustrations—Śaṃvara (Plate 55), Hevajra (Plates 52 and 53) and the god of death, Vajrabhairava or Yamântaka (Plate 66).

Cakrasaṃvara, the Secret Lord of Mount Kailash

For our examination of the deity Śaṃvara (Tib.: bDe-mchog) or Cakrasaṃvara (Tib.: 'Khor-lo sdom-pa) we have chosen the beautiful Maṇḍala according to the doctrinal tradition of Maitrîpâda (Plate 55). Śaṃvara is a Yidam of highly esoteric character, whose doctrines of mystic realization are exceedingly voluminous and enjoy high respect among the Tibetan schools. The doctrinal tradition concerning the nature of this deity is based on the Śrîcakrasaṃvara Tantra and its commentaries as handed down by Indian masters. These writings were followed by countless texts, the Sâdhanas (Tib.: sGrub-thabs), which concern the ritual for realization of the secret doctrine as well as extensive explanatory commentaries written by Indian and Tibetan scholars.

The name Śaṃvara means "supreme bliss" (Tib.: bDe-mchog). This title conceals an exten-

sive system of meditational instructions and yogic practices designed to help the devotee achieve perfect bliss through the most perfect of all secret doctrines. The Tantra of this secret deity thus uses a variety of means and methods of spiritual exercises for teaching the path towards man's inner bliss, experienced in the permanent union of opposites and manifested in a true experience of the void. Inner freedom begins where the opposites have ceased to exclude each other in continuous conflict. The fading of transience, to which consciousness in its unenlightened state is attached, begins with insight into the void and the path of a Bodhisattva's great compassion. These eventually lead to spontaneous and perpetual bliss. This harmonious state of creation and union, active compassion and all-embracing wisdom, is symbolized by the complex figure of the Cakrasaṃvara in union with its female counterpart Vajravârâhî. Events at each separate step of meditation, resulting in a steady shortening of the distance between the seeker and the object of his meditation, the path and the goal, are represented here by the mystic union of the divine pair of Saṃvara.

With the Maṇḍala, at whose centre the Yidam appears, we have before us the complete meditational system, characterized only by the presence of colours and various deities which are to be understood symbolically. This Maṇḍala, however, is only one form of the many different Saṃvara traditions which reached Tibet from India. The most important Maṇḍalas of Saṃvara are those handed down by the Mahâ-

siddhas Lu'i-pa, Nag-po-pa, Ghaṇṭâpâda (Tib.: Dril-bu-pa) and Maitrîpâda.

Cakrasaṃvara, Secret Lord of the Sacred Mount Kailash in south-western Tibet, is a heroic deity of deep blue colour. He has four faces, each with three eyes, which gaze towards the four points of the compass; he has twelve arms and with his first pair of hands embraces the red Ḍâkinî Vajravârâhî. Of his four faces the middle one is blue, the left one is green, the right one yellow and the rear one red. We see at once that the four heads correspond to the basic colours of the Maṇḍala, relating to the five Tathâgatas and the basic elements. The middle or principal face is blue, since as a Heruka from the Vajra family of the Tathâgata Akṣobhya the deity is oriented towards the east. The three eyes of the four faces symbolize the god's knowledge of the three ages (Tib.: Dus-gsum): the past, the present and the future, and his gaze penetrates the three worlds (Tib.: Khams-gsum). The five-fold crown of skulls on each of Saṃvara's four heads symbolizes the tantric aspect of the five Tathâgatas and their wisdoms. In his hair, to the left, the Heruka wears the sign of the moon as a symbol of the spirit of enlightenment (Skr.: Bodhicitta) which totally pervades the deity along the steps of the four supreme joys. The moon is a symbol of supreme bliss which flows through the secret Cakras in the body of the enlightened and which is experienced in the four steps of bliss (Tib.: dGa'-ba-bzhi). In his twelve hands Saṃvara holds various symbolic objects associated with the twelve links of the Buddhist chain of causation

(the twelve Nidânas). In his first pair of hands the god holds the Vajra and the bell, symbols of the method and goal of redemption. With these two arms he simultaneously embraces the Dâkinî Vajravârâhî, the divine manifestation of the principle of the void. In his second pair of hands, in the Mudrâ of of menace (Skr.: Tarjanî-mudrâ), he holds an elephant skin which is draped over his back. This is a symbol of conquered ignorance. In his third right hand he holds a Damaru, the Tibetan ritual drum, symbolizing the voice of Dharma, and in his fourth hand he holds an axe to sever the fetters of birth and death. In his fifth right hand he holds a ritual chopper (Tib.: Gri-gug) and in his sixth a trident symbolizing the conquest of the three fundamental evils of hatred, desire and ignorance. On his left, Śaṃvara holds a long staff (Skr.: Khaṭvâṅga) topped by a Vajra in his third hand. This staff of the Heruka symbolizes supreme enlightenment. In his fourth hand, as a token of supreme bliss, he holds the tantric Kapâla (Tib.: Thod-pa), in his fifth a noose (Skr.: Vajrapâśa) and in his sixth the four-faced head of Brahmâ symbolizing the fact that all errors of ignorance in the world of suffering have been overcome.

Standing in front of Śaṃvara and united with him in mystic embrace is the red Dâkinî Vajravârâhî (Tib.: rDo-rje phag-mo). In esoteric Buddhism she is the most important Dâkinî and occupies a leading position in many traditions, especially in the bKa'-brgyud-pa sect. Vajravârâhî is venerated by many Tibetan yogis as a Yidam in her role of mediatrix of secret knowledge. In her right hand she holds a ritual knife with a diamond haft (Tib.: Gri-gug) which severs all false concepts from the pure knowledge of truth. With her left arm she embraces the god Śaṃvara; in her left hand she holds a Kapâla. It is also claimed that the two arms symbolize the doctrine of the two truths—the distinction between relative truth (Tib.: Kun-rdzob bden-pa) and absolute truth (Tib.: Don-dam bden-pa). The fact that the Dâkinî has only one head is taken to be a symbol for the single taste of all things. And this taste is that of the void which penetrates all phenomena, the void personified by the nature of the Dâkinî as the goal of all wisdom.

Even this short and incomplete list of pointers to the symbolism of the Yidam Śaṃvara provides an idea of the basic prerequisites under which these deities have to be seen as personifications of esoteric doctrinal systems of northern Buddhism. However, in the interpretation of such symbols a distinction can be made in all iconographies between external, internal and secret symbols, and those which require a different explanation at each separate step of initiation. Even the various paired symbols, such as Vajra and Ghaṇṭâ, Khaṭvâṅga and Kapâla, or even Heruka and Dâkinî point to a wealth of secret multi-level relationships between the concepts of tantric doctrine. Some of these we have already encountered.

Far more extensive still are the symbol series deriving from the constellations of the attendant

deities of Śaṃvara, as shown in the Maṇḍala of Maitrîpâda. The Thang-ka reproduced on Plate 55 reflects the complete tradition. At the centre we see the manifestation of the esoteric deity Cakrasaṃvara in mystic union with the red Ḍâkinî amidst the fire of melting pure insight. These are the flames of discriminating knowledge whose fire will consume all passions, for only then can Śaṃvara be experienced as the secret ruler over the inner Cakras. The inner centre is enclosed by the eight petals of the lotus flower. On four petals stand Ḍâkinîs with four arms each, on the remaining four petals are four sacred vessels, each with a Kapâla above, as ritual vessels for the five kinds of Amrita. Outside, in the square field, in the four doors of the Maṇḍala and in the four corners, there are altogether eight Ḍâkinîs. The Ḍâkinîs at the corners are two-coloured, each of them participating in two elements of the cosmic order. We also recognize the basic order of the colours, familiar to us from the Maṇḍala of the five Tathâgatas. Cakrasaṃvara has the colour of the Buddha Akṣobhya, while the white colour from the centre has now been transposed to the east (the bottom) of the Maṇḍala. In the doors are four animal-headed Ḍâkinîs with four arms each. The whole traditional doctrine according to the system of the Indian teacher Maitrîpâda is revealed in the following twelve Ḍâkinîs and the central figure of the Heruka with his Ḍâkinî:

1. Inner circle of eight lotus petals

East	Ḍâkinî	Black
North	Lâmâ	Green
West	Khaṇḍarohî	Red
South	gZugs-can-ma	Yellow

Each Ḍâkinî has four arms with the symbols: knife, Ḍamaru, Kapâla and Khaṭvâṅga

2. In the four doors of the Maṇḍala

East	Khva-gdong-ma Raven-headed Ḍâkinî	Black
North	'Ug-gdong-ma Owl-headed Ḍâkinî	Green
West	Khyi-gdong-ma Dog-headed Ḍâkinî	Red
South	Phag-gdong-ma Pig-headed Ḍâkinî	Yellow

Each Ḍâkinî has four arms with the symbols: knife, Ḍamaru, Kapâla, Khaṭvâṅga

175

3. In the four corners of the Maṇḍala

South-east	gShin-rje brtan-ma	Blue/Yellow	Each with four arms and with the same attributes as above
South-west	gShin-rje pho-nya-mo	Yellow/Red	
North-west	gShin-rje mche-ba-mo	Red/Green	
North-east	gShin-rje 'joms-ma	Green/Blue	

Notes on the Plates 70 to 74

70 *This tantric painting on a black ground shows the visionary Maṇḍala of the four-armed Mahâkâla according to the version of Rva Lo-tsa-ba (Tib.: mGon-po phyag-bzhi-pa rva-lo'i-lugs). This translator of Rva was a notable eleventh century scholar. The four-armed Mahâkâla is seated on a sun lotus throne, with the blue sword of insight in his right hand. He is also known as the Protector of Wisdom (Tib.: Ye-shes mgon-po). From the black ground, the colour of the void, his two companions emerge; below the lotus throne are four animal-headed deities. Three of these have raven's heads and are called Las-kyi mgon-po; the fourth, with a lion's head, is Seng-ge'i gdong-ma. Under the flowering tree (bottom left) a yogi is contemplating the nature of transience in sight of the graveyard; on the right is an elephant-headed deity (Gaṇapati) with a healing herb. Between the two lamas (at the top) we can see the sun and moon (lunar and solar energy in the yoga) and the Yidam bDe-mchog lhan-skyes on a sun lotus. This painting belongs to the group of extremely esoteric representations and was accessible in Tibet only to initiates. Pictures of this kind are therefore invariably kept in the locked temples of the guardian deities which are found in every monastery.*

71 *This detail from a Thang-ka on a black ground shows the deity of riches Vaiśravaṇa (Tib.: rNam-thos-sras) riding a lion. He is the ruler of the northern world and guardian of earthly and spiritual riches. In his right hand he holds a sceptre with the flaming Ratna symbol and in his left a jewel-spewing ichneumon. The economical use of colour accents makes the delicate gold painting stand out against the black background.*

72, 73 *Two Tibetan bronzes showing the guardian deity Dam-can rdo-rje legs-pa (Plate 73) and one of his four companions riding a horse. Dam-can rdo-rje legs-pa is riding a goat and wearing a helmet-type hat; in his right hand he holds a bronze hammer and in his left a bellows (here missing). This Dam-can is an ancient Tibetan deity and was revered as the guardian of blacksmiths. In pre-Buddhist times the Dam-can deities probably belonged to the pantheon of the Bon religion. When Padmasambhava came to 'O-yug in Tibet he defeated the demon Dam-can rdo-rje legs-pa by magic and appointed him, together with his 360 companions, as "oath bound" (Tib.: dam can) guardian deities to watch over the gTer-ma (treasures). Gilded bronzes of the eighteenth century.*

74 *Beaten bronze of the Guru Rin-po-che (Padmasambhava) with his two disciples and wives Mandârava and Ye-shes mtsho-rgyal. The statue is the work of Nepalese artists and was made in separate parts and subsequently assembled. The "Precious Guru" holds the Vajra in his right hand and the Kapâla in his left. The Khaṭvânga (trident staff) is missing.*

176

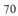

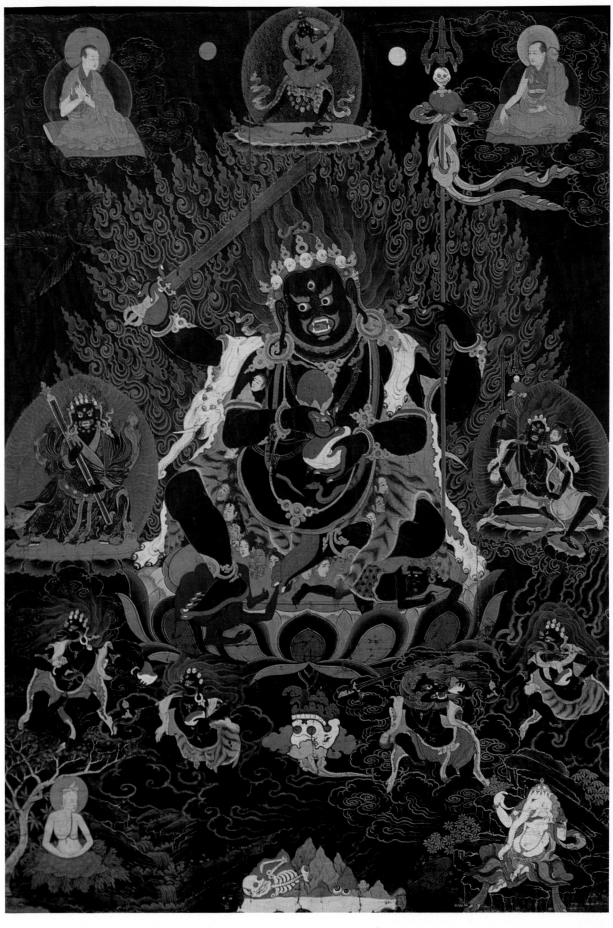

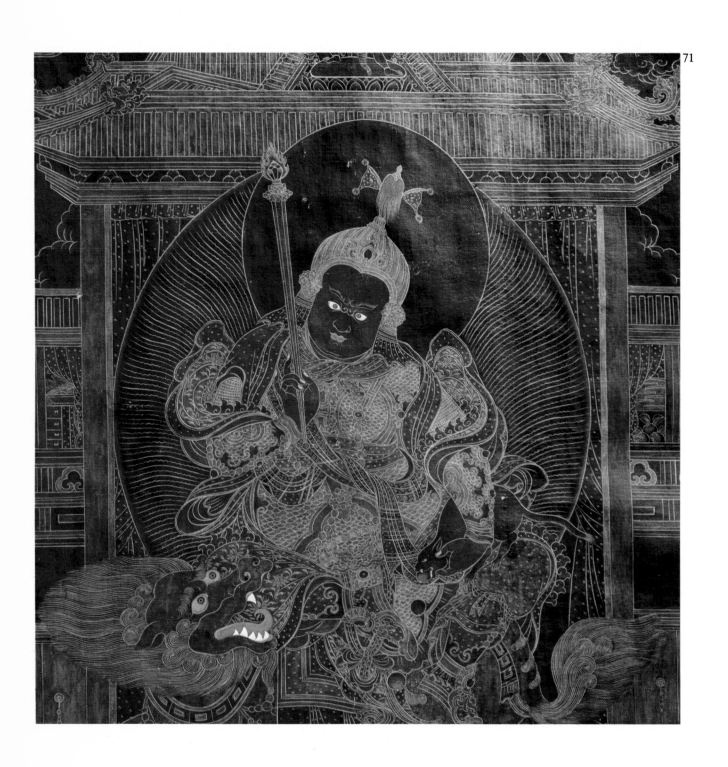

72

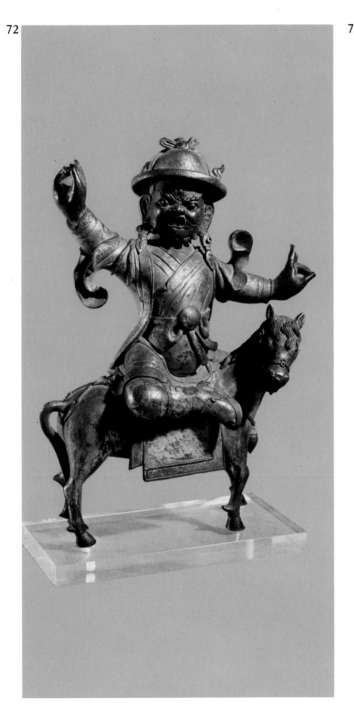

73

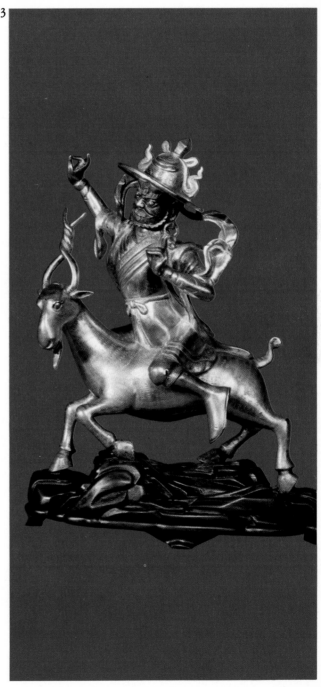

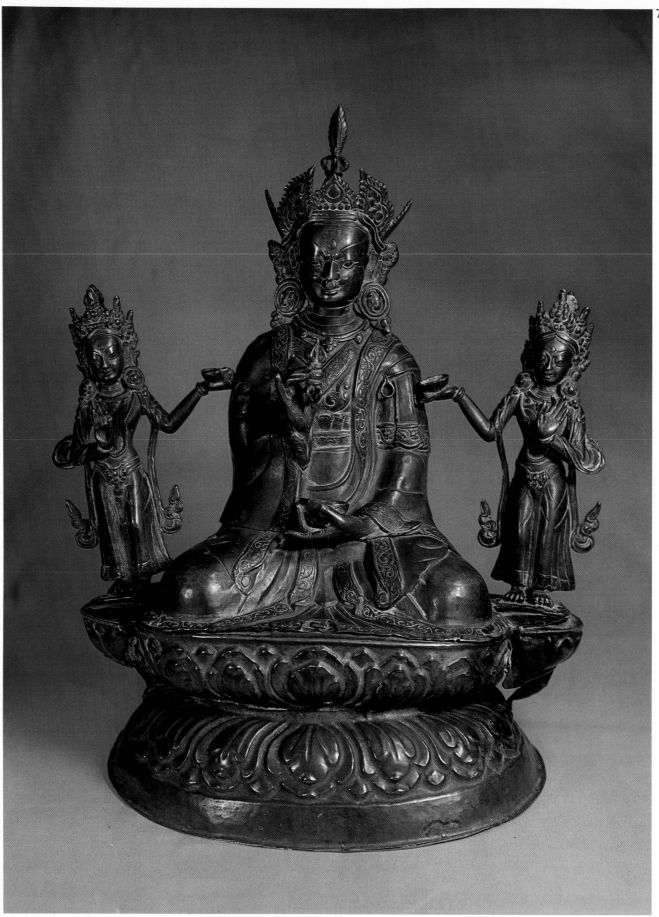

The Yidam Hevajra, the Proclaimer of Compassion and Wisdom

Another initiation deity of crucial importance to the tantric system of knowledge is the Yidam Hevajra. This tradition, too, goes back to the work of the eighth century Indian Mahâsiddhas; among them the Siddhas Saraha and Kampala deserve special mention. The Hevajra Tantra is one of the five great works of Buddhist tantrism; like the other Tantras it gave rise to an extensive literature. Just as the doctrines of Cakrasamvara, the god Hevajra symbolizes a particular system of yogic doctrine, offering different stages of insight worked out in minutest detail with secret instructions. All aspects of the tantric teachings and of applied thought are listed, and the various stages ending with the most sublime similes about the experience of the world and the transcendental, leading the initiate to ever higher knowledge. The great demand made by the Hevajra Tantras on philosophical thought and empirical experience of the world explains why initiation into these comprehensive systems was started only after long years of preparation and following the acquisition of a solid grounding in the Buddhist doctrines. Almost every word in this Tantra has its underlying symbolical meaning and represents a step on the path towards inner perfection and towards the knowledge of the external world. It is not, therefore, surprising that these writings are of an extremely esoteric nature and that their profound wisdom and the magic practices contained in them had to be kept secret. Any misuse of these teachings by the ignorant or uninitiated might lead to grave errors and do much harm to men and the doctrine. That is why the Hevajra Tantra has this to say about the handling of these scriptures:

"This book should be written down by one of our tradition, upon sheets of birch bark twelve *angula* long, with *collyrium* for ink and with human bone for a pen. But if an unworthy being should see either the book or a painting [of a deity] then perfection will not be achieved either in this or the next world. To one of our own tradition it may be shown at any time."

Even the name of the deity Hevajra consists of two parts the meaning of which refers to one of the foundations of Buddhism. "Through *He* the great compassion is proclaimed and wisdom through *Vajra*. Listen then to the Tantra, the essence of wisdom and of means now proclaimed through me."

Hevajra is therefore the proclaimer of supreme tantric knowledge; indeed he appears as the symbol and essence of the entire world of phenomena which is visible through him and becomes animate through him. If the yogin, in his search for supreme knowledge, succeeds in understanding him as the great symbol (Skr.: Mahâmudrâ) of the universe he will achieve perfect liberation. The god Hevajra and his entire Mandala must be recognized as a reflection of that universality which manifests itself in the words of the Tantra as follows: "The totality of existence arises within me, within me arises the three-fold world. Through me all this is per-

181

vaded, and this world consists of nothing else."

The guardian deity Hevajra is found in different forms—two-armed, four-armed, six-armed and the large manifestation with sixteen arms. In this book we show, for the sake of comparison, two forms of the sixteen-armed Hevajra—one an impressive gilded bronze (Plate 52) and, by way of contrast, a Maṇḍala on black ground (Plate 53) which shows the same iconography in the prescribed colours surrounding the Ḍâkinîs. Hevajra has eight faces, sixteen arms and four legs. His aspect is terrifying and as adornment he wears a chain of skulls. Nairâtmyâ, his Ḍâkinî, embraces him in mystic union. Hevajra is seen standing in the pose of the ritual dance (Skr.: Pratyâlîḍha) upon a sun lotus throne, stepping upon the four forms of Mâra. Even though in his outward appearance Hevajra presents a terrifying aspect, his inner nature is pervaded by the greatest peace, as is proclaimed in the Tantra, and he holds his Ḍâkinî in an embrace of divine love. The Maṇḍala shows us his middle face in blue colour; his right face is white and his left is red. His eight faces have altogether twenty-four eyes and each head is adorned with the quintuple crown of the Buddha. In his eight hands on the right side Hevajra carries one Kapâla each with the symbols of the elephant, horse, ass, ox, camel, man, lion and cat. In his eight hands on the left he likewise holds one Kapâla each with the symbols of earth, water, air, fire, moon, sun, Yama and Vaiśravaṇa. The elements in his right hands correspond to the eight Lokapâlas and those in his left to the eight planets. The Ḍâkinî of Hevajra, the light blue Nairâtmyâ, is the personification of the perfection of wisdom; she is permeated by the true nature of the void. Her name—Nairâtmyâ—means "emancipation from self" or "the one without self".

We have described here a few aspects out of the vast field of secret doctrines of the Hevajra Tantra so that, when contemplating the picture, we might undertand a little more of the meaning of this blue dancing Heruka accompanied by his eight Ḍâkinîs of the Maṇḍala (Plate 53). These eight Ḍâkinîs alone, of different colour and with different symbols in their hands, represent a series of symbols which are in manifold relationship to the central figure of Hevajra. The table below lists their names, colours and hand-symbols.

Dâkinî	Colour	Symbol of the right hand	Symbol of the left hand	Position in the Maṇḍala
Gaurî	Black	Knife	Fish	East
Caurî	Red	Ḍamaru	Bear	South
Vetâlî	Reddish gold	Tortoise	Kapâla	West
Ghasmarî	Green	Snake	Kapâla	North
Pukkasî	Blue	Lion	Axe	North-east
Śavarî	White	Monk	Begging staff	South-east
Caṇḍâlî	Blue	Cakra	Plough	South-west
Ḍombî	Greenish gold	Vajra	Mudrâ	North-west

Vajrabhairava, a wrathful manifestation of Mañjuśrî

Finally we have to look at the exceedingly powerful Yidam Vajrabhairava, the most important guardian deity of the dGe-lugs-pa sect. Vajrabhairava (Tib.: rDo-rje 'jigs-byed) is represented in one of his Maṇḍalas on an ancient painting (Plate 66). This deity is a terrifying emanation from the peaceful form of the Bodhisattva Mañjuśrî. That is why we find his peaceful face at the top of the nine heads of the bull-headed god who is usually known by the name of Yamântaka. The tantric doctrines of Vajrabhairava reached Tibet by three different routes through outstanding translators.

The bull-headed god with his nine heads, thirty-four arms and sixteen legs was venerated as a Yidam and Dharmapâla, as guardian of the sacred doctrine. Because of his manifold power he was called upon to fight against all opposing forces and against all enemies of the doctrine, and his aspect was to keep all uninitiated away from the great mystery of the Tantras. Yamântaka, as the most powerful of the terrifying aspects, thus also became the leader of the "eight dreadful deities" (Tib.: Drag-gshed-brgyad) which form a favourite group in tantric painting. According to a different tradition, Yamântaka became the conqueror of Yama, the death god himself. Contemplating the numerous symbols of this complex deity, we find that their significance far surpasses that of physical death and reaches into the realm of perfection to which his Tantra points.

Yamântaka is of bluish-black colour and appears adorned with a chain of fifty skulls and a wealth of bones. He stands in an aura of red flames and smoke with the manifold series of strong arms and legs. The thirty-four arms symbolize the thirty-four elements of the highest enlightenment, which is reached in meditation on the meaning of these symbols. The symbols in the deity's right hands are: knife, stiletto with

three peacock's feathers, pestle (Tib.: gTun-shing), razor, lance (Tib.: Ka-ṇa-ya), axe, spear (Tib.: mDung), arrow, iron hook, club (Tib.: dByug-to), Khaṭvâṅga, Cakra, Vajra, hammer, sword, Ḍamaru and an elephant's skin. In his left hands Yamântaka holds: a Kapâla, the qua-druple head of Brahmâ, a shield, foot, noose, bow, intestines, Ghaṇṭâ, hand, scrap of material from a graveyard (Tib.: Dur-khrod-kyi ras), an impaled man, a triangular firing kiln, a Kapâla, the Mudrâ of menace, a trident, a scrap of flag-cloth (Tib.: rLung-ras) and an elephant's skin. Let us pick out only two of the thirty-four in order to suggest the real meaning of these hand-held symbols: the knife in the first right hand destroys all ignorance and the Kapâla in the first left hand is a reminder that the sacred vows of renunciation should be observed.

Yamântaka has sixteen legs, arranged in two groups of eight, closely behind each other. With them he tramples on a number of beasts and humans which should be seen as symbols of the defeated enemies of the doctrine. With his right feet he crushes a human, buffalo, elephant, ass, camel, dog, sheep and a fox. Under his left feet are a vulture, owl, crow, parrot, falcon, heron, cock and a swan. Among these beasts there are again a few deities from Hindu mythology con-quered by Yamântaka—Brahmâ, Indra, Râhula, Rudra, Kumâra, Siṃha, Gaṇeśa, moon and sun.

This list, of course, has only shown us the power-ful Yidam's external symbols, which are of more or less mythic origin and contain but a few hints to a Buddhist way of interpretation. We may quote one of these from Tsong-kha-pa, the great Tibetan reformer and founder of the Yellow Church. His greatly abridged interpretation of the symbols of Vajrabhairava states that the nine heads represent the nine-fold division of the scriptures, that the two horns represent relative and absolute truth, and that the twice eight crea-tures crushed under his feet symbolize the eight abilities and the eight surpassing forces.

These brief explorations of the bewildering sym-bolism of the guardian deities must suffice; fur-ther information can be gleaned from the cap-tions to the plates. We have seen how the charac-ters of the guardian deities present themselves and how their functions in tantric Buddhism are to be assessed. But the very multiplicity and complexity of the manifestations of the numer-ous guardian deities reveals that their symbolism is too complex and elaborately stratified for us to plumb its full depth. As soon as we spotlight one figure among them, new horizons open beyond it and with it new levels of contemplation of the secret symbolism. For example, there are the demons and local deities of ancient Tibet con-quered by Padmasambhava and since integrated into Lamaist doctrine as tutelary deities. Then there is the large group of Ḍâkinîs and the num-erous, mostly unknown, local guardian deities. Nearly every monastery had chosen one of these to be responsible for the special protection of its walls. Others were invoked to dispel the evil and pain-causing demons of sicknesses, while still others uttered secret prophecies through the

medium of Tibetan oracle priests. Here, without any doubt, we come close to ancient Tibetan tradition and to the concepts of Tibet's original Bon religion, which comprised a vast number of local deities inhabiting nature, water, rocks and trees, the ground and the air. Many of these deities, in transformed meaning, were assigned new duties in Lamaism.

The concept of the guardian deities as really existent powerful beings, to whom one might appeal for personal protection, help, and riches, was widespread among the people. But Buddhist doctrine was always far above any idea of real transitory earthly divine beings. The gods were regarded as the highest manifestations of the universal void to which they must all revert. They were merely an interplay of forces, different manifestations of the mind, whose reality dissolved with the yogi's increasing insight into the void. This attitude is expressed time and again in the Tibetan texts which reveal to us the true origin of all manifestations. For instance, in the introductory portrayal of the guardian deity Vajrapâṇi (Plate 65), his visionary nature is described as follows:

"From the sphere of the void there emerges a lotus moon throne and (above it), arising out of himself in total transmutation, there dawns from the azure-blue syllable *Hûṃ,* Vajrapâṇi, the Victorious One in Three Worlds. He is of black colour, with one face and two arms. Raising the Vajra in his [right] hand in the gesture of menace, garlanded with the precious snake-jewel, he stands with both his feet on the lotus moon throne of the Diamond Path."

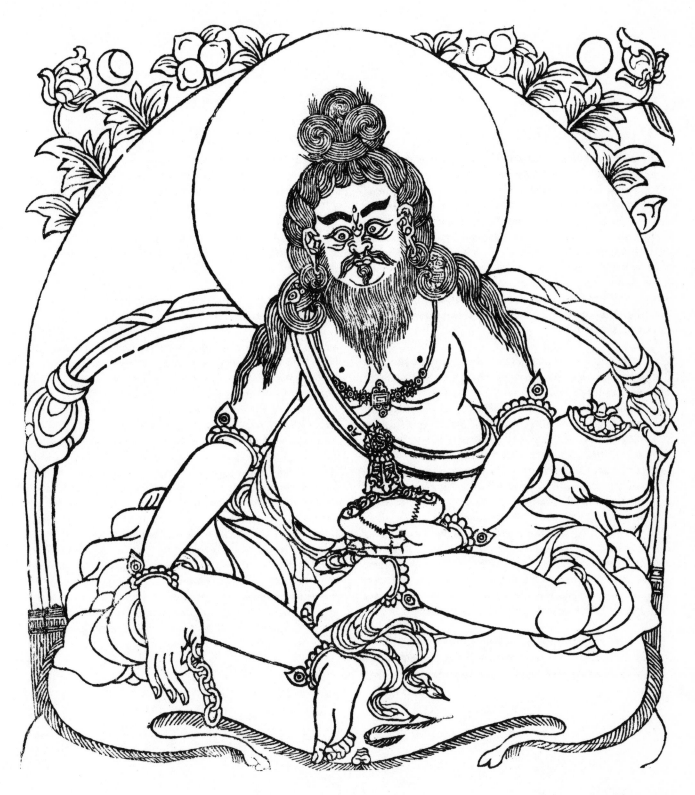

Fig. 17. Tibetan block-print showing the Siddha Thang-stong rgyal-po (1385–1464). He gained fame as a bronze-smith and the inventor of Tibetan chain-bridges.

75 *Silver-fronted metal containers, such as the silver-fronted one reproduced here, were found on every Tibetan house altar and on the shrines of temples. These containers (Tib.: Ga'u) have a small window in front, through which a painted miniature or a small bronze of a Buddha or a saint can be seen. These containers were particularly popular as portable travelling shrines; with straps fitted to them they could be taken along on journeys across the vast distances of Tibet. The plate shows such a container with a beaten silver face-plate and a miniature of the Tibetan master and translator Mar-pa of Lho-brag. Mar-pa was the founder and first guru of the bKa'-brgyud-pa line in Tibet.*

76 *This painting shows the Tibetan lama and physician gYu-thog-pa yon-tan mgon-po. There were in fact two physicians of this name, living in the eighth and eleventh centuries respectively. gYu-thog-pa was closely associated with the translation and commentary on the teachings of the Book of "Four Roots" (Tib.: rGyud-bzhi). This important Tibetan medical work was a translation of a classical Indian work whose original is not extant. At the centre of the picture we see gYu-thog-pa; above him, on clouds, there are, from left to right, Amitâbha, Amitâyus (the Buddha of long life), the blue Buddha of medicine (Tib.: sMan-bla), Padmasambhava and a Rishi (Tib.: Brang-srong). In the lower part of the picture, in a triangle, there are nine guardian deities of Tibetan medicine, and to the right of them a further group of six medical deities. In a rock to the left of the triangle we can see the "treasure-finder" Grva-pa mngon-shes discovering gTer-ma writings in a cleft. Painting from central Tibet, eighteenth century.*

77 *The Guru Padmasambhava in symbolic manifestation as a lama of medicine. In his right hand he holds a healing herb. The plinth shows the eight Buddhas of medicine.*

78 *Gilded bronze of the Karma-pa Grand Lama Byang-chub rdo-rje. He was the eleventh incarnation of the Karma hierarchy with the black hat (Tib.: Zhva-nag-pa) and lived from 1703 to 1733.*

79 *Gilded bronze of a lama and yogi by name of Ngag-dbang bzang-po. He is seated on a goat's skin and wears the cap of the hermit lamas.*

80 *The great yogi Mi-la ras-pa. Gilded bronze in the Sino-Tibetan style of the eighteenth century.*

81 *This delicate eighteenth century painting portrays the first masters of the bKa'-brgyud-pa sect. The principal figure at the centre is the mystic and poet Mi-la ras-pa in his cave of meditation. He is wearing the band of meditation (Tib.: sGom-thag) and the white garment of the cotton-clothed (Tib.: Ras-pa); his right hand is placed behind his ear. On his left, wearing the same clothing but a pointed hat, is his favourite disciple Ras-chung-pa. Standing in front of the great yogi, in white robes, is his disciple Dvags-po lha-rje, the physician, handing him offerings. Dvags-po lha-rje (often called sGam-po-pa) soon became his most important disciple and successor; in this capacity of Grand Lama we see him to the left of Mi-la, wearing red garments and an abbot's hat. At the top, above the mountain peaks, are Nâropa (left) and Tilopa (centre), the Indian gurus of the line, and Mar-pa, the first Tibetan master and the guru of Mi-la ras-pa. The painting shows the influences of Chinese art which greatly contributed to a loosening of iconographic rigidity and formal arrangement and instead emphasized the value of landscape as an artistic element.*

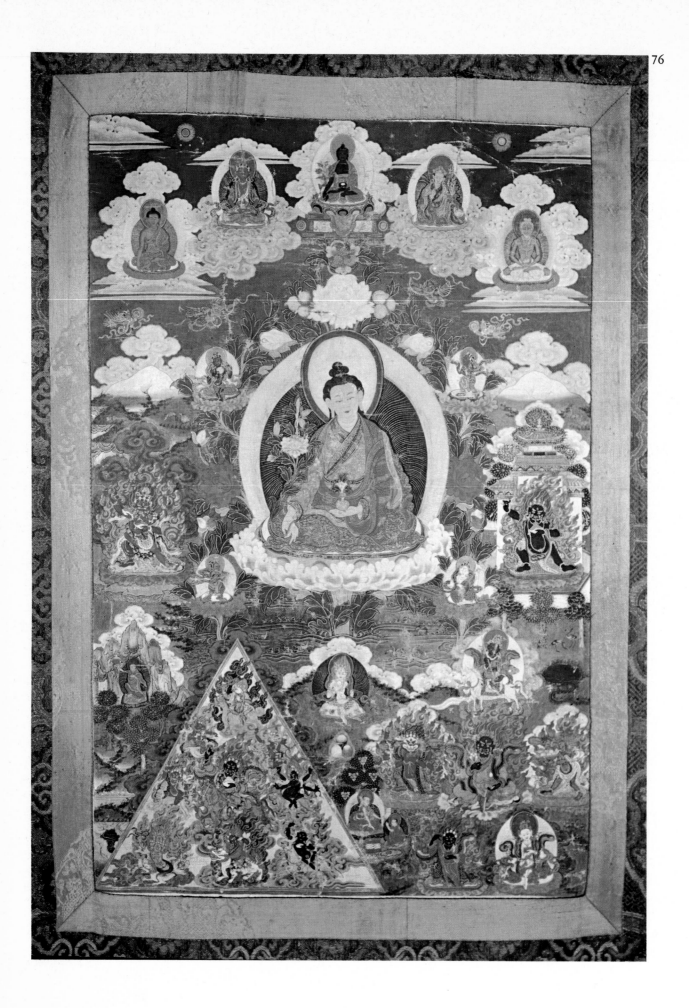

77
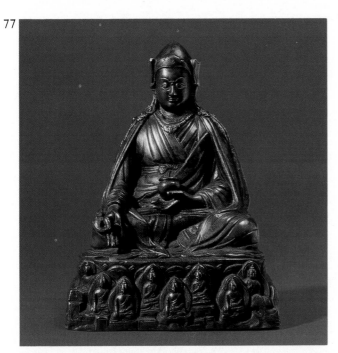

78
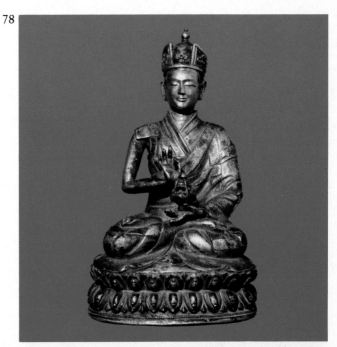

79
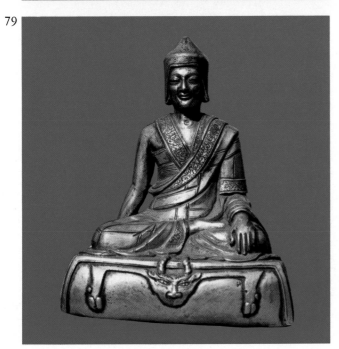

80
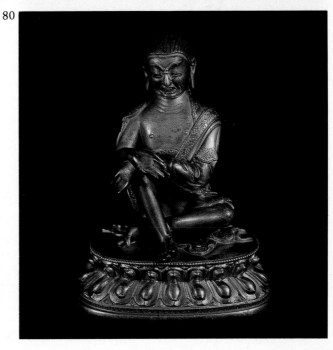

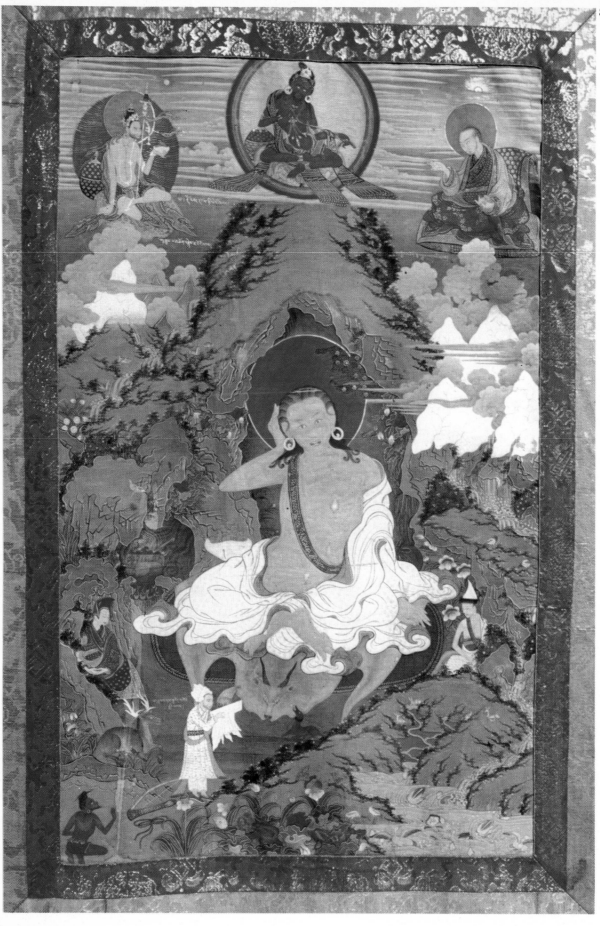

Great Masters and Saints in Tibet

Padmasambhava

One of the most important and most interesting figures in Tibetan Lamaism is the Guru Padmasambhava (Tib.: Gu-ru rin-po-che). Although we mentioned him briefly in the opening chapter, the remarkable personality of this almost legendary Tibetan guru deserves closer examination. The many traditions associated with him, and in particular the biographical writings, record far more magic deeds and miracles than solid historical facts. Yet in spite of the veil of legend which surrounds the accounts of his life, we know, especially from the period of his first monastic foundation in Tibet, of his historic and important efforts to establish tantric Buddhism in the Land of Snows. Considering the frequency and extent of his journeyings and his numerous exorcisms of demons in Tibet, the work of this first Indian master must have been indefatigable.

Even his birth as a divine incarnation on earth is said to have been accompanied by miracles. Since these events are entirely typical of the gnostic ideas of tantrism, we shall describe them briefly. At the time of his appearance (about the second half of the eighth century), King Indrabhûti and his subjects were in dire distress. This was observed in the higher spheres by the great compassionate Bodhisattva Avalokiteśvara, who turned to the Buddha Amitâbha (in Sukhâvatî Paradise) with the plea that he should call a halt to suffering on earth. The Buddha Amitâbha resolved to let a divine emanation of himself arise on earth and emitted a red ray of light which struck the middle of Lake Dhanakhosha (a small lake in the mountains of the Kangra Himâlayas). At once a small island with golden grass arose from the depths of the lake and at the centre of this island a wonderful lotus blossomed. Thereupon a golden Vajra came out of the heart of the Buddha Amitâbha and dropped into the centre of the lotus flower. All this was seen in a dream by King Indrabhûti and his ministers, and they understood that an important event was about to occur. A minister was dispatched who found a miraculous child of divine aspect sitting upon a lotus flower in the middle of the lake, just as had been vouchsafed to the King in his dream. The King was summoned and they all sailed in a boat to the island radiant with rainbows and miraculous beauty. They then took the child to the palace. The King paid homage to the spontaneously born child and asked him: "Where are your father and mother, where is your home and what is your caste?" Thereupon the divine child replied: "My father is wisdom and my mother is the void, my country is the land of the sacred doctrine and I am of no caste and no faith." Because of his miraculous birth, the child was later called "Lake-born Vajra" (Tib.: mTsho-skyes rdo-rje) or Padmasambhava, "the lotus-born".

These short excerpts already contain some essential statements about the typical tantric attitude of Vajrayâna Buddhism, in which worldly existence and the transcendental, myth and reality become relative concepts in the symbolic formulation of the voidness of all phenomena as the

supreme ideal. For the initiated tantrist this short account provides a clear insight into the doctrines whose essence is manifest through their symbolic language. According to this tradition, Padmasambhava is the spiritual son of the Buddha Amitâbha. He was created in a spontaneous manner through the compassion of Avalokiteśvara. His parents stand symbolically for the primal pair of the unity of the concepts of "wisdom and void", which are the principal goals of tantrist knowledge, the universal realm of the law or doctrine. Thus, even to this day, we frequently find in Tibetan paintings the Buddha of infinite radiance (Amitâbha) as the spiritual ancestor of the Guru Padmasambhava. In the Trikâya doctrine Amitâbha resides in Dharmakâya; his projection on the plane of the visionary body (Sambhogakâya) is the Bodhisattva Avalokiteśvara; and in his earthly form (Nirmânakâya) his incarnation appeared as the Guru Padmasambhava. The biography of Padmasambhava further states that he travelled throughout India and neighbouring countries to study the doctrines of the Tantras, magic incantations and exorcisms of demons. Taught by monks, scholars and yogis, he acquired great powers of knowledge and magic. At the eight sacred burial grounds of India he devoted himself to meditation in order to learn the higher wisdom from the secret Dâkinîs, the tantric goddesses of initiation. It is said that in numerous initiations these Dâkinîs imparted to him arcane and transcendental wisdom, all of which later became integrated into the teachings of Lamaism.

Eventually, at the invitation of the Tibetan King Khri-srong lde'u-btsan, Padmasambhava set out to that country to propagate the doctrine. Even on his journey through Nepal, and the mountain valleys of Tibet, the master was frequently confronted with the need to exorcise demons and malicious local deities. His journey to Lhasa took him through regions dominated by demonic forces, many of which he had to conquer by magic powers. These exorcisms reported by his biographers were, of course, his clashes with the deities of the indigeneous faith. All these old pre-Buddhist demonic deities, however, were converted to the new doctrine and enlisted as guardian deities of the Buddhist faith. They then opposed the enemies of the doctrine and protected the holy places. Difficulties were also encountered during the building of the first Buddhist monastery in Tibet, bSam-yas, south of Lhasa. Demons and earth spirits tried all kinds of machinations to prevent the erection of the walls. Padmasambhava's biographer reports that he thereupon magically defeated and exorcised all the demons and that they henceforth helped to build the monastic edifice. Thus, with the converted demons working at night and humans during the day, the monastery is said to have been completed in a much shorter time than planned.

We thus see the early period of Buddhism in Tibet as one of conflict with the native Shamanist tradition and the Bon religion, whose demons had ruled the country. As a result of this collision with the teachings of Vajrayâna Buddhism, 194

many of the concepts and religious practices of ancient Tibet, and a number of converted deities, entered the pantheon of Buddhism which then developed its specific Tibetan form known as Lamaism.

Mar-pa, the translator from Lho-brag

A very important figure among the great scholars of the classical age of Lamaism was Mar-pa who was from the south Tibetan province of Lho-brag. The most important achievement of his life (1012–1097) was the establishment of a great spiritual tradition in Tibet—those sects which became known as the bKa'-brgyud-pa. Mar-pa first studied the Sanskrit language in Tibet under the outstanding translator 'Brog-mi at his monastery of Myu-gu-lung, which was an early centre of Lamaist scholarship. Soon, however, Mar-pa decided to study the Buddhist teachings in their country of origin, India. After a few stops in Nepal he reached India and there studied under various masters until, one day, after much searching, he found a guru in the person of the great tantrist and Siddha Nâropa. Mar-pa offered Nâropa a lot of gold as a present and inducement to instruct him in the secret doctrines. But Nâropa flung the gold away and touched the big toe of his foot, whereupon the ground turned to gold. Nâropa said to his Tibetan disciple: "All this is a golden island." With these words he disappeared.

195 Mar-pa made several journeys to India and brought back to Tibet the doctrines of Vajrayâna which he received from Nâropa and Maitrî-pa. He then settled in Tibet and married a Tibetan woman by name of bDag-med-ma ("the unselfish one"). He began to translate into Tibetan the sacred scriptures he had brought with him, and soon he was surrounded by many disciples. Later, when he had moved into his new hermitage at Drobolung (Tib.: Gro-bo-klungs), new disciples came to him from all parts of the country to be instructed by this great translator. Among the "four great columns" (Tib.: Kachen-bzhi), as his four most important disciples are sometimes called, was the great yogi Mi-la ras-pa, who later carried on his teacher's tradition. On one occasion, when Mar-pa was at Phulahari (in India), and asked for further teachings, the aged Nâropa bowed respectfully towards the north and spoke these words:

Just as in the darkness of the north
the sun rises over the snowy mountains
so is the venerable Thos-pa-dga';
to him I bow with respect.

The reference was to Mi-la ras-pa who soon became the most important successor and mystic in this line. After Nâropa had spoken these words tradition has it that all trees and mountain tops in the area bowed three times towards the north in confirmation of the master's words. When Mar-pa had reached the fullness of his years and his disciples were steadfast in the doctrine, he transmitted to his accomplished disci-

ples, (the "four great columns") all the teachings and sacred instructions together with precious religious objects. On this occasion the spiritual line of the bKa'-brgyud-pa was officially proclaimed and the successors appointed. After Mar-pa's death his relics were preserved in a precious silver tomb and later a temple was built at the site.

Mi-la ras-pa, the great yogi of Tibet

When Mi-la ras-pa (pronounced: Milarepa) was born in 1040 he was first given the name of Thospa-dga'. While he was still a child his father died of a serious illness. His uncle promptly seized the entire inheritance and abandoned the widow and the child to utter poverty. To add insult to injury they had to toil on the uncle's estate in return for scant and coarse food. When Mi-la ras-pa had grown to manhood his mother persuaded him to learn the magic arts from an experienced lama of the rNying-ma-pa sect in order to destroy all enemies of the family, including the miserly uncle. At his mother's request he therefore sought out a magician in the Yarlung valley and there studied the black art. One day, when the uncle's son was at his wedding feast, Mi-la ras-pa succeeded through magic incantations in causing the house where the feast was held suddenly to collapse. The uncle and the aunt were spared but the remaining thirty-five guests lost their lives. In order to strike at his uncle and aunt Mi-la ras-pa later used his magic powers during harvest time to bring down heavy hailstorms on fields in the valley, so that the whole area was turned into a region of bare rock. In order to pay back all the suffering inflicted on himself and his mother he caused a great deal of damage by his black magic. But one day he felt that by his actions he had placed a heavy burden of guilt upon himself and he urgently desired to learn the true religion.

His lama supported him in his search for the right teacher and told him about a master called Mar-pa. The lama said to him: "In Lho-brag there lives a famous disciple of the Indian Siddha Nâropa and his name is Mar-pa the translator. There is a karmic connection between you which derives from past lives. You must go to him." After prolonged wanderings he eventually found his master engaged in ploughing his fields. Although Mar-pa accepted him he put Mi-la through a long period of severe trials accompanied by disappointments and suffering. Mar-pa made him plough, build stone walls and houses, and persisted in refusing him any kind of higher teaching although other disciples were being initiated. Eventually, when Mi-la was also to be initiated into the secrets of the Buddhist doctrines, Mar-pa said to him: "I knew when you came that you were a disciple of special grace, but as you had been such a great sinner I first had to purify you." In a canto to Ras-chung-pa, subsequently the favourite disciple of Mi-la ras-pa, handed down to us in the "Blue Annals" of Tibet, he had this to say about his time with the Guru Mar-pa:

196

Regardless of the hardships of the path
I strove to meet him,
and the mere aspect of his visage transformed
 my mind.
It seemed to me as though he had been my
 teacher in earlier lives.
In the presence of this benign father
I spent some six years and eight months,
my body following his like a shadow.
Even though I did not possess presents of
 worldly things,
by serving him with body and speech
I gave myself to him to the last.
Thus satisfied he transmitted to me
from the depths of his spirit
the complete oral and secret instructions.

The initiation of Mi-la ras-pa was extensive and required some preparation. In the presence of all Mar-pa's disciples his hair was cut and a monk's habit put on him. He then took the vow of a Buddhist lay brother (Tib.: dGe-bsnyen-gyi sdom-pa) and was enjoined to follow the teachings of the Bodhisattvas. In addition he received the ordained name of "Mi-la Diamond Victory Token" (Tib.: Mi-la rdo-rje rgyal-mtshan); Mar-pa claimed that he had received it from his Guru Nâropa in a dream-vision. As Mar-pa dedicated the Kapâla of the "inward offering", a five-coloured light shone from it which was seen by all. Mi-la then received the four initiations (Tib.: dBang-bzhi) and the following day the sacred ceremonies continued. The great sixty-two-fold Maṇḍala of Śaṃvara was drawn on the ground with coloured dust and the guru explained it in every detail. He named the twenty-four places sacred to Śaṃvara, the thirty-two places of pilgrimage and the eight great graveyards with the heroic gods and goddesses assembled all round. And then the lamas and all the deities of the Maṇḍala with one voice gave him the sacred initiation name of dPal-bzhad-pa rdo-rje.

One day, when Mi-la ras-pa had greatly advanced in his studies under his master, the question arose of how the spiritual tradition of bKa'-brgyud-pa had best be preserved, seeing that Mar-pa was well advanced in years. He therefore enjoined all his disciples to heed their dreams during the time to come in order to discover if they contained any propitious tokens with regard to these questions. Of all the dreams which were subsequently reported the decisive one was the famous dream of Mi-la ras-pa. We will report it in full, and moreover in the manner in which his teacher Mar-pa interpreted it, as this dream symbolically codified the foundation and future of the bKa'-brgyud-pa hierarchy. Parallel with the account of the dream of the "four great columns" we might regard the Tibetan representation on Plate 82, which is a clear pictorial version of Mi-la ras-pa's memorable vision.

To thee, Buddha of the three ages and protector
 of creatures,
o great Panditâ Nâropa, I bow to the ground in
 respect.

197

All you, my disciples, seated here in assembly,
pay careful heed to the dream
and its miraculous and prophetic prediction
which I, your master, will now interpret for
 you.

The vast regions in the north of the world
characterize Buddha's doctrine now spreading
 in Tibet.
The glacier mountain rising there
symbolizes old father Mar-pa, the translator,
and the whole doctrine of the bKa'-brgyud-pa
 order.
The mountain peak, touching the clouds,
means incomparable mystic insight.
Sun and moon, moving about the peak,
are the clear light of meditation and [omnis-
 cient] love.
Their light, radiant in the heaven above,
is the benevolence which illuminates the night
 of ignorance.
The foot of the mountain, piercing the ground
 of the earth,
symbolizes that the earth is filled with our good
 deeds.
The rivers originating in the four directions
are the instructions for the four initiations of
 ripening and redemption.
Their waters, refreshing all creatures,
mean that all shall partake of transformation,
 ripening and redemption.
Their waters, sinking in the ocean,
betoken the encounter of the inward and out-
 ward clear light.

The mass of flowers which bloom there
are the unblemished fruit of bliss.
O my disciples here assembled,
the dream is not bad, the dream is good!

The great column in the east at the high glacier
 mountain
is mTshur-ston dbang-nge from Dol.
The lion rising from the column's top
symbolizes his lion-like nature.
The lion's mightily spreading mane shows
that he is perfect in the instructions of the oral
 tradition.
The lion's four paws, gripping the mountain-
 side,
show that he is imbued with the four divine vir-
 tues.
His eyes, turned heavenward, show
that he has renounced the life of Saṃsâra.
The lion's free roaming over the snowy moun-
 tain
symbolizes that he has reached the realm of
 freedom.
O my disciples here assembled,
the dream of the east is not bad, the dream is
 good!

The great column rising in the south
is rNgog-ston chos-rdor from gZhung.
The tigress roaring from the column's top
symbolizes his tiger-like nature.
The tigress' stripes extending over her skin
 show
that he is perfect in the teachings of the oral tra-
 dition.

198

Her stripes trebly enclosing everything signify
that he has perfected in himself the three
 bodies.
The four paws outstretched in the jungle show
that he has mastered the four religious services.
Her eyes, turned heavenward, show
that he has renounced the life of Saṃsâra.
The tigress, freely roaming through the jungle,
symbolizes that he has reached the realm of
 freedom.
Her crossing of plains and forests reveals
that the hierarchy is continued through his suc-
 cessors.
O my disciples here assembled,
the dream of the south is not bad, the dream is
 good!

The great column rising in the west
is Mes-ston chen-po from gTsang-rong.
The great Garuḍa on the column's top
symbolizes his Garuḍa-like nature.
The Garuḍa's outspread wings show
that he is perfect in the teachings of the oral tra-
 dition.
The Garuḍa's feathers raised to the heights of
 heaven
symbolize that he has severed meditation from
 error.
His eyes, turned heavenward, show
that he has renounced the life of Saṃsâra.
The Garuḍa, flying in celestial spheres,
symbolizes that he has reached the realm of
 freedom.

O my disciples here assembled,

the dream of the west is not bad, the dream is
 good!

The great column rising in the north
is Mi-la ras-pa from Gung-thang.
The vulture spreading on the column's top
symbolizes his vulture-like nature.
The vulture's outspread wings show
that he is perfect in the instructions of the oral
 tradition.
The vulture's nest, clinging to the rock
shows that his life shall endure as the rocks.
The vulture nurturing its young shows
that he will have an incomparable [spiritual]
 son.
The heavens filled with small birds show
that the teaching of bKa'-brgyud-pa will
 spread.
Its eyes, turned heavenward, show
that the teaching of bKa'-brgyud-pa will
The vulture soaring in the heights of heaven
symbolizes that he has reached the realm of
 freedom.
O my disciples here assembled,
the dream of the north is not bad, the dream is
 good!

Now I, the aged father, have done what
 remained to be done;
it is up to you, my disciples, to see that it comes
 to pass.
And if my words are prophetic
then the teaching of bKa'-brgyud-pa will spread
 far and wide.

Thereupon Mar-pa handed over to his four principal disciples, each according to his abilities, part of the doctrines together with the books associated with them, as well as various relics and objects of the earlier Indian gurus of his line. Lama rNgog-pa received the texts for explaining the Tantras; mTshur-ston received the doctrines of "Consciousness-transference" (Tib.: 'Pho-ba); Mes-ston was given the instructions about the "Clear Light" (Tib.: 'Od-gsal) and Mi-la received the texts of the doctrine of the inner "Mystic Warmth" (Tib.: gTum-mo).

Ras-chung-pa

Among the many disciples of Mi-la ras-pa, one was regarded as his favourite and spiritual son—Ras-chung-pa. Like his teacher he came from the Gung-thang region in southern Tibet, where he was born in 1083. His real name was rDo-rje grags-pa. He learnt to read the scriptures at an early age and when he was eleven he met his guru, Mi-la ras-pa, with whom he stayed for the next four years. From him he successfully learnt the systems of the inner "Mystic Warmth". When he fell sick with leprosy Indian ascetics took him to India with them to have him cured there. There, as also in Nepal, Ras-chung found important teachers who passed on to him many secret doctrines. By means of a particularly effective Mantra he also succeeded in completely overcoming his disease. Having studied several Tantras he returned to Tibet via Nepal

and rejoined his teacher. Later Mi-la once more asked him to go to India to collect further important doctrines about the Dâkinîs. In India Ras-chung received from the Siddha Ti-phu-pa all the instructions about the nine categories of Dâkinîs and these he then passed on to his Guru Mi-la ras-pa as a gift. The biography of Mi-la speaks of his deep affection for his disciple Ras-chung whom he instructed to the very end in all secret doctrines of the oral tradition.

Ras-chung-pa later went to central Tibet and to the southern provinces where he collected a great many disciples around him. Among these was also Dus-gsum mkhyen-pa, a great scholar and, later, the first abbot of the Karma-pa sect (one of the main branches of the bKa'-brgyud-pa). When he died in 1161, Ras-chung-pa left to his successors an important collection of doctrines which have been preserved under the name of "The Line of the Oral Tradition of Ras-chung".

There is a noble dignity and profound wisdom in the last spiritual instructions given by the great yogi Mi-la ras-pa to his favourite disciple when he appeared to him for the last time, in a heavenly vision after death. His words have been handed down to us in the biography of Mi-la ras-pa as follows:

O Ras-chung, my son, like my own heart,
listen to this hymn, my last testament of instructions:
In the ocean of the three worlds of Saṃsâra
the earthly body is a great sinner.

200

82

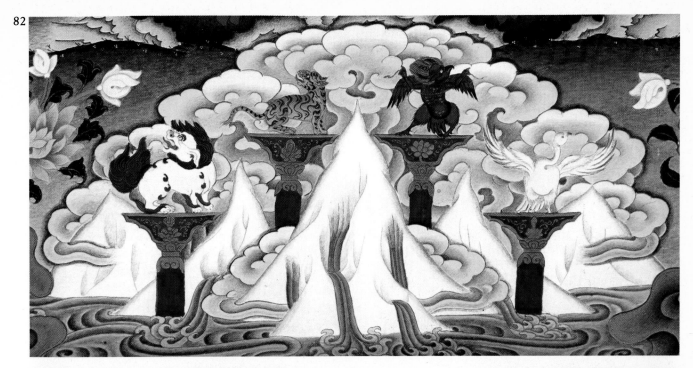

83

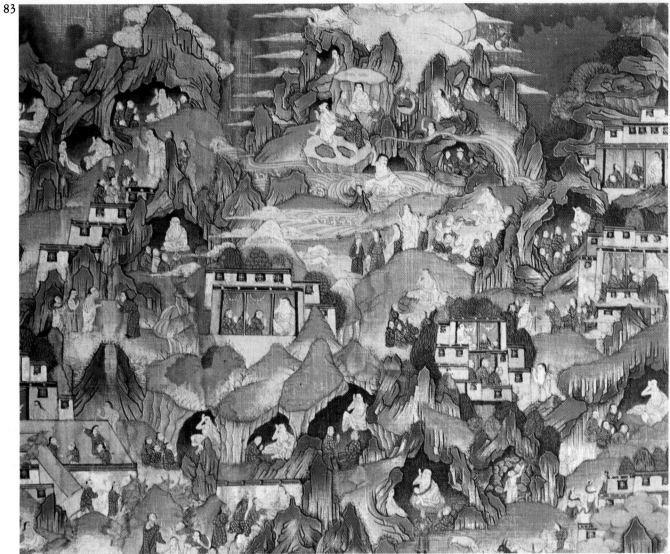

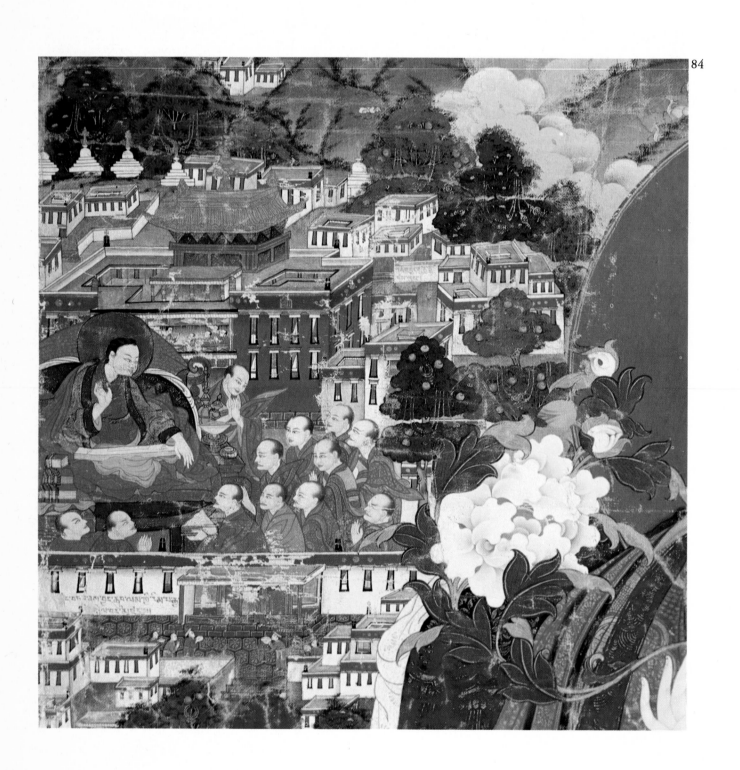

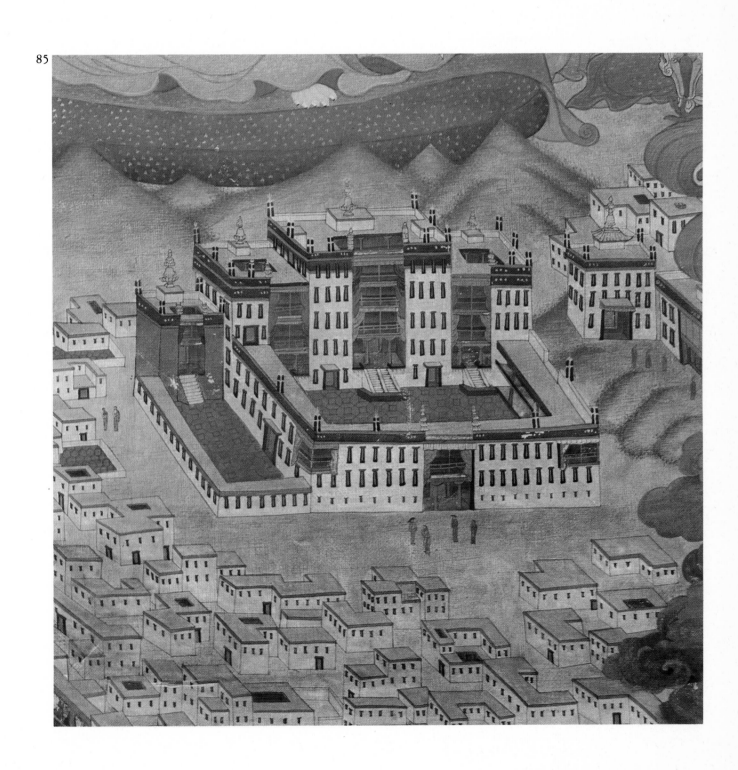

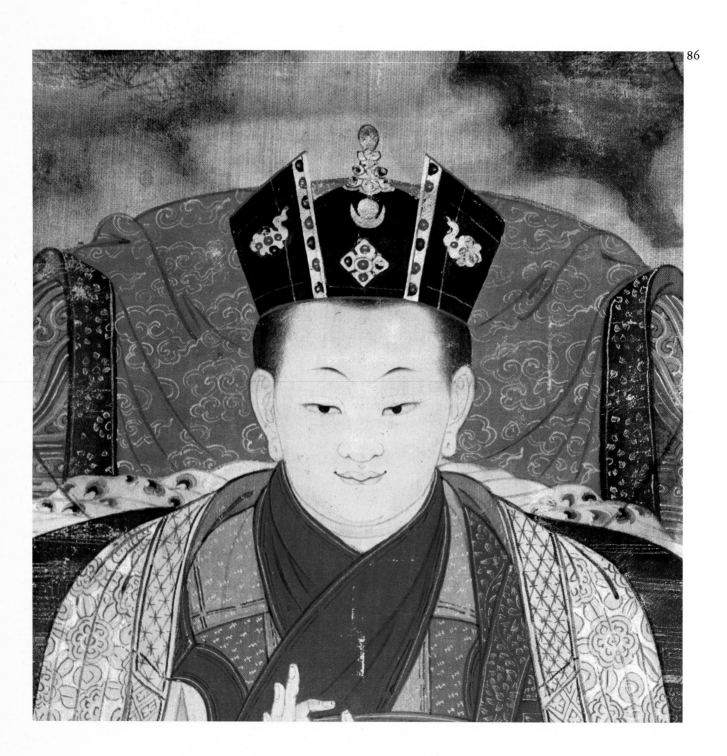

82 Detail from a painting representing the famous dream of Mi-la ras-pa (see pages 197–199). The tall snow-covered mountain at the centre represents Mar-pa who, with the "four great columns" (Tib.: Ka-chen-bzhi), forms a Mandala of the first bKa'-brgyud-pa masters. Standing on top of the four columns are a lion, a tiger, the mythical Garuḍa bird and a white vulture.

83 Detail from a typical historical representation from Tibet, with a rich sequence of scenes from the life of the great yogi Mi-la ras-pa. The top centre depicts the events at the sacred Ti-se (Kailash) mountain when Mi-la ras-pa defeated the Bon lama Na-ro bon-chung and his followers in a magic contest. This victory of the Buddhist yogi symbolically marked the defeat of the Bon religion in western Tibet.

84 'Brom-ston (1005–1064) was the most important disciple of the Indian scholar Atîśa. In 1056 he founded the Reting (Tib.: Rva-sgreng) monastery. The reproduced section of the painting shows the Tibetan 'Brom-ston with a group of his disciples in his monastery. According to the inscription on the painting he is explaining to them the doctrine of the Path of Enlightenment (Tib.: Byang-chub lam-sgron), an important work of his master Atîśa.

85 Views of cities or monasteries, not to mention geographical views and maps, are by no means common in Tibetan art. The section of the picture here reproduced shows a large monastery of the dGe-lugs-pa sect. The red extension to the left of the main monastery building is the temple of the guardian deities (Tib.: mGon-khang). This is perhaps a view of the bLa-brang monastery in eastern Tibet.

86 A particular refinement of techniques was achieved by the painting schools of Khams Province in eastern Tibet. The most important movement among them was the Karma dga'-bris. It is to this tradition that the reproduced detail of a portrait of a Grand Lama of the Karma-pa sect belongs – Byang-chub rdo-rje (1703–1733). According to tradition the famous black hat of the Karmapa lamas came from the hair of Ḍâkinis. This hat is shown on special occasions during a solemn initiation ceremony; it is studded with precious stones. To see the hat is regarded in Tibet as one of the four blessings of a sacred locality (Tib.: Grol-ba bzhi-ldan). The first blessing is the "liberation through seeing" (Tib.: mThong-grol).

In constant search craving for nourishment and
clothing
it has no time to emancipate itself from worldly
action.
Renounce worldly activity, o Ras-chung-pa!

In the city of the delusive earthly body
unreal knowledge is a great sinner.
It always follows the form of flesh and blood
and has no time to recognize the meaning of
reality.
Accurately discern the nature of the spirit, o
Ras-chung-pa!

On the boundary between physical body and
spirit
self-generated knowledge is a great sinner.
Always turning against sudden disaster, against
itself,
it has no time to recognize the nature of the un-
born.
Preserve the powerful realm of the unborn, o
Ras-chung-pa!

On the boundary between this life and the next
consciousness of the intermediate state is a
great sinner.
Seeking to unite with the form it does not pos-
sess
it has no time to recognize the real meaning of
things.
Find the path to the true essence of things, o
Ras-chung-pa!

At the place of illusion of the six worlds
vice and delusion from bad karma are a great
evil.
One always pursues it in desire and hate
and has no time to recognize equality.
Emancipate yourself from desire and hate, o
Ras-chung-pa!

In an invisible sphere of celestial mansions
the perfect Buddha resides, experienced in ap-
pearance and illusion.
Always tempted to champion the common
meaning
one has no time to recognize the absolute
knowledge of truth.
Avoid the meanings of relative truth, o Ras-
chung-pa!

Guru, Yidam and Ḍâkinî, these three
join in unity in order to revere them.
Mystic insight, meditation and the goal of per-
fection, these three
join in unity in order to practise them.
This life, the next life and the intermediate
state, these three
bring to unity and make yourself familiar with
it.
This is the last of all my instructions;
of my whole testament it is the end.
There is no other truth than this, o Ras-chung-
pa!
Comprehend this well and discover the mean-
ing, my son!

Dvags-po lha-rje

Among his large number of disciples Mi-la ras-pa had several important successors. While Ra-schung is to be seen as Mi-la's direct spiritual son, the greatest of his disciples was Dvags-po lha-rje (1079–1153). He was predestined for this role since it was generally known that, according to various prophecies, he was an incarnation of the Bodhisattva Candraprabhakumâra who was believed to have lived many aeons before. As an inspired incarnation of this Bodhisattva, Dvags-po lha-rje (frequently also known as sGam-po-pa) seemed chosen to accomplish great tasks. The second son of a family of three, he studied Tibetan medicine with his father and also, at an early age, studied various religious doctrines of the rNying-ma-pa sect. He was soon an accomplished expert in the art of healing and was married at the age of twenty-two. However, his wife and two children soon died of the plague which swept through his village. This caused him to become introspective and at the age of twenty-six he decided to become a novice and soon after a monk in a monastery. After his ordination he applied himself to his studies, learnt the interpretations of several different teachers and eventually became a disciple of certain outstanding masters of the bKa'-gdams-pa sect.

One day, while he was deep in meditation, three mendicants happened to pass, talking to each other. One of them mentioned Mi-la ras-pa, and as soon as Dvags-po lha-rje heard this name uttered he instantly felt confidence in him and in-

quired where the great guru was to be found. At once he set out on his long journey to find the famous yogi. The meeting between the two representatives of different Buddhist doctrinal traditions clearly reveals the typical differences between the rules and way of life of the tantric yogis and those of the fully ordained monks of Tibet. Each of the two paths of Buddhist practice was taught and championed by outstanding authorities. Dvags-po lha-rje found Mi-la ras-pa sitting on a massive boulder. To lend support to his request for spiritual instruction he offered him a lump of gold and a brick of tea. But Mi-la courteously declined both, with the remark that the gold did not befit his age and as for the tea, he had no stove to cook it on. Mi-la on his part then offered him a Kapâla filled with wine. Dvags-po lha-rje at first hesitated: a monk was not allowed to drink wine. But he soon overcame his scruples and drained the bowl and was consequently accepted by Mi-la ras-pa. To the tantrist, therefore, rules are of only relative value, and they apply only to a man who has not yet overcome the world. Dvags-po lha-rje stayed with his master for more than thirteen months and was initiated into the highest grade of the secret doctrine of the "mystic fire". He then returned to his home, having remembered his guru's instructions that he should thenceforward only practise meditation and reside in remote hermitages. He followed these instructions for the next three years and subsequently journeyed far afield to various monasteries in order to initiate numerous disciples into the doctrines. He

also wrote a number of valuable treatises and commentaries on the doctrines of the "Great Seal" (Tib.: Phyag-chen) which, by the name of Mahâmudrâ, represent the foundation of the bKa'-brgyud-pa line. His extensive knowledge made him a true inheritor of Mi-la ras-pa and the greatest expert on and interpreter of the Mahâmudrâ doctrines. Among his twenty most important disciples the most famous was the Lama Dus-gsum mkhyen-pa ("the omniscient one of the three times"). With him began the series of incarnated hierarchs of the Karma-pa which formed the principal branch in the oral tradition of Mi-la ras-pa's school.

We will conclude with the words of Mi-la ras-pa, spoken to his disciple Dvags-po lha-rje as his last instructions and reminders on the occasion of his return to his native central Tibet (dBus Province) in order to proclaim his master's teachings:

O my son and proclaimer of the doctrine, are
 you now going to dBus?
If, o lama, you go to dBus
it may be that choice dishes appear to you (in
 spirit).
So long as such dishes appear
eat of the inexhaustible Samâdhi.
Be aware that all sweetmeats are illusion.
Thus comprehend the apparition in the spirit of
 Dharmakâya.

It may be that glittering garments appear to
 you.
So long as such glittering garments appear
take as a garment the blissful warmth of mystic
 fire.
Be aware that all softness and pleasure is but il-
 lusion.
Thus comprehend the apparition in the spirit of
 Dharmakâya.

It may be that your native land appears to you.
So long as your native land appears
take as your homeland the constant nature of
 the void.
Be aware that all homelands are but illusion.
Thus raise the apparition into Dharmakâya.

It may be that costly riches appear to you.
So long as such riches appear
take for your riches the seven noble jewels of
 the saints.
Be aware that all riches are but illusion.
Thus raise the apparition into Dharmakâya.

It may be that friends appear to you.
So long as such friends appear
your only trustworthy friend is self-born wis-
 dom.
Be aware that all friends are but illusion.
Thus raise the apparition into Dharmakâya.

It may be that your guru appears to you.
So long as the guru appears
above your head, inseparable from you, pray
 for his blessing.
Meditate on the unutterable in the Maṇḍala of
 the heart.

Be aware that even the guru is an illusion and
 dream vision
and that all other things are but illusion.

In the east stands Mount sGam-po-gdar,
like a king upon his throne.
The mountain behind it is like a waving white
 shawl,
the mountain in front is like a pile of jewels
and its peak is like a precious crown.
All round stand seven mountains, bowing like
 ministers,
and wooden flagpoles are like a golden
 Maṇḍala.
Upon the shoulders of this mountain are the
 disciples.
Go there, my son, for the sake of all beings,
that through you these beings may attain per-
 fection.

Rin-chen bzang-po

Rin-chen bzang-po, the great Tibetan translator,
was a totally different personality. His name is
associated with the so-called Buddhist renais-
sance, the new flowering of the doctrine in Tibet
following its virtual extinction through its perse-
cution under King gLang-dar-ma. In western
Tibet the kings of Guge began to support Bud-
dhism and to promote its spread. King Ye-shes-
'od, in particular, commanded the centre of
Guge to be rebuilt and magnificent temples and
monasteries to be erected.

The history of the Buddhist revival in western
Tibet is unthinkable without Rin-chen bzang-po.
He was born as one of four children at Rad-nis
in 958. He is reputed to have acquired, at an
early age, an extensive knowledge of existing
texts awaiting translation. He was also accepted
as a monk into the order, probably by the Bud-
dhist king of Guge. He was only sixteen when he
was chosen by the king, together with a group of
other gifted Tibetans, to go to India to study the
religious teachings of Buddhism and to bring as
many books as possible back to Tibet. To this
end the monks crossed the Himalayas from the
western Tibetan plateau and reached Kashmir,
which was then known as the classical country of
tantric Buddhism. To start with, the young
translator remained in Kashmir for seven years
in order to learn the native languages and, more
particularly, Sanskrit. He then returned to Tibet
with a vast amount of new knowledge. Twice
more he was to cross the high passes into India
in order to study the commentaries on the doc-
trines and bring a large quantity of sacred writ-
ings back to Tibet. Altogether he spent
something like seventeen years studying in India.
In Tibet he then embarked on his vast translat-
ing activity which was supported by the kings of
Guge through the enlistment of a further large
group of translators and scholars. Rin-chen
bzang-po started with an extensive revision of
extant old translations. His greatest achievement
for Mahâyâna Buddhism, among his many new
translations, was the Prajñâpâramitâ, the writ-
ings about "transcendental wisdom" which

Fig. 18. Title vignette from a book of ritual for the deity Śaṃvara: the Yidam Śaṃvara.

represented the foundation of the doctrine. According to the chronicle, helped by a host of translators he translated more than 150 Sanskrit texts into the Tibetan language. From the two groups of texts, the Sûtras and the Tantras, the translators chose the ones which seemed to them the most important.

In other respects too, Rin-chen bzang-po was an outstanding and versatile personality of considerable artistic gifts. These soon led him to the practical side of Buddhist art and he began to erect temples, monasteries and royal palaces in the country. Under Kings Ye-shes-'od and Byang-chub-'od of Guge, Rin-chen bzang-po gave full rein to his architectural talents. On one occasion, when returning from Kashmir, he brought with him thirty-two Kashmiri artists who collaborated in the decoration of the temples as painters, wood carvers and sculptors. In addition to his work as a translator he now travelled more frequently beyond the regions of western Tibet, as far as Ladakh, Zanskar, Lahul, Spiti and Kunavar and there founded temples and monasteries according to his own plans and instructions. Many of these proved of major importance to Tibetan art and, with their artistic furnishings, became models to other schools in subsequent centuries. The greatest and most important temple founded by Rin-chen bzang-po was the famous golden temple in the monastery of Toling (Tib.: mTho-gling); it was followed by the temples of Kha-char, Tabo, Nako, Lha-lung and Alchi. In all these temples, and many others which date back to that period of the eleventh century, the walls were covered with frescoes by Kashmiri and west Tibetan artists, and the chambers and shrines contained a wealth of sculptures in stucco and bronze. It is said that the small monastery of Lha-lung, in remote Spiti, was for a long time his favourite place of residence for meditation. In these temples we encounter an artistic style which derives directly from Indian Kashmiri models. The principal figures ordered by Rin-chen bzang-po were precious wooden statues or stucco figures representing the Buddha Vairocana, Avalokiteśvara,

Hevajra and others. In the libraries the valuable original Buddhist texts, brought from India for translation, were preserved.

When the great master was eighty-seven he had a meeting at Toling with Atîśa, the famous Indian master who had come to Tibet in 1042 at the invitation of the king of Guge. Atîśa similarly developed an intensive translating and teaching activity and later travelled to central Tibet. He also undertook certain revisions and reforms of the ancient doctrines still existing in Tibet and founded an important doctrinal tradition by the name of bKa'-gdams-pa.

Rin-chen bzang-po, the great translator and architect of west Tibet, died in 1055, aged ninety-eight. Thus, over a period of nearly seventy years, the spiritual, religious and artistic life of the old kingdom of Guge was guided and inspired by one of the greatest of Tibetan scholars and artists. Supported by numerous scholars from his own country and by artists from Kashmir, Rin-chen bzang-po established a flourishing Buddhist culture in the western Land of Snows at a time when the doctrine was on the decline in India. The influences of this era can be traced far into the sixteenth century.

Notes on the Spelling of Technical Terms

(1) The spelling of Sanskrit terms in this book follows the most widely adopted international transliteration from the Indian Nâgarî alphabet.

(2) For the classical Tibetan language, scholarly transliteration seemed the only sensible choice. Since the pronunciation of Tibetan words can vary greatly, and any method (following either German, French or English pronunciation) would require totally different spellings, the only reasonable choice here is a correct transliteration which will at least be meaningful to the student or expert in the field. As with many other ancient languages, the pronunciation of Tibetan has greatly departed from the classical literary language and, moreover, shows considerable dialectical differences. A pronunciation which remains reasonably close to the ancient literary language of Tibet is still found in parts of Ladakh and in a few provinces of eastern Bhutan.

Our transliteration largely follows the method proposed by Prof. Turrell V. Wylie (in "A Standard System of Tibetan Transcription", Harvard Journal of Asiatic Studies, vol. XXII, 1959) with one exception made in the interest of the student: at the beginning of a word or sentence only the true radical letters are spelt with a capital. This will make it easier for the beginning student to find the word in a Tibetan dictionary, where terms are arranged by radicals. Although the Tibetan terms are arranged, in the index of this book, in order of the Latin alphabet, this alphabetical arrangement applies to the Tibetan radicals. In the text of this work technical terms are written with hyphens for an easier understanding of the relationship between syllables; but this practice has not been followed in the Tibetan bibliography.

The thirty basic characters of the Tibetan alphabet have been transcribed as follows:

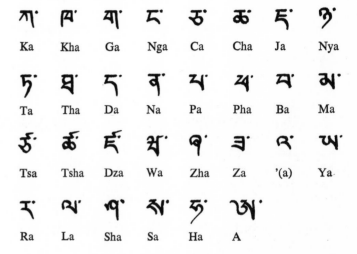

Ka	Kha	Ga	Nga	Ca	Cha	Ja	Nya
Ta	Tha	Da	Na	Pa	Pha	Ba	Ma
Tsa	Tsha	Dza	Wa	Zha	Za	'(a)	Ya
Ra	La	Sha	Sa	Ha	A		

For purely practical considerations a few Tibetan names which occur frequently in the text or are well known as geographical names have been rendered in phonetic transcription. They are listed below, with the correct Tibetan transliteration given in parentheses.

Bardo	(tib. Bar-do)
Derge	(tib. sDe-dge)
Guge	(tib. Gu-ge)
Gyantse	(tib. dGyal-rtse)
Labrang	(tib. bLa-brang)
Lhasa	(tib. Lha-sa)
Lithang	(tib. Li-thang)
Narthang	(tib. sNar-thang)
Reting	(tib. Rva-sgreng)
Sakya	(tib. Sa-skya)
Yidam	(tib. Yi-dam)

Acknowledgments

Color Photographs:
Author: No. 1–13, 15–21, 24–26, 28–33, 35–39, 42, 46–51, 53–56, 59–64, 67, 71, 75, 78, 79, 81–86 as well as endpapers and dust-wrapper
Swiss Tibetan Aid Committee: No. 11, 14, 22, 23, 27, 34, 40, 42–44, 65, 66, 68–70, 72–74, 76, 77, 80
Markert: No. 52
University of Zürich: No. 57, 58

Proprietors of Art:
Musées Royaux d'Art et Histoire, Brussels: No. 5, 6, 27, 83
Dr. med. K. Bröchin, Aarburg: No. 11
Dr. A. Schwaninger, Basle: No. 14
Mann Collection, New York: No. 15, 16, 53
Dr. T. Grad, Aichach: No. 18, 32, 81
B. Aschmann, Zürich: No. 22, 23, 34, 40, 42, 43, 44, 68, 69, 73, 77
Museum für Völkerkunde der Universität Zürich: No. 51, 57, 58
G. Markert, Verscio: No. 25, 65, 80
Dr. Jucker, Basle: No. 66
R. Gedon, Munich: No. 72
Linden-Museum, Stuttgart: No. 74
Van de Wee, Antwerp: No. 76
Anonymous Proprietors and Private Collections: No. 7, 8, 12, 17, 20, 21, 24, 26, 28–31, 33, 35, 38, 39, 41, 45, 46, 48, 49, 54, 64, 67, 70, 71, 75, 78, 82, 84–86

Black and White Illustrations:
Author: No. 1–7, 10–15, 17
Museum für Völkerkunde der Universität Zürich: No. 8, 9, 16, 18

Endpapers: Detail of an ancient Tibetan Manuscript in gold and silver ink on paper specially prepared with blue dye
Frontispiece: Reproduction of Khadiravanî-Târâ from an eighteenth century beaten bronze statue from Nepal

Dust-wrapper, front:
The gilded statue of the Buddha Maitreya (Tib.: Byams-pa) in the shrine of the Pha-jo-lding monastery in Bhutan. He is regarded as the Buddha of the Age-to-Come, who will proclaim the law of all-embracing love. Standing in front of the statue are votive Stûpas serving as reliquaries of various sizes.

Dust-wrapper, back:
A Maṇḍala may be represented not only by the arrangement of circle and square, but also by an appropriate grouping of the deities in a "free space". Such a painting is the picture of the Yidam Cakrasaṃvara in the Zlum-rtse lha-khang temple in Bhutan. Cakrasaṃvara (or Śaṃvara) is an initiation deity whose secret residence is believed to be on Mount Kailash, the holiest mountain in Tibet (see also pp. 172–175). The fresco shows the attendant deities of the Yidam Śaṃvara (Tib.: bDe-mchog lha-tshogs) grouped about the central figure in a prescribed order.

Bibliography I

Tibetan Block-Prints and Manuscripts
The full Tibetan title is followed by an abridged translation of its content.

1. Grub chen thang stong rgyal po'i rdo rje'i gsungs skya nad grol mar grags pa'i smon lam byin rlabs can
 Diamond words of the Mahâsiddha Thang-stong rgyal-po.
2. gSol 'debs le'u bdun' pa'i lo rgyus dmigs rim phan yon dang bcas pa snyan brgyud zab mo yi ger bkod pa
 Path of contemplation of history, compiled in seven chapters from the profound scriptures of the oral tradition.
3. Grub dbang rin po che'i dag snang bcu gcig zhal gyi rjes gnang bum dbang sems dpa'i bzhi brtesgs su grags pa
 Consecration through the vessel, according to the precious, great and perfect and purely radiant eleven-headed Avalokiteśvara
4. Thugs rje chen po'i sgrub thabs yang snying gsang ba bcud dril
 A Sâdhana of the all-benign Avalokiteśvara
5. Chos skyong ba'i rgyal po srong btsan sgam po'i bka' 'bum las smad kyi cha zhal gdams Kyi skor
 From the instructions of the Dharmapâla King Srong-btsan sgam-po
 Volume I, Instructions
6. Chos skyong ba'i rgyal po srong btsan sgam po'i bka' 'bum las stod kyi cha thog mar bla ma brgyud pa'i gsol 'debs lo rgyus sogs
 From the collected works of the Dharmapâla King Srong-btsan sgam-po
 Volume II, Invocations of gurus and history
7. Chos skyong ba'i rgyal po srong btsan sgam po'i zhal gdams / 'Phags pa nam mkha'i rgyal po'i mngon rtogs sogs phran 'ga'
 From the instructions of Dharmapâla King Srong-btsan sgam-po
 Volume III, Clear recognition of the venerable king of heaven
8. 'Phags pa gsol 'debs zhal mthong ma
 Invocations for the dawning of Ârya-Avalokiteśvara
9. Yang zab mkha' 'gro snyan rgyud las / Thugs rje chen po 'khor ba 'jigs sgrol gyi las byang bklag chog tu bkod pa
 From the most profound oral tradition of the Dâkinîs /
 Deliverance from the dreadful Saṃsâra through Avalokiteśvara
10. 'Phags pa bcu gcig zhal dpal mo lugs kyi sgrub thabs dang 'brel ba'i smyung bar gnas pa'i cho ga gzhan phan kun khyab
 Uposatha rite and Sâdhana according to the female counterpart of the eleven-headed Avalokiteśvara
11. 'Phags pa bcu gcig zhal dpal mo lugs kyi rjes su gnang ba dang gso sbyong yan lag brgyad pa'i sdom pa 'bog pa'i cho ga gzhan phan rab 'byams
 The exquisite rite of the eightfold fasting vow according to the tradition of the female counterpart of the eleven-headed Avalokiteśvara
12. Thugs rje chen po yi ge drug pa'i gsol 'debs kyi sgrub thabs byin rlabs can
 Beneficial Sâdhana for the invocation of the six-syllabic Avalokiteśvara
13. rDo rje 'chang / rje btsun rdo rje rnal 'byor ma / gsang bdag rdo rje snying po / grub chen te lo pa / mkhas grub na' ro pan chen / sgra sgyur mar pa lo tsa rnams kyi rnam thar gsol 'debs las dang por rgyal dbang rdo rje 'chang gi bstod pa mi zang rgyan gyi 'khor lo'i rnam rol
 History and invocations of Vajradhara, Vajravârâhî, the secret Vajragarbha, the Mahâsiddha Tilopa, the perfect great Paṇḍita Nâropa and of Mar-pa, the translator
14. dPal rdo rje sems dpa' thugs kyi sgrub pa'i bsnyen sgrub phrin las kyi cho ga rnam grol lam bzang
 The good path to complete liberation with the Karma rite through perfect veneration and offerings to the Buddha Vajrasattva
15. dPal gsang ba 'dus pa zhes bya ba'i rgyud kyi rgyal po chen po
 Śrî-Guhyasamâjatantrarâja
16. Chos 'byung bstan pa'i padma rgyas pa'i nyin byed
 Tibetan Chronicle of Padma dkar-po, ed. by L. Chandra, Delhi 1968.
17. Bod snga rabs pa gsang chen rnying ma'i chos 'byung legs bshad gsar pa'i dga' ston gyi dbu 'dren gzhung don le'u'i ngos 'dzin
 History of the rNying-ma-pa sect in Tibet by Bdud-'joms 'jigs-bral ye-shes rdo rje, Kalimpong
18. Deb ther dmar po
 The red annals of Lama Kung-dga' rdo-je

19. O rgyan gu ru padma 'byung gnas la gsol ba 'debs pa gu ru nyid kyi zhal lung le'u bdun pa bar chad lam sel rje dbangs nyer lnga gter ston brgya rtsa'i gsol 'debs smon lam
The obstacle-removing path of the words and invocations of Padmasambhava in seven chapters and the invocations of the twenty-five yogis and one hundred treasure-finders

20. Na'ro gsang spyod kyi dmigs rim
Path of contemplation on the secret method of Nâropa

21. Zab chos zhi khro nges don snying po sgo nas rang dang gzhan gyi don mchog tu sgrub pa'i las rim 'khor ba'i mun gzhoms kun bzang thugs rje'i snag mdzod
The heart essence of absolute knowledge of the profound doctrine of the peaceful and wrathful deities

22. dPal 'khor lo sdom pa'i dbang chog ngag 'don gyi rim pa
The path of consecration of Cakrasamvara reproduced in words

23. dPal 'khor lo sdom pa lu'yi pa lugs kyi dbang gi brgyud 'debs dang mngon rtogs
Path of insight and invocation of Cakrasamvara according to the Siddha Lûyipa

24. dPal 'khor lo sdom pa l'han cig skyes pa'i dkyil 'khor gyi cho ga byin rlabs bdud rtsi'i gter bum
Beneficent treasure vessel of the Mandala rite of Sahaja-Cakrasamvara

25. Shangs lugs bde mchog lha lnga'i sgrub thabs kyi rnam par bshah pa zab don gsal byed
Complete explanation of the profound significance of the five divine forms of Samvara according to the Shangs tradition

26. Dam tshig thams cad kyi nyams chag skong ba'i lung lnga
The five prescriptions for the implementation of all neglected vows

27. Bar do thos grol chen mo
The great path of liberation from the Bardo through listening

28. Zab chos zhi khro dgongs pa rang grol las / Bar do'i gsol 'debs thos grol chen mo bklag chog tu bkod pa 'khrul snang rang grol
From self-liberation through meditation on the profound doctrine of the peaceful and wrathful deities [Large collection of writings on the Tibetan Book of the Dead]

29. Zab chos zhi khro dgongs pa rang grol las / Chos spyod brgya phyag sdig sgrib rang grol
From self-liberation through meditation on the profound doctrine of the peaceful and wrathful deities | Self-liberation from errors and sins through religious practice of hundred-fold veneration

30. Chos spyod bag chags rang grol
Religious exercise for the self-liberation from vicious inclinations

31. dBang bskur 'bring po 'gro drug rang grol
General mandate for the self-liberation of the six classes of beings

32. Kar gling zhi khro las lha dbang
Initiations through the deities from [the cycle of] peaceful and wrathful deities according to Karma gling-pa

33. O rgyan gu ru padma 'byung gnas kyi skyes rabs nam par thar pa rgyas par bkod pa padma bka'i thang yig
Padma-bka'-thang, the [famous] biography of O-rgyan guru Padmasambhava

34. Dam can rdo rje legs pa'i bskang ba mchod stod kyi rim pa stobs ldan yid 'gul
Path of veneration and sacrificial rite for the deity Dam-can rdo-rje legs-pa

35. sKyes mchog rdo rje legs pa'i bskang gsol dgra bgegs tshar gcod
Destruction of the dGra and bGegs demons through sacrifice and invocation of the deity rDo-rje legs-pa

36. bCom ldan 'das dpal rdo rje 'jigs byed dpa' bo gcig pa'i sgrub thabs bdud las rnam rgyal gyi ngag 'don nag 'gros blo dman las dang po pa la khyed bde bar bkod pa
Sâdhana for the deity Ekavîra-Vajrabhairava

37. dPal rdo rje 'jigs byed lha bcu gsum ma'i bdag skyed
The thirteen self-arisen deities [through] Śrîvajrabhairava

38. 'Phags yul grub pa'i dbang phyug dpal te lo na' ro gnyis dang / dgyes mdzad mar pa lo tsa' / rje btsun bzhad pa rdo rje bcas kyi rnam thar mdor bsdus dang / mkhas grub dvags po lha rje'i rnam thar snyan pa'i bden 'dzam gling mtha gru khyab pa'i rgyan
Abridged history of the two Siddhas Tilo and Nâro from India, of Mar-pa the translator and of the venerable Mi-la bzhad-pa rdo-rje, and the totally world-embracing jewel of the real history of the perfect Dvags-po lha-rje

216

39. bKa' brgyud mgur mtsho 'og don khog dbubs spyi chings rnam par bshad pa skal bzang yid kyi ngal gso
Ocean of cantos of the bKa'-brgyud-pa sect

40. rNal 'byor gyi dbang phyug dam pa rje btsun mi la ras pa'i rnam par thar pa dang thams cad mkhyen pa'i lam ston
Life history of the venerable yogi Mi-la ras-pa

41. rJe btsun mi la ras pa'i rnam thar rgyas pa phye ba mgur 'bum
The hundred thousand cantos of the venerable Mi-la ras-pa

42. mNyam med dvags po bka' brgyud kyi bstan rtsa so thar sdom rgyun du bzhugs pa'i mkhan rabs kyi rnam thar mdor bsdus tshul khrims mdzes rgyan
Abridged history of the line of abbots of the Dvags-po bka'-brgyud-pa

43. rTa mgrin gsang sgrub rjes gnang smin byed bdud rtsi'i chu rgyun
Shower of liberating nectar according to the tradition of Guhyasâdhana-Hayagrîva

44. Khro bo'i bar do ngo sprod gsol 'debs thos grol
Liberation through hearing the prayer of confrontation with the wrathful deities in Bardo

45. Klong chen snying gi thig le las / Yum ka'i gsang sgrub seng ge'i gdong can
From the "heart drop" of [the Guru] Klong-chen-pa / The Guhyasâdhana-Dakînî Simhavaktrâ

46. Yum ka'i gsang sgrub seng ge'i gdong can las / gTor zlog byad gdong yul 'joms
gTor-ma offering for the Guhyasâdhana-Dakînî Simhavaktrâ

47. Pad gling gter byon bla ma nor bu rgya mtsho'i las byang padma'i ljon shing kha skong dang bcas pa nag 'gros bklag chog tu bsgrigs pa
The jewel ocean of the lamas taken from the treasure of Padma gling-pa

Bibliography II

Books and Specialized Periodicals

Anuruddha R.P., An Introduction into Lamaism, Hoshiar-
pur 1959.
Bacot J., Introduction à l'Histoire du Tibet, Paris 1962.
– La vie de Marpa le "traducteur", Paris 1937.
– Le Poète tibétain Milarépa, Paris 1925.
Bapat P.V., 2500 Years of Buddhism, Delhi 1956.
Bell Ch., The Religion of Tibet, Oxford 1968.
– The People of Tibet, Oxford 1968.
– Tibet, Past and Present, Oxford 1924.
Bharati A., The Tantric Tradition, London 1965.
Bhattacharya B., Guhyasamâja-Tantra, G.O.S. No. 53,
Baroda 1967.
– Sâdhanamâlâ, Vols. I, II, G.O.S. No. 26, 41, Baroda 1968.
– An Introduction to Buddhist Esoterism, CH.S.S. Vol. XL-
VI, Varanasi 1964.
– Nispannayogâvalî of Abhayâkaragupta, G.O.S. CIX,
Baroda 1949.
– The Indian Buddhist Iconography, Calcutta 1968.
Bhavnani E., A Journey to "Little Tibet", N.G.M., Vol. X-
CIX, No. 5.
Burrows C., Tibetan Lamaist Art, New York 1970.
Candra L., A New Tibeto-Mongol-Pantheon, Vols. 1–17,
New Delhi 1961–1967.
Chang G.C.C., The Hundred Thousand Songs of Milarepa,
2 Vols., New York 1962.
Clark W.E., Two Lamaistic Pantheons, New York 1965.
Conze E., Buddhismus, Wesen und Entwicklung, Stuttgart
1953.
Dalai Lama, Mein Leben und mein Volk, Zürich 1962.
– The Opening of the Wisdom-Eye, Bangkok 1968.
Das S.C., Indian Pandits in the Land of Snow, Calcutta,
Repr. 1965.
– Journey to Lhasa and Central Tibet, New Delhi, Repr.
1970.
Dasgupta S.B., An Introduction to Tantric Buddhism, Cal-
cutta 1958.
Datta, B.N., Mystic Tales of Lama Taranatha, Calcutta
1944.
David-Neel A., Unbekannte tibetische Texte, München-
Planegg 1955.
– Magic and Mystery in Tibet, London 1965.

– Initiations and Initiates in Tibet, London 1970.
Desjardins A., Le Message des Tibétains, Paris 1966.
Ekvall P.B., Religious observances in Tibet, Chicago 1964.
Eracle J., L'Art des Thanka et le Bouddhisme tantrique,
Geneva 1970.
Evans-Wentz W.Y., Das Tibetanische Totenbuch, Zürich
1953.
– Yoga und Geheimlehren Tibets, München-Planegg 1937.
– Das Tibetische Buch der Großen Befreiung, München-
Planegg 1955.
– Tibet's Great Yogi Milarepa, London 1963.
Ferrari A., Mk'yen brtse's Guide to the holy places of Cen-
tral Tibet, S.O.R., Vol. XVI, Rome 1958.
Filchner W., Wissenschaftliche Ergebnisse der Expedition
Filchner nach China und Tibet, Band VIII, Tibet, Berlin
1910.
– Das Kloster Kumbum, Berlin 1906.
– Kumbum Dschamba Ling, Leipzig 1933.
Filippi F. de, An Account of Tibet; the travels of Ippolito
Desideri of Pistoia S.J. 1712–1727; London 1937.
Forstmann C., Himatschal, Die Throne der Götter, Berlin
1926.
Francke A.H., Antiquities of Indian Tibet, 2 Vols., Calcutta
1914, 1926.
Getty A., The Gods of Northern Buddhism, Oxford 1928,
Tokyo 1962.
Goidsenhoven J. van, Art Lamaïque, Art des Dieux, Brus-
sels 1970.
Gordon A.K., The Iconography of Tibetan Lamaism, New
York 1939, Tokyo 1959.
– Tibetan Religious Art, New York 1952.
Govinda A., Grundlagen tibetischer Mystik, Zürich 1956.
Grünwedel A., Mythologie des Buddhismus in Tibet und
der Mongolei, Repr., Osnabrück 1970.
Guenther H.V., The Jewel Ornament of Liberation by
sGam-po-pa, London 1959.
– The Life and Teaching of Naropa, Oxford 1963.
– Yuganaddha, The Tantric View of Life, Ch.S.S. Vol. III,
Varanasi 1969.
– The Royal Song of Saraha, Seattle 1969.
Heissig W., Ein Volk sucht seine Geschichte, Düsseldorf
1964.
Hoffmann H., Quellen zur Geschichte der Tibetischen Bon-

Religion, Mainz 1950.
- Die Religionen Tibets, Freiburg i.Br. 1956.
- Mi-la ras-pa, Sieben Legenden, München-Planegg 1950.
Hummel, S., Lamaistische Studien, Leipzig 1950.
- Geschichte der tibetischen Kunst, Leipzig 1953.
- Tibetisches Kunsthandwerk in Metall, Leipzig 1954.
- Lamaistische Kunst in der Umwelt von Tibet, Leipzig 1955.
- Die lamaistischen Miniaturen im Linden-Museum, Tribus Nr. 8, Stuttgart 1959.
- Die lamaistischen Kultplastiken im Linden-Museum, Tribus Nr. 11, Stuttgart 1962.
- Profane und religiöse Gegenstände aus Tibet und der lamaistischen Umwelt im Linden-Museum, Tribus Nr. 13, Stuttgart 1964.
- Tibetische Architektur, Bulletin der Schweizerischen Gesellschaft für Anthropologie und Ethnologie 1963/1964.
- Die lamaistischen Malereien und Bilddrucke im Linden-Museum, Tribus Nr. 16, Stuttgart 1967.
Jisl L., Mongolei, Kunst und Tradition, Prag 1960.
Joshi L.M., Studies in the Buddhist Culture of India, Delhi 1967.
Kazi, S.T., Tibet House Museum, Catalogue, New Delhi 1965.
- Second Exhibition of Tibetan Art, New Delhi 1966.
Kramrisch, S., The Art of Nepal, New York 1964.
Lalou M., Les Religions du Tibet, Paris 1957.
Lauf D.I., Die gCod-Tradition des Dam-pa Sangs-rgyas in Tibet, EZZ, Nr. 1, Zürich 1970.
- Initiationsrituale des Tibetanischen Totenbuches, Asiatische Studien, Vol. XXIV, 1–2, Bern 1970.
- Zur Ikonographie einiger Gottheiten der tibetischen Bon-Religion, EZZ, Nr. 1, Zürich 1971.
- Zur Geschichte und Kunst lamaistischer Klöster im Westhimalaya, Asiatische Studien, Vol. XXV, 1–2, Bern 1971.
- gYu-thog-pa und Medizingottheiten in Tibet, Sandoz-Bull. Nr. 23, Basel 1971.
- Tshe-ring-ma, die Berggöttin des langen Lebens und ihr Gefolge, EZZ, Nr. 1, Zürich 1972.
- Preliminary report on the history and art of some important buddhist Monasteries in Bhutan, Part I, EZZ, No. 2, Zurich 1972.

Lucas, H., Lamaistische Masken, Kassel 1962.
Maraini F., Secret Tibet, London 1952.
Monod O., Peintures Tibétaines, Paris 1954.
- Guide du Musée Guimet No. 1, Paris 1966.
Müller M., Buddhist Mahâyâna Texts, S.B.E., Vol. XLIX, Varanasi 1965.
Muralt R. von, Meditations-Sûtras des Mahayana-Buddhismus, Bd. I, II, Zürich 1956.
Nadou J., Les Bouddhistes Kaśmîriens au Moyen Age, Paris 1968.
Nebesky-Wojkowitz R. de, Oracles and Demons of Tibet, Den Haag 1957.
Olschak B.C., Tibet, Erde der Götter, Zürich 1960.
- Religion und Kunst im alten Tibet, Zürich 1962.
- Sikkim, Zürich 1965.
Olschak/Gansser U., Bhutan, Land der verborgenen Schätze, Bern 1969.
Olson E., Catalogue of the Tibetan Collection and other lamaist articles in the Newark-Museum, Vols. I–V, 1950–1971.
Pal P., The Art of Tibet, New York 1969.
- Lamaist Art, the Aesthetics of Harmony, Boston 1970.
Pander E., Das Pantheon des Tschangtscha Hutuktu, Berlin 1890.
Pascalis C., La Collection Tibétaine, Musée Louis Finot, Hanoi 1935.
Pott P.H., A remarkable Piece of Tibetan Ritual-Painting and its Meaning, Internat. Archiv für Ethnographie, Bd. 43, 1943.
- De "Ars Moriendi" van Tibet, Phoenix, Vol. I, No. 9, Amsterdam 1946.
- Introduction to the Tibetan Collection of the National Museum of Ethnology, Leiden 1951.
- Tibet, in "Kunst der Welt", Baden-Baden 1963.
- Yoga and Yantra, Den Haag 1966.
- The Mandala of Heruka, Ciba-Journal, No. 50, Basel 1969.
Pranavananda Swami, Kailas-Manasarovar, Calcutta 1949.
Richardson H.E., The Karma-pa Sect, A Historical Note, JRAS, Parts 1, 2, 1958.
- Tibet, Geschichte und Schicksal, Frankfurt 1964.
Roerich G., Tibetan Paintings, New York 1925.
Roerich G.N., The Blue Annals of gZhon-nu-dpal, 2 Vols.,

Calcutta 1949, 1953.

Saha K., Buddhism in Central Asia, Calcutta 1970.

Sankrityayana R., History of Central Asia, Calcutta 1964.

Schäfer E., Geheimnis Tibet, München 1943.

Schlagintweit E., Buddhism in Tibet, London 1863, Repr. 1968.

Schmid T., The cotton-clad Mila, Stockholm 1952.

- Saviours of mankind, 2 Vols., Stockholm 1961, 1964.

Schmidt R., Der Eintritt in den Wandel in Erleuchtung, von Śântideva, ein buddhistisches Lehrgedicht des VII. Jh., Paderborn 1923.

Schulemann G., Geschichte der Dalai Lamas, Leipzig 1958.

Schulemann W., Die Kunst Zentralasiens als Ausdrucksform religiösen Denkens, Köln 1967.

Schumann H.W., Buddhismus—Philosophie zur Erlösung, Bern 1963.

Seckel, D., Kunst des Buddhismus, in "Kunst der Welt", Baden-Baden 1962.

Shor F. and J., The caves of the Thousand Buddhas, N.G.M., XCIX, No. 3.

Singh, M., Himalayan Art, London 1968.

Sís Vanis, L'Art Tibétain, Prag 1958.

Sís V./Vanis J., Der Weg nach Lhasa, Prag 1956.

Snellgrove D.L., Buddhist Himalaya, Oxford 1959.

- The Hevajra Tantra, 2 Vols., London 1959.

- Himalayan Pilgrimage, Oxford 1961.

- Four Lamas of Dolpo, 2 Vols., Oxford 1967/1968.

- The nine ways of Bon, London 1967.

Snellgrove/Richardson, A Cultural History of Tibet, New York 1968.

Talbot Rice T., Kunst van Central-Azie, Den Haag 1965.

Tibetan Art in "Marg", Vol. XVI, No. 4, Bombay 1963.

Tibetische Kunst, Ausstellungskatalog, Zürich 1969.

Tolstoy J., Across Tibet from India to China, N.G.M., Vol. XC, No. 2.

Tucci G., Indo-Tibetica, Vols. I–IV, Rome 1932–1941.

- Teoria e Pratica del Mandala, Rome 1949.

- Tibetan Painted Scrolls, 3 Vols., Rome 1949.

- Tra Giungle e Pagode, Rome 1953.

- To Lhasa and Beyond, Rome 1956.

- Tibet, Land of Snow, London 1967.

Tucci G./Heissig W., Die Religionen Tibets und der Mongolei, Stuttgart 1970.

Vostrikov A.J., Tibetan Historical Literature, Calcutta 1970.

Waddell L.A., The Buddhism of Tibet or Lamaism, London 1895, Repr. 1959.

- Lhasa and its Mysteries, London 1906.

Waldschmidt E., Gandhara, Kutscha, Turfan, Leipzig 1925.

Waldschmidt E. und R.L., Nepal, Kunst aus dem Königreich im Himalaya, Recklinghausen 1967.

Winternitz M., der Mahâyâna-Buddhismus nach Sanskrit- und Prâkrittexten, Tübingen 1930.

Abbreviations:

CH.S.S. = Chowkhamba Sanskrit Studies, Varanasi
EZZ = Ethnologische Zeitschrift Zürich, Zürich
G.O.S. = Gaekwad's Oriental Series, Baroda
JRAS = Journal of the Royal Asiatic Society, London
N.G.M. = National Geographic Magazine, Washington
S.B.E. = Sacred Books of the East, Delhi, Varanasi, Patna
S.O.R. = Serie Orientale Roma, Rome

Index